The Spirit of Writing

A NEW
CONSCIOUSNESS
READER

This New Consciousness Reader is part of a series of original and classic writing by renowned experts on leading-edge concepts in personal development, psychology, spiritual growth, and healing. Other books in this series include:

ALSO BY *Mark Robert Waldman*

LOVE GAMES:
How to Deepen Communication, Resolve Conflict,
and Discover Who Your Partner Really Is

THE ART OF STAYING TOGETHER:
Embracing Love, Intimacy, and Spirit in Relationship

DREAMSCAPING:
New and Creative Ways to Work with Your Dreams
(with Stanley Krippner)

The Spirit

of Writing

CLASSIC AND CONTEMPORARY
ESSAYS CELEBRATING
THE WRITING LIFE

Edited by *Mark Robert Waldman*

Jeremy P. Tarcher / Putnam
A Member of Penguin Putnam Inc.
New York

Most Tarcher/Putnam books are available at special quantity discounts
for bulk purchase for sales promotions, premiums, fund-raising, and
educational needs. Special books or book excerpts also can be created
to fit specific needs. For details, write Putnam Special Markets,
375 Hudson Street, New York, NY 10014.

Jeremy P. Tarcher/Putnam
A member of
Penguin Putnam Inc.
375 Hudson Street
New York, NY 10014
www.penguinputnam.com

Library of Congress Cataloging-in-Publication Data

Printed in the United States of America

1 3 5 7 9 10 8 6 4 2

Book design by Lovedog Studio

To David Groff
for his vision and support of the literary arts,
and to the International Women's Writing Guild,
for encouraging people throughout the world
to write about societal oppression and hate

Contents

PART TWO
Memories and Inspirations from the Past

PART THREE
Advice to Writers Young and Old

PART FOUR

Bending the Muse and Breaking the Rules

Acknowledgments

THE MAKING OF an anthology is a collaborative process influenced by many people and events—a world that is filled with publishers, editors, and agents, and the voices of a thousand inner critics who haunt a writer's brain. But the soul of an anthology rests ultimately with its contributors, whose voices bring the book to life. Many of the following essays and poems were specifically written or revised for *The Spirit of Writing*—each one a genuine gift from the author's heart. To those fine contributors, my deepest appreciation is given. Thank you for sharing the inner layers of your being, for your humor and support, and for spreading worldly compassion with your song.

I am greatly indebted to Jeremy Tarcher, Sara Carder, and Joel Fotinos for their sensitive and excellent input in the development of this project, and as always, my appreciation to Wendy Hubbert, Mitch Horowitz, Scott Brower, and to all the wonderful people behind the scenes at Tarcher/Putnam who help give birth to our books.

Finally, a special note of love and respect to Susan, for putting up with the endless piles of paper that comprise a writer's world: of notepads scribbled with unreadable words, spilling down stairways and shelves—an avalanche of ink-stained debris. Thank you for having faith that the job will be done, when a semblance of order returns and a gentle embrace is found. Until . . .

the next . . .

few . . .

letters . . .

intrude.

Franz Kafka in His Small Room on the Street of the Alchemists, 1916–1917

One winter Kafka rented a white room
high near the castle where he tired his pen
during the day. At night he rinsed the gloom
out of his eyes and was a crow in heaven,
rising, dancing on awful heights. Before
dawn fed him sleep, the Golem far below
the wall whispered a gravesong in his ear
in ancient Hebrew vague to him. Although
he slept, the ghost of Jewish friends in Prague
(Max Brod who loved his ink) helped him
survive close to the sky. A winter wood
of horses floated on the city fog.
The castle mastered him, but in a whim
he drank white ink and hungered where he stood.

—WILLIS BARNSTONE

Introduction

WHAT IS IT LIKE to *be* a writer? What motivates so many people to pick up the pen and bare their most intimate and vulnerable feelings to the world? For novelists like William Faulkner and John Steinbeck, it is the need to reveal the frailties of the human condition and the potential we have to transcend personal pain. And there are those, like Sindiwe Magona, who use their writing to expose the social injustices of the world.

Some, like Sylvia Plath, write because they are haunted by the painful experience of their existence, while others write to savor a childhood sentiment or express a moment of grace. There are authors like Henry Miller who exult in violating taboos, and poets like Pinsky and Paz who forge new literary ground as they experiment with language and form. Others, instead, apply their talents to educate and inform, while some simply write for the pleasure of entertaining their friends.

Writers love language, and they will arrange and rearrange their words until they come alive on the page. The meanings may be stretched and changed, but if a writer is successful, he or she will lure the reader into a world where deeper realities unfold. But writing about *writing*—which is the theme of this book—can be a particularly challenging task, even for a seasoned author, for when you write about yourself it is like entering a

hall of mirrors. At first, all one sees is a repetition of narcissistic images fading away behind the glass. But somewhere in that imagery, in that jumble of phrases and words, fragments of truth erupt: a forgotten memory, a hidden meaning, or a fleeting glimpse of one's soul. These are the kinds of personal stories that you will find in this anthology—of writers ruminating on the sacred moments of their lives and sharing the lessons they have learned.

For millions of Americans, writing has become an impassioned pursuit. We fill diaries, compose memoirs, trade stories with our friends. We attend classes and workshops, dreaming of literary fame. Why are we so enamored with our words? Is it for pleasure, or recognition, or something more? The answer, psychologists conclude, is simple: we write because we have to write—because it keeps us grounded and sane. Writing is powerful because it expands our ability to communicate with others. "But more important," says Mihaly Csikszentmihalyi, a professor of social psychology and author of *Creativity,* "the written word allows us to understand better what is happening within ourselves":

> By reading and repeating a verse or passage of prose, we can savor the images and their meaning and thus understand more accurately how *we* feel and what *we* think. Fragile thoughts and feelings are transformed by words into concrete thoughts and emotions. In this sense, poetry and literature allow the creation of experiences that we would otherwise not have access to; they take our lives to higher levels of complexity.

To understand the writer's world is to grasp and comprehend our own ability to live a more satisfying life. This was my goal in constructing this anthology: to give each reader a greater insight into the creative processes that lay dormant within us all, and to encourage as many people as possible—adults and children alike—to delve into the writing life, be it as a reader, a diarist, a storyteller, or a composer of poetry and prose. Toward this end, I have collected a wide range of classic, original, and experimental essays that capture the complex nuances of writing—of the

struggles and revelations that every author must face. In these reflective tales you will find a rare combination of intimacy and advice, vulnerable moments that are balanced between wisdom, innocence, and pain. Their words leap across the page with beauty and intrigue, for each vignette is a masterful example of compositional craft.

Writing encompasses many directions and forms, and so, in addition to the dozens of legendary and award-winning contributors that are contained in this anthology, I have included works by contemporary journalists, screenwriters, nonfiction authors, and novelists who specialize in specific genres of style (romance, mystery, suspense, science fiction, children's stories, etc.). These working-class heros of the publishing world compose ninety percent of the literature we read, yet their perspectives—which are filled with important insights and advice—are often excluded from writer's anthologies.

Humor, too, plays an important part in many writers' lives, and so I have included a handful of essays that use satire, fiction, and wit to expose the underbelly of the writing life, be it through the sarcasm of Mark Twain as he lampoons the "littery" masters of his time or the whimsical spirit of Natalie Goldberg who likens the art of writing to the process of eating a car. As Emily Dickinson once said, you should always tell the truth when writing, *"but tell it slant."*

Part 1 of this book delves into the complex dimensions of a writer's vision and the subtle urges that guide one's inner muse, while Part 2 focuses upon memories and inspirations from the past. Be it a cherished moment with a parent or friend, a traumatic childhood event, or a intimate encounter in school, such experiences often initiate an author's lifelong desire to write. Many of the pieces in this section reveal the psychological benefits of writing, challenging the controversy surrounding creativity and its relationship to madness and health.

Part 3 offers a wide range of literary advice to writers. From Rilke's letter to a struggling poet, to Julia Cameron's attack upon arrogant authors, these essays bring inspiration to all who want to write. Be it about money or style or drafting clumsy first drafts, their message reflects a common theme: that there is no "right" way to write; that writing is an intimate

adventure, requiring persistence and faith; and that every story written, or poem composed, will open a door to a deeper appreciation of life.

The creative essays in Part 4 highlight an essential dimension of the writing life: that writing is an artful experiment in the expression of one's individual self. These essays were composed by writers who employ startling techniques to address fundamental issues about their craft. By deliberately violating the "rules" of style and composition, writers like Miller and Nin transformed the landscape of literature. But experimental writing is more than simply breaking a few rules, for such authors are also challenging those aspects of society that threaten freedom of speech. In the process of expressing themselves openly, they also expose the most vulnerable sides of their personalities as they explore the creative processes within.

* * *

Words, like eyes, are windows into a person's soul, and thus each writer, in some small way, helps to enrich the world. But it takes courage to share one's life with another, for we live in a world where every sentence penned can be criticized or praised. But it is a risk worth taking, for a greater vision remains: that through our words, be they fiction or fact, we might touch another soul as we share our stories and song. In that moment, however brief, we suspend the walls of separateness that so often cause suffering and pain.

Through reams of reality, in tenderness and tears, we celebrate each writer's life.

M. R. W.
January 2001

Living the Writing Life

The writer, perhaps more than any of his fellow artists, has access to the human subconscious. His words sink deep, shaping dreams, easing the pain of loneliness, banishing incantations and omens, keeping alive the memories of the race, providing intimations of immortality, nourishing great anticipations, sharpening the instinct for justice, and imparting respect for the fragility of life. These functions are essential for human evolution. Without them, civilization becomes brittle and breaks.

—NORMAN COUSINS

When I'm writing, I am trying to find out who I am, who we are, what we're capable of, how we feel, how we lose and stand up, and go on from darkness into darkness.

—MAYA ANGELOU

Writing is an adventure. To begin with, it is a toy and an amusement. Then it becomes a mistress, then it becomes a master, then it becomes a tyrant. The last phase is that just as you are about to be reconciled to your servitude, you kill the monster and fling him to the public.

—WINSTON CHURCHILL

In many ways, writing is the act of saying *I*, of imposing oneself upon other people, of saying *listen to me, see it my way, change your mind*. It's an aggressive, even a hostile act. You can disguise its aggressiveness all you want with veils of subordinate clauses and qualifiers and tentative subjunctive, with ellipses and evasions—with the whole manner of intimating rather than claiming, of alluding rather than stating—but there's no getting around the fact that setting words on paper is the tactic of a secret bully, an invasion, an imposition of the writer's sensibility on the reader's most private space.

—JOAN DIDION

THERE ARE TIMES when a writer might gaze into the mirror and ask, "Why? Why am I driven to write?" For each author, as the essays in this section reveal, the answer is different, evolving through time and changing with every perception and mood.

"I write for revenge," contends Bob Shacochis. "Revenge against apathy . . . against the bullets of assassins . . . against the Devil . . . against the silence into which we fall." "And I write," says Kelly Cherry, "to heighten, provoke, prod, even create" an imaginative awareness of the inner life. But for a man like Joseph Conrad, the motivation was a mystery, "a madness perhaps," that drove him to pick up "that beastly pen" and compose. "But give me the right word and the right accent," he added, "and I will move the world." It is a dream that many authors share.

Writing is an unpredictable act, for with each new word that is placed on paper, the author moves farther away from the original vision—a process that Annie Dillard refers to in her essay as "ruining the page." Ultimately, each writer must learn to trust the instinctive direction of the work, but it is not an easy choice, for it often evokes a barrage of inner critical voices. Fortunately, these "watchers of the gate," as Gail Godwin calls them, can be countered by those muse-like angels who reside within. Similar demigods and "mistresses" are echoed in Cathy A. Colman's poem and Jeffrey A. Carver's piece.

The writing life is a journey that is filled with unexpected turns. Sometimes the path can be "pampered with the grace of quiet illumination," as Laura Cerwinske portrays in her memoir, or filled with frenzy, as Michael Dare discovered when he attempted to seduce Tom Robbins into following basic screenwriting rules. Madness, too, may intervene, as

you will see in Tom Bradley's tale of Streckfuss, a half-crazed Vietnam veteran who terrorizes an ivy-league author and his class.

On occasion, the dark side of one's psyche can dominate the pen, perhaps in an unconscious attempt to regulate the madness within. To illustrate this phenomenon, I have selected several passages from Sylvia Plath's journal, moments in which her wounded spirit takes hold and pushes her toward a posthumous fame. Such encounters with madness seem to be the exception and not the rule, as recent studies indicate,[1] but there are still a number of psychiatrists who suggest a close relationship between creativity and mental illness.[2] These authors often mention the suicides of Hemingway, Sexton, Brautigan, and Woolf, and the alcoholic histories of Poe, Parker, Capote, Kerouac, and Cheever, to name a few. But if one looks carefully at the statistics, the suicide rate of successful writers is far less than the national average (.005% compared to 1.3%). In addition, the incidence of alcoholism is no higher than in other professions and trades.

Scholars have also argued that there is a higher rate of depression and mania among artists. They cite dozens of well-known writers like Dickens, Keats, Shelley, Byron, Browning, Dickinson, Nietzsche, and Styron, but others have convincingly argued that a tendency toward manic-depression (in addition to such personality traits as sensitivity, openness, and a lack of interest in social norms) might actually be useful in an artist's creative pursuits.[3] According to Mihaly Csikszentmihalyi, creative people, rather than being disturbed, have a *greater* command over their emotions. Like a tool, many can use their ups and downs to enrich the quality of their work, balancing their moods with exceptional discipline and perseverance.[4]

Why, then, do we tend to look at creative artists and writers as somehow being less balanced than others? Publicity may be a possible explanation: the media give more attention to celebrities, especially when a tragedy or death occurs. Thus, a writer like Truman Capote stands out because his controversial behavior attracts our curiosity. One must also remember that writers, when creating autobiographical memoirs, tend to dramatize (and thus distort) the emotional conditions about which they

write. Author and psychotherapist Eric Maisel, who specializes in working with creative individuals, emphasizes this distinction between mental illness and the metaphorical "madness" that writers so often refer to:

> We are not mad, most of us, but our minds nevertheless resemble lunatic asylums. It is real bedlam in there. This is what cognitive therapists have been telling us for several decades. . . . When you are watching television or pruning the roses, all hell is not breaking loose in your mind. . . . The asylum is quiet, drugged, dreamy, asleep. But as soon as you say "Shall I write?" all hell breaks loose. The demons arise, shrieking. Then it is bedlam.[5]

For a writer, a much greater danger lies not within the mind but within society itself, especially for those who live under dictatorial regimes where freedom of speech is curtailed. For such individuals, and especially women, the danger is increased, where writing about violence and abuse can be punishable by death, as we have recently seen with writers in China, Pakistan, South Africa, and parts of Central America. In addition, if the color of your skin is not white, your chances of being published are impaired. These missing colors are often the voices of the hungry, the suffering, and the poor—lives that have witnessed decades of persecution and neglect—yet they are also the key to bringing forth our humanitarian compassion. To honor those writers who have bared witness to the plight of the oppressed, I open this anthology with a memoir from Sindiwe Magona who courageously writes about the oppression and injustices she has seen. By sharing our stories and personal woundings, she reflects, we might be empowered to improve the future of our world. It is a vision, I hope, that every writer will embrace.

Notes

1. For research demonstrating a positive correlation between creativity and health, see *Creativity,* by Mihaly Csikszentmihalyi (HarperCollins, 1996), *Consciousness Explained,* by Daniel C. Dennett (Little, Brown,

1991), and *Multimind: A New Way of Looking at Human Behavior,* by Robert E. Ornstein (Houghton Mifflin, 1986), and works by Rogers, Maslow, and Gardner.

2. See, for example, D. Jablow Hershman and Julian Lieb's book, *Manic Depression and Creativity* (Prometheus, 1998), and *Beyond Reason: Art and Psychosis,* by Bettina Brand-Claussen, Inge Jádi, and Caroline Douglas (University of California Press, 1998).

3. Major researchers supporting this more optimistic view include Albert, Andreasen, Barron, Runco, and others.

4. Mihaly Csikszentmihalyi, *Creativity* (HarperCollins, 1996).

5. Eric Maisel, *Deep Writing* (Tarcher/Putnam, 1999).

Clawing at Stones

Sindiwe Magona

I have seen the thick welted scars
on people rudely plucked from hearth
and home. Bound hand and bleeding foot.
Kicked, punched, raped, and ravaged
every which way you dare to think.
Killed, in their millions and
dumped on icy wave.

And today, those unlucky enough to
survive the gruesome plunder
annoy the world by failing to be quite,
quite human. By falling short of accepted
standards of civilization. Never mind that
on these people, was performed a
National Lobotomy, that has left them with
No tongue of their own.

I WAS IN my thirties before I ever held a book written by a black
woman in my hand; that was Maya Angelou's *I Know Why the Caged Bird
Sings*. Now I am in my fifties and have read a few more such books, not

as many as could be reasonably expected given our numbers—Africa alone has three hundred million women. However, for reasons too many, too painful, sickeningly familiar and inseparable as resin to bark in our lives, the vast majority of African women and women of African descent have yet to tell their stories.

I am no historian. Thus, in my case, the telling cannot be in that mode. History's dry exactitude kills the story; too many details simply disappear. My personal preference is music. If I could sing, I would leave songs that spoke of incredible beauty and unspeakable horror for I have witnessed such things as make me want to shout about them from the mountaintops; the courage of women, forced to live whole lifetimes without their husbands. In my poetry, I call these women "gold widows," for their men slaved hard in the gold mines of Johannesburg for gold they and their women would never see, never wear. Meanwhile, alone in the damned villages, the women kept home, family, and communities intact. They raised children, sowed and reaped fields, nursed the sick, and buried the dead—women dug graves and put corpses to rest. When, in desperation, they went to work in towns, domestic servants to white women, they became the invisible, recyclable hands that made things work, getting little for their pains.

I was there in 1950 when women marched, protesting the Pass Laws. They went to the Pass Office in Langa and, in the act of desperate courage, burned their passes; the police, the white superintendent and his cronies watching, the women burned their passes.

I have also seen the most vile acts of man. Evil. Chief Albert Luthuli and Steve Biko are heroes who were killed because of apartheid. Many others remain nameless skeletons hikers have stumbled across on isolated mountains or were made manure on obscure Boer farms. We, the Africans against whom that evil was fully unleashed, have survived apartheid. But the whole country has survived apartheid. The whole country. For none were (or could have been) left untainted by such evil. Yet the story of apartheid has still to be told. And, I want to be part of that telling. If only I could sing! Thousands would cram into the world's most famous music halls and sacred stadiums, come to hear me sing of sorrow . . . and of joy.

Of humiliation . . . and of triumph. Of terrible loss . . . and of man's redemption.

Alas, I cannot sing. But I have always enjoyed stories. Those told to me around the fire in the village of my birth, Gungululu, by my grandmothers. And, later, those that came to me via the written page.

As a child, I loved reading. When I could lay my hands on a book, even the play I enjoyed, perhaps to excess, suffered. Books were prized possessions, I suppose precisely because of their scarcity. I come of peasant stock and no one ever read me to sleep as a child. The only books my parents ever bought were those demanded at school. Like most Africans of their generation in South Africa, they'd had the most rudimentary of educations. Besides, we were dirt poor. Books and book buying had no business in our life. However, I was very fortunate that Jola, a neighbor, worked as a domestic servant in a white home. There must have been children about my age in that white family. I will never know. Often, she brought back books and comics from her "kitchen," as these places of employment are called by the women who slave their lives away in them. Thus, I grew up reading good British comics as well as classic children's books and it was with exceeding impatience that I waited for "Jola's white people to be throwing out books."

Those books and stories they brought me—that was magic and mystery all rolled into one. The stories were, at one and the same time, about strange faces, strange places, and even stranger happenings, that's true. But, they were also about me. They gave me hope. This could also happen to me. I, also, could do this. When I finished reading the last book of a batch, I fell into gloom. When would the next crop come? What stories would those books bring me? Where would those stories take place? Who would be doing what in them? The waiting was sheer torture. Therefore, mindful of the terrible inevitability of book endings and the long dry periods that threatened, when I might have absolutely nothing to read, I would read a book, especially the last of a batch, with artful slowness: stopping when I sensed that something exciting was about to happen in favor of anticipation; rereading whole chunks before proceeding after a pause.

And long before I came across enterprising teachers, I reveled in new words. When I met a new word for the first time, I immediately recognized it as a newcomer, a stranger whose acquaintance I had to make, an addition to my gem collection. With no dictionary to aid me (who had dictionaries in the African townships then? who has them now?), I would attempt to decipher its meaning by examining its role, its function in the sentence and its relationship to the rest of the words in that sentence as well as, of course, within the realm of the story as a whole. Thereafter, I would try and use the new word myself. Do so as soon as opportunity presented itself. In class, I always came up with these clever expressions, phrases, or words no one else knew—to the delight of the teacher and the chagrin of my classmates and my utter stupefaction that the other children failed to admire, applaud or feel the excitement I myself felt. I dare say mistakes were made in this manner of vocabulary building—but hey, I enjoyed the stories and marveled as I whizzed through time and vast distances, well beyond the confines of Blouveli, the sprawling tin shack location, where I was growing up—to places of splendor and grandeur, of the mystic and of magic, excitement and adventure.

However, even then I recognized that important as the story details and actions were, the more real story aspect, the power and magic, lay in the telling. Knowing nothing of story technique, I fully understood there was a difference in how stories were told. Thanks to those village evening sessions of my childhood where, around a fire, we children often heard the same story from different tellers. I grew up, therefore, aware that the same story sounded much more interesting (or less so), depending on who was telling it . . . or, indeed, what mood, emphasis or nuance the same teller brought to its telling. It is from these fireside storytellers' sessions that I learned that the audience has to be engaged from the very start of the tale. Iintsome, the Xhosa folktales of my early childhood, are begun with a short call and response format:

"Kwathi ke kaloku ngantsomi!" "Once, there so happened, according to tale!" the teller says in opening.

"Chosi!" ("Well!," i.e., "tell it well"), respond the listeners. And throughout, the audience is actively involved: clapping or singing or

chanting responses. Today, I read and enjoy the convenience that comes with this method of story sharing. But the thrill is the well remembered, the same as that of my childhood.

The creative process has always been sacred to me and although I grew up with no role models in this field, I've always enjoyed writing. As a pupil, if the teacher was going to read an essay to the class, invariably, that essay would be mine. And I was not averse to the flattery such feedback implied. Later, as a grade teacher, I found it very hard to grade essays. Grammar and spelling errors would go unmarked (and unpunished) while I marveled at the creative genius of the young artist. The unknown worlds reading opens to me are an endless source of both awe and inspiration.

As late as 1990, I stumbled on the sad statistic that in South Africa, since African women there began writing and publishing (any genre, any language), five women had accomplished that feat. Five! I write to change that—to bear witness, to tell those who will people this world long after I have gone what it was I saw, heard, experienced. They need to know who we were and what we were about. I believe they'll welcome hearing our perspective of things. Forced removals and the brutal scattering of the African community in South Africa killed the oral tradition, through which the history of the nation was preserved. However, the imperative of that preservation not only stands but, doubtless, is the more urgent today . . . more urgent than ever before. Therefore, I write to leave footsteps.

Writing brings me healing. It is therapeutic. Writers write about what they know. And that knowledge is sometimes far from pleasant. But it is in writing about our disappointments, our failures, our losses, our defeats, and our pain and suffering that we discover the startling fact that we have survived all this and perhaps even thrived . . . despite whatever challenges such setbacks forced us to face.

Also, I am learning that writing is a long journey. Even in these times of modern travel, a journey can be full of surprises, unpredictable and fraught with danger. Delays, handicaps, deceptive companions, and tantalizing distractions abound. One's mettle is sorely tested in this process.

The present lap of my journey began with my late father's biography. The first surprise was that the outpouring came through in the form of poetry. I offered no resistance but reveled in the new. Some sixty pages later, Father's family welcomes his bride. I anticipate as many (if not more) pages as I begin writing of his life as experienced by us, his children. Naturally, this will include Mama. And there's a book of poetry in two parts! But Mama has survived Tata by almost thirty years. Is she not to get a part of her own? Voila: Penrose and Lilian, a biography of my parents, in verse, in three parts!

From this it can be correctly surmised that I am having a wonderful time remembering and recapturing what the essence of my parents was, certainly to me. However, traveler beware: there may be mines on the road you're embarking on.

Father worked in the gold mines of Johannesburg before I was born. I was in my thirties when I first laid eyes on Peter Magubane's book of photos of "mine boys." That book angered and disgusted me. But it wasn't till I came to the corresponding part of my father's life that a mule kicked me full in the belly. All this time, more than two decades after, the despicable things those photos depicted: grown men "naked as unpodded beans . . . dusted with sprayings of DDT" and forced to show their anuses, regular inspection against theft of precious stones—the vicious truth never penetrated my defenses.

Father worked in the mines. Mine bosses did such things to mine boys. But that such things were done to Father never occurred to me. How do you look at the man you have known all your life as "Protector, Provider, Soother of spirits bruised" and admit to yourself he suffered unimaginable violation, endured unspeakable humiliation? How does a child love and respect a father and know that that man has been treated in a manner no animal ever suffered and know that there are many who saw him as less than human? How do you swallow a father's bitter impotence?

I wept when the realization hit me. When I could no longer deny that my father underwent such brutality, a sorrow so intense overcame me. And, I wept for my father. For all the men who had to leave their wives and their children, every year, for eleven months of the year, to go

to a place of shadows, of dreams, of promises false.
Where lives are slighted, wasted, ill-used and squandered;
sacrificed to greed and need, real and manufactured.
Where rich men dream of richer reaches;
and poor men die clawing at stones.

Do I wish I had not begun the project? Has the pain the revelation brought made me wish to write less or stay away from intimate subjects? No! To the contrary. I now recognize that this pain is an integral part of who I am. The need to mine the past even as I witness the present is an honor I accept without question. For all the vexing perplexity this might bring, I am convinced that it is only by probing both the joys and woundings of time that we might be blessed and empowered to affect the future.

Sindiwe Magona calls herself a migrant worker—a South African woman living in the Bronx and working for the United Nations. Her novel, *Mother to Mother,* was prompted by the 1993 mob killing of the American Fulbright scholar Amy Biehl, which happened in Guguletu, the black township of South Africa that Ms. Magona calls home. She has also authored *To My Children's Children, Forced to Grow,* and two collections of short stories, *Push-Push!: And Other Stories* and *Living, Loving and Lying Awake at Night.* She received an honorary doctorate in Humane Letters from Hartwick College and was a New York Foundation for the Arts Fellow in the nonfiction category. A longer version of this memoir appears in the newsletter of the International Women's Writer's Guild (www.iwwg.com), an organization that actively encourages women writers to commit their stories and lives to ink.

2

Writing for Revenge

Bob Shacochis

I do not write to discover myself. I think writers who declare such a motive are guilty of fraud, although it's probably true for anybody that you never really know the precise nature of how you feel about something until you write your way into it and through it. But, then what? I suppose what I'm reacting to here is the received truth that discovery is synonymous with change, progression, betterment of self: that writing has the capacity to lead you onward into some Buddhist state of wisdom and inner peace. How I wish that were true, but, in fact, the writing life is a paradox. A writer may indeed engrave a page with wisdom, serenity, beauty, and enlightenment, and yet in everyday life remain lodged in stupidity—unwise, tormented, unenlightened and ugly. While a writer's work might be angelic, his or her life might be simultaneously demonic; or, as is most often the case, merely human, as awkward and clumsy and flawed as anyone else's. You can—and perhaps *must*—manipulate the story and its characters with godlike authority, exerting a level of control you could never approach, not even as a tyrant, in your own life. Writers conjure their best, most focused and perfect selves and drag them to the page, but they can't walk off with those selves, back into reality, and have them make a difference. . . .

14

I write to keep myself educated and when I don't write, I feel myself—and my intelligence—rapidly fading into oblivion, where I'm perfectly content to be the ne'er-do-well my parents were once so concerned I would become.

I write because I hold the conviction, smarmy as it might seem, that we must give back to that from which we take. Take a penny, leave a penny. What I've most taken from in my life is the banquet table of literature. What most fulfills my sense of worth are my own attempts to contribute to this timeless feast, to keep the food replenished and fresh, perhaps introduce an unfamiliar recipe, or a variation on one of the favorites. *There are no old myths,* the writer Jim Harrison once said, *only new people.*

But the foremost reason I write might at first strike you as petty. I write for revenge—that time-honored but somewhat cliched motivation. Living well isn't the best revenge, I can tell you from experience. Writing well, on the other hand, is.

Revenge against apathy, against those who are not interested in listening to the voices that surround them—wife, husband, brother, daughter, father, friend or nameless traveler.

Revenge against the bullets of assassins, against the wild forces that trample the earth, against the terror and tragedy that is in every life.

Revenge against the Devil and, pardon the blasphemy, revenge against God, for slaughtering us in the crossfire of their eternal quarrel.

Why do I write? Because I know my children's children, and your children's children, would like to hear a story before they go to sleep, and I'd like to tell them one so that when they finally close their eyes, the story will melt into a dream, and the dream will fill the emptiness, the loneliness, and leave them with a magnificent burning image of desire to be alive, and who can say with certainty, Which is the story? Which is the dream? And which is life? I want to tell my stories with the franticness of a parent whose child is dying, as if the story can keep the child alive until help arrives.

I write for revenge against silence, revenge against the endless silence that seems to erupt, right beyond the tips of humanity's fingers, into infinity; revenge against the silence into which we fall.

Against that silence, we move, we create. We breathe. Exhale.

Bob Shacochis is the author of *Immaculate Invasion, Domesticity,* and two collections of short stories, *Easy in the Islands,* which won the National Book Award, and *The Next New World.* His novel, *Swimming in the Volcano,* was a 1993 National Book Award finalist. He is a contributing editor to *Harper's* and *Outside* magazines.

3

Ruining the Page

Annie Dillard

HERE IS A fairly sober version of what happens in the small room between the writer and the work itself. It is similar to what happens between a painter and the canvas.

First you shape the vision of what the projected work of art will be. The vision, I stress, is no marvelous thing: it is the work's intellectual structure and aesthetic surface. It is a chip of mind, a pleasing intellectual object. It is a vision of the work, not of the world. It is a glowing thing, a blurred thing of beauty. Its structure is at once luminous and translucent; you can see the world through it. After you receive the initial charge of this imaginary object, you add to it at once several aspects, and incubate it most gingerly as it grows into itself.

Many aspects of the work are still uncertain, of course; you know that. You know that if you proceed you will change things and learn things, that the form will grow under your hands and develop new and richer lights. But that change will not alter the vision or its deep structures; it will only enrich it. You know that, and you are right.

But you are wrong if you think that in the actual writing, or in the actual painting, you are filling in the vision. You cannot fill in the vision. You cannot even bring the vision to light. You are wrong if you think that you can in any way take the vision and tame it to the page. The page is

17

jealous and tyrannical; the page is made of time and matter; the page always wins. The vision is not so much destroyed, exactly, as it is, by the time you have finished, forgotten. It has been replaced by this changeling, this bastard, this opaque lightless chunky ruinous work.

Here is how it happens. The vision is, *sub specie aeternitatis,* a set of mental relationships, a coherent series of formal possibilities. In the actual rooms of time, however, it is a page or two of legal paper filled with words and questions; it is a terrible diagram, a few books' names in a margin, an ambiguous doodle, a corner folded down in a library book. These are memos from the thinking brain to witless hope.

Nevertheless, ignoring the provisional and pathetic nature of these scraps, and bearing the vision itself in mind—having it before your sights like the very Grail—you begin to scratch out the first faint marks on the canvas, on the page. You begin the work proper. Now you have gone and done it. Now the thing is no longer a vision: it is paper.

Words lead to other words and down the garden path. You adjust the paints' values and hues not to the world, not to the vision, but to the rest of the paint. The materials are stubborn and rigid; push is always coming to shove. You can fly—you can fly higher than you thought possible—but you can never get off the page. After every passage another passage follows, more sentences, more everything on drearily down. Time and materials hound the work; the vision recedes ever farther into the dim realms.

And so you continue the work, and finish it. Probably by now you have been forced to toss the most essential part of the vision. But this is a concern for mere nostalgia now: for before your eyes, and stealing your heart, is this fighting and frail finished product, entirely opaque. You can see nothing through it. It is only itself, a series of well-known passages, some colored paint. Its relationship to the vision that impelled it is the relationship between any energy and any work, anything unchanging to anything temporal.

The work is not the vision itself, certainly. It is not the vision filled in, as if it had been a coloring book. It is not the vision reproduced in time; that were impossible. It is rather a simulacrum and a replacement. It is a

golem. You try—you try every time—to reproduce the vision, to let your light so shine before men. But you can only come along with your bushel and hide it.

<div align="center">* * *</div>

Who will teach me to write? a reader wanted to know.

The page, the page, that eternal blackness, the blankness of eternity which you cover slowly, affirming time's scrawl as a right and your daring as necessity; the page, which you cover woodenly, ruining it, but asserting your freedom and power to act, acknowledging that you ruin everything you touch but touching it nevertheless, because acting is better than being here in mere opacity; the page, which you cover slowly with the crabbed thread of your gut; the page in the purity of its possibilities; the page of your death, against which you pit such flawed excellences as you can muster with all your life's strength: that page will teach you to write.

Annie Dillard is adjunct professor of English at Wesleyan University and is the author of nine books, including *The Writing Life, An American Childhood,* and *Teaching a Stone to Talk,* a book of essays. In 1975, *Pilgrim at Tinker Creek* won the Pulitzer Prize for general nonfiction. She has received grants from the Guggenheim Foundation and the National Endowment for the Arts.

4

Watcher at the Gate

Gail Godwin

KAFKA PUT DOWN his pen, and went to play with his hair in the mirror, and washed his hands three times . . . and returned to record in his diary: "Complete standstill . . . incapable in every respect . . . have achieved nothing."

Who is this critic within us who keeps assuring us we have glimpsed neither swallow nor angel, and even if we imagine we have, it's not worth recording because it would be only ours?

Let me introduce him to you. Or rather, let me introduce you to *my* inner critic, so that you may recognize from him some aspects of your own. I call him my Watcher at the Gate, and have written about him in an essay by that title.

I first realized I *had* a Watcher when I was leafing through Freud's *Interpretation of Dreams* some years ago. Ironically, it was my Watcher who had sent me to Freud in the first place. A character in my novel was having a dream and I lost confidence in my ability to give her the dream she needed, so I rushed to "an authority" to check out whether she ought to have such a dream. And, thanks to my angel, I found instead the following passage.

Freud is quoting from the poet Schiller, who is writing a letter to a friend. The friend has been complaining to Schiller about his own lack of

creative power. Schiller tells him it's not good when the intellect exam-
ines too closely the ideas pouring in at the gates. In isolation, Schiller
explains, an idea may be quite insignificant, and venturesome in the
extreme, but it may acquire importance from an idea *which follows it*.

"In the case of a creative mind, it seems to me," Schiller goes on, "the
intellect has withdrawn its watchers from the gates, and the ideas rush in
pell-mell, and only then does it review and inspect the multitude. You are
ashamed of the momentary and passing madness which is found in all
real creators, the longer or shorter duration of which distinguishes the
thinking artist from the dreamer . . . you reject too soon and discriminate
too severely."

So that's what I had: a Watcher at the Gate. I decided to get to know
him, and I have. I have written notes to him and he has replied. I even
drew a portrait of him once.

Punctual to a fault, he always arrives ahead of me and is waiting for
me in my study. The touching thing is, he's on my side. He doesn't want
me to fail. He couldn't bear it. It would be so humiliating for both of us.
So he is constantly cautioning me against recklessness and excesses,
some of which might lead to brilliance. He is partial to looking out the
window, looking for a wrinkle in the rug, looking up words. He adores
looking up things, any kind of research. And before I had my computer,
he was always advising me to stop in the middle of a typewritten page
and type it over. "The neatness will re-establish the flow," he explained to
me solemnly, wringing his hands—a favorite gesture of his.

That's my daily regular, who has been with me, looking exactly the
same, since I first drew his portrait in 1976 (rather than get on with that
morning's work). He's thin, with a willowy, ethereal stance; his hands are
clasped tightly before him; he has abnormally round eyes, gazing slightly
to his right—my left—bushy eyebrows, a fastidious little mustache and
prissy lips. He has all his hair and it's still black. It's beginning to worry
me that it's still so black, because he's somewhere between fifty and sixty
and it would embarrass me to think he dyes it. He wears a black suit and
a black tie. The only *sportif* note is the tightly buttoned collar of a dark
plaid shirt peeping out above his lapels. I used to wonder whether he

might be a clergyman, but couldn't settle on what denomination. More likely he's a bachelor scholar, with a neat little house full of antiques, who reads edifying books with his supper, committing to memory instructive passages to intimidate or slow me down the next day.

I don't know what this says about me, but I have become rather fond of my Watcher and sometimes think I have learned to work so well *in spite of him* that I wouldn't know what to do if he failed to show up one morning.

The other presence who inhabits the mysterious space in which we go to write is, of course, the angel. I first heard about another person's angel from the late painter Philip Guston. I asked him what he did on the mornings he didn't feel inspired. He said he usually went to his studio anyway. "And then I'll find myself thinking, well, I've got some of this pink paint left, so I'll brush some of it on and see what happens. And sometimes the angel comes. But what if I hadn't gone to my studio that day, and the angel *had* come?"

In my experience, the angel *does,* almost always, come. If I keep faith. On some days, keeping faith means simply *staying there,* when more than anything else I want to get out of that room. It sometimes means going up *without hope* and *without energy* and simply acknowledging my barrenness and lighting my incense and turning on my computer. And, at the end of two or three hours, and *without hope* and *without energy,* I find that I have indeed written some sentences that wouldn't have been there if I hadn't gone up to write them. And—what is even more surprising—these sentences written without hope or energy often turn out to be just as good as the ones I wrote *with* hope and energy.

So for me, the angel presides in that mysterious slice of time between when *I don't know what I'm going to write that day* and when I'm looking afterward at the evidence of *what I did write that day.*

Sometimes the best thing you can do is say: I've gone as far as I can. I'm empty. You might even pick up your diary and write, as Kafka did: "Complete standstill. Incapable in every respect." Or your own version of the above. "I can go no further," perhaps.

And then wait.

The German poet Rilke wrote two of his *Duino Elegies* and then lapsed into an almost decade-long depression. And then suddenly "utterance and release" came to him again. In only eighteen days he wrote the *Sonnets to Orpheus* and the remaining eight of his *Duino Elegies*. In the *Elegies*, the predominant symbol is the angel. The angel, for Rilke, as he explained to his Polish translator, is that creature in whom the actual and the ideal are one. Being in the angel's presence, for Rilke, meant being able to give the highest possible significance to our moments as they pass. And works of art, he further testifies, "are always products of having been in danger. Of having gone to the very end of an experience, to where one can go no further."

To where one can go no further. That is often the very point at which we issue our most irresistible invitation to the angel.

Gail Godwin has received a Guggenheim Fellowship and the 1981 Award in Literature from the National Academy and Institute of Arts and Letters. Three of her critically acclaimed novels, *The Odd Woman, Violet Clay,* and *A Mother and Two Daughters,* were nominated for the National Book Award. She is the author of two collections of short stories, four libretti, and twelve novels, including *Heart, The Finishing School, Evensong, The Good Husband, A Southern Family, The Perfectionists,* and *Father Melancholy's Daughter.*

Mistress

Cathy A. Colman

> The thing that usually gets me through writing
> is that my feelings of wretched inadequacy are
> irregularly punctuated by brief flashes of impotence.
> —JAMES L. BROOKS

The usual trouble is in the morning light,
the now-or-never part of the day's voice.

The cure?
I have a mistress who retells my stories

in a dishonest, but more entertaining way;
who balances pieces of camouflage on her lips

and calls it cake; who sleeps like a knife;
whose iridescent veins are a map of the Russian steppes.

If I want dreams, I'll ask for them.
Right now I'm trying to get The Ineffable to talk.

Threatening to leave it in a men's room
in Atlantic City. I know I shouldn't

use force. But soon I'll hear my mistress
scuffing down the hall

in her paper shoes.

Cathy A. Colman is a poet, journalist, and teacher whose poetry
has appeared in the *Colorado Review,* the *Southern Poetry Review, The
Spoon River Poetry Review, Mudfish, The GW Review,* and elsewhere.
Author of *Borrowed Dress,* she received the Browning Poetry Award, The
Academy of American Poets Award, the Asher Montandon Award for
Poetry, and was twice nominated for The Pushcart Prize in Poetry.

6

And a Cold Voice Says, "What Have You Done?"

From the Journals of Sylvia Plath

December 12, 1958: What a writer I *might* have been, if only. If only I'd had the guts to try and work and shoulder the insecurity all that trial and work implied.

Writing is a religious act: it is an ordering, a reforming, a relearning and reloving of people and the world as they are and as they might be. A shaping which does not pass away like a day of typing or a day of teaching. The writing lasts: it goes about on its own in the world. People read it: react to it as to a person, a philosophy, a religion, a flower: they like it, or do not. It helps them, or it does not. It feels to intensify living: you give more, probe, ask, look, learn, and shape this: you get more: monsters, answers, color and form, knowledge. You do it for itself first. If it brings in money, how nice. You do not do it first for money. Money isn't why you sit down at the typewriter. Not that you don't want it. It is only too lovely when a profession pays for your bread and butter. With writing, it is maybe, maybe-not. How to live with such insecurity? With what is worst, the occasional lack or loss of faith in the writing itself? How to live with these things?

The worst thing, worse than all of them, would be to live with not writing. So how to live with the lesser devils and keep them lesser?

October 22, Thursday. A walk today before writing, after breakfast. The sheer color of the trees: caves of yellow, red plumes. Deep breaths of still frosty air. A purging, a baptism. I think at times it is possible to get close to the world, to love it. Warm in bed with Ted I feel animal solaces. What is life? For me it is so little ideas. Ideas are tyrants to me: the ideas of my jealous, queen-bitch superego: what I should, what I ought.

Ambitious seeds of a long poem made up of separate sections: Poem on [my] birthday. To be a dwelling on madhouse, nature: meanings of tools, greenhouses, florists shops, tunnels, vivid and disjointed. An adventure. Never over. Developing. Rebirth. Despair. Old women. Block it out.

Two dead moles in the road. One about ten yards from the other. Dead, chewed of their juices, caskets of shapeless smoke-blue fur, with the white, clawlike hands, the human palms, and the little pointy corkscrew noses sticking up. They fight to the death Ted says. Then a fox chewed them.

The shed of the hydraulic ram. Black, glistening with wet: gouts of water. And the spiderwebs, loops and luminous strings, holding the whole thing up to the rafters. Magic, against principles of physics. . . .

No mail. Who am I? Why should a poet be a novelist? Why not?

Dream, shards of which remain: my father come to life again. My mother having a little son: my confusion: this son of mine is a twin to her son. The uncle of an age with his nephew. My brother of an age with my child. Oh, the tangles of that old bed.

Drew a surgical picture of the greenhouse stove yesterday and a few flowerpots. An amazing consolation. Must get more intimate with it. That greenhouse is a mine of subjects. Watering cans, gourds and squashes and pumpkins. Beheaded cabbages inverted from the rafters, wormy purple outer leaves. Tools: rakes, hoes, brooms, shovels. The superb identity, selfhood of things.

To be honest with what I know and have known. To be true to my own weirdnesses. Record. I used to be able to convey feelings, scenes of youth; life so complicated now. Work at it.

November 4, 1959: Paralysis again. How I waste my days. I feel a terrific blocking and chilling go through me like anesthesia. I wonder, will I ever be rid of Johnny Panic? Ten years from my successful *Seventeen* [publication], and a cold voice says: what have you done, what have you done?

Sylvia Plath was born on October 27, 1932, in Jamaica Plain, Massachusetts. She married Ted Hughes in 1956, gave birth to two children and two books, *The Colossus* and *The Bell Jar,* and separated in 1962. She then began work on *Ariel,* composing thirty poems in one month. To her mother, she wrote: "I am a genius of a writer; I have it in me. I am writing the best poems of my life; they will make my name. . . ." Four months later, in 1963, at age thirty-one, she committed suicide. In 1982, her collected poems were awarded the Pulitzer Prize.

Sylvia's Honey

Catherine Bowman

THE YEAR I first tasted Sylvia's honey. Dipped my fingers deep into the page, into what was raw and unfiltered. *Queer alchemy, zoo yowl, heel-hung pigs, nerve curlers, smashed blue hills, exploding seas, bald-eyed Apollos, freakish Atlantic, midget's coffin.* That year and forever after. *Honey feast of berries, surf creaming, polish of carbon, ku klux klan gauze, pockets of wishes, cracked heirloom, soul-shift, baby crap. Cave of calcium icicles.* The golden bough that tricked me into the underworld. *Acid kisses, blood-caul, a briefcase of tangerines.*

That was the year we dubbed ourselves Dumb Bitches. D.B.s. Joy and I sitting in Pancho's All You Can Eat Mexican Buffet on the west side of San Antonio, just down the road from Randy's Rodeo, where a mob of Texas shit-kicker teens had made headlines for hurling Lone Star Longnecks at Sid Vicious and the Sex Pistols. A man just two red greasy booths away raging.

—Shut the fuck up, you worthless dumb bitch cunt.

—Hey Dumb Bitch, I said to Joy,—pass the salsa.

Now your head, excuse me, is empty.

I have a ticket for that.

Come here, sweetie, out of the closet.

Well, what do you think of that?
Naked as paper to start

But in twenty-five years she'll be silver,
In fifty, gold.
A living doll, everywhere you look.
It can sew, it can cook,
It can talk, talk, talk.

D.B., engraved with ancient glittering sharks' teeth on our mistitled upside-down Texas crowns. And Sylvia Plath, our martyred honey goddess, our Queen D.B. In a town where you could find with ease the Virgin of Guadalupe tattooed across a man's back, Our Lady of Sylvia was emblazoned into our souls' tongues. *Bald and Wild. Not sweet like Mary. Her blue garments unloose small bats and owls.* Her Ariel poems, and especially "Daddy," our sacred text full of high jinks and masks, rage and rebellion, a mirror to behold our self-loathing, our complicity in male authority, our ambivalence about promiscuity and virginity, and our fear.

Plath was teaching us a new way to sing. Besides, we couldn't help but love our Sylvia all dolled up in her achoo giddy-up, red leather saddle, riding English style, her Smith girl voice—*Daddy, daddy you bastard I'm through.* Calling each other D.B. was our way of being smart and satirical, just like Plath. We were taking the way that men looked at us and making fun of it, taking it on, reversing it. Plath was acutely aware of how she was seen. *Ted is a genius. I his wife.* She understood the game and she played for keeps—each round a kind of metaphysical kamikaze mission. No matter how hard she tried to conceal her brilliance and genius it kept coming up to the surface.

So many of our friends, all smart even brilliant women, were in trouble. Edna, gang-raped at the age of thirteen, now drugged on Thorazine and locked in at the Santa Rosa Hospital. Margaret, hiding naked on Christmas Eve behind a carwash, her doctor husband searching for her with army-issue flashlight and weapon. Valerie, stabbed to death in broad daylight while jogging with her baby. Even my mother, one summer night,

trying to take herself out of life. So much pain. So much silence. A rage
suppressed comes soaring and creeping out in ugly ways.

> The tongue stuck in my jaw.
> It stuck in a barb wire snare.
> Ich, ich, ich, ich,
> I could hardly speak.

That year Joy and I were studying politics and philosophy at St.
Mary's. Doc Crane, an Adlai liberal who loved boys from the border, told
us stories about Yahoos and morals, the old dirty days of Texas politics,
mystification, how deals were made over margaritas at Ma Crosby's
down in Ciudad Acuña. The different ways a man and a vote could be
bought and sold. After class, at my house, Joy delivering a luminous
explanation of Marx and Habermas. My twelve-year-old brother looking
up from the table.
—Man, she really laid that out smooth.
—Go for it like a big dog.

> O pardon the one who knocks for pardon at
> Your gate, father—your hound-bitch, daughter, friend.

Big dogs. Dumb Bitches.

> Dirty girl,
> Thumb stump.

Joy practicing her Spanish—Hey D.B. *no más cabeza sin dolares?*
Mujer fuerte. Quit partying down with *muchachos* with *narizes llenas de*
coke and condos on the coast. Stay away from gas ovens. Write your
poems.
Writing poetry at the time seemed as distant as the moon, as natural
as pecan trees and the steering wheel of my blue Nova. I was going to
school, waitressing at the Bijou, hanging out, listening hard, Clifford

Scott playing bebop at the Sugar Shack, the mariachis at the Esquire after-hours, the Clash. Lessons in poetry. Lessons in swing.

I had an apartment above two Iranian spinster sisters who thought I was possessed by the devil and brewed smelly comfrey teas for me to clear up my complexion. They gave me an old pair of silver high heels. Ricardo Sanchez asked me to read my poems at his bookstore, Paperbacks y Más. My philosophy professor awarded me honors on my "City Planning and Aristotle" paper, telling me later at a party how good I would look nude on a haystack. That was cool, he was taking me seriously as a poet. I wrote my final in rhymed couplets.

Oozing with jammy substance, dead eggs, lullaby, a saint's falsetto, body parts swimming with vinegar. The sugar belly. *Black keys, wedding rings, nazi lampshades, tiger pants, potato hiss.* For honey absorbs the taste of everything growing around the hive. That's how I came to understand Plath's poems, as a kind of bitter honey infused with everything going on around her at the time. "Daddy" is not just a poem about her father and her bad marriage; it is perverse lament for the censoring voices she has killed off, a shrieking assault on our rules for mourning. More than that, the poem is a coup d'état in which, in an effort to find a lineage and a language, Plath dethrones the psyche's *Panzer-man,* i.e., the voices of authority that had empowered her but also who have censored and "dumbed" her.

> So I could never tell where you
> Put your foot, your root,
> I never could talk to you.
> The tongue stuck in my jaw . . .
>
> So daddy, I'm finally through.
> The black telephone's off at the root,
> The voices just can't worm through.

The poem's central emotion is rage. A rage born from pain. A rage so stylized that it almost becomes a poetic form in itself.

You do not do, you do not do
Any more, black shoe
In which I have lived like a foot
For thirty years, poor and white,
Barely daring to breathe or Achoo.

In 1962 she writes to her mother from England:

> Don't talk to me about the world needing cheerful stuff. It is much
> more help for me, for example, to know that people are divorced
> and go through hell, than to hear about happy marriages. Let the
> *Ladies' Home Journal* blither about those. Now stop trying to get me
> to write about "decent courageous people" . . . It's too bad my
> poems frighten you. . . . I believe in going through and facing the
> worst not hiding from it.

I read how Plath's father, a specialist in bees, would begin his college lec-
tures by killing, skinning, cooking, and eating a rat in front of the class. Plath
shared her father's tastes for breaking taboos and exhibitionism. She has
taken a lot of flack from critics and readers for appropriating the imagery of
the Holocaust to describe her own pain, but I don't think she is compar-
ing the two, it's more complex. She is not stoking up and sensationalizing her
own domestic pain with the news and horrors of the day, but rather search-
ing for a language to understand the censoring powers that controlled her
world. She knows how our most private fantasies and obsessions cannot be
separated from history and public life. In Plath, I learned to hear a new kind
of tune, harsh and sarcastic, a ghastly fugue, that interweaves the nursery
rhyme, marriage vows, love cry, goose step and train engine dirge.

I made a model of you,
A man in black with a Meinkampf look

And a love of the rack and the screw,
And I said I do, I do.

Joy and I loved to quote the famous lines to each other:

Every woman adores a Fascist,
The boot in the face, the brute
Brute heart of a brute like you.

We knew that the boot in the poem did not belong to our lovers or fathers but rather it was our own boot that we smacked ourselves hard in the face with doing dazzling high kicks. We were learning all kinds of contortions, and not just in bed.

One night at the Broadway 50/50 we played Marvin Gaye's "Sexual Healing" and Prince's "Little Red Corvette" on the jukebox. Joy grabbed my arm.

—Come on, D.B., let's dance.

We knew that at this longitude and latitude and under this light, we were both supremely D.B. And we danced and laughed. *They will not smell my fear, my fear, my fear.* The way that bees can smell fear. Her words became us. *Ghost column, teacup, silk grits, Hiroshima, babies' bedding, thalidomide, rubber breasts and rubber crotch, bits of burnt paper, balled hedgehog, plato's afterbirth.* A honey that hurt. *Mouth plugs, morning glory pool, earwig biscuits, dead bells, desert prophet, owl cry, some hard stars.* That healed. *Yew tree and moon, wormed rose, Jesus hair, hot salt, eel, widow frizz, blue volt.* That we couldn't stop wanting. That would bear us out. *An earthen womb, the deep throats of night flower.* Sylvia's clove orange honey. *Six jars of it. Six cats' eyes in the wine cellar. The bees are flying. They taste the spring.*

Catherine Bowman teaches at Indiana University and is the author of two collections of poems, *Rock Farm* and *1-800-HOT-RIBS*. Her writing has been awarded a New York Foundation for the Arts Fellowship in Poetry, the Peregrine Smith Poetry Prize, the Kate Frost Discovery Award for Poetry, and the Dobie Paisano Fellowship. Her

poems have appeared in literary magazines, anthologies, and journals, including *The Paris Review, TriQuarterly, The Kenyon Review,* and *River Styx.* She has produced two award-winning videos on poetry and hosts the program *Poetry Showcase* on National Public Radio's *All Things Considered.*

Alas, Madness!

Joseph Conrad

IN THE CAREER of the most unliterary of writers, in the sense that literary ambition had never entered the world of his imagination, the coming into existence of the first book is quite an inexplicable event. In my own case I cannot trace it back to any mental or psychological cause which one could point out and hold to. The greatest of my gifts being a consummate capacity for doing nothing, I cannot even point to boredom as a rational stimulus for taking up a pen.

The pen, at any rate, was there, and there is nothing wonderful in that. Everybody keeps a pen (the cold steel of our days) in his rooms, in this enlightened age of penny stamps and halfpenny post-cards. In fact, this was the epoch when by means of postcard and pen Mr. Gladstone had made the reputation of a novel or two. And I, too, had a pen rolling about somewhere—the seldom-used, the reluctantly taken-up pen of a sailor ashore, the pen rugged with the dried ink of abandoned attempts, of answers delayed longer than decency permitted, of letters begun with infinite reluctance, and put off suddenly till next day—till next week, as like as not! The neglected, uncared-for pen, flung away at the slightest provocation, and under the stress of dire necessity hunted for without enthusiasm, in a perfunctory, grumpy worry, in the "Where the devil IS the beastly thing gone to?" ungracious spirit. Where, indeed! It might

have been reposing behind the sofa for a day or so. Or it might even be resting delicately poised on its point by the side of the table-leg, and when picked up show a gaping, inefficient beak which would have discouraged any man of literary instincts. But not me!

O days without guile! If anybody had told me then that a devoted household, having a generally exaggerated idea of my talents and importance, would be put into a state of tremor and flurry by the fuss I would make because of a suspicion that somebody had touched my sacrosanct pen of authorship, I would have never deigned as much as the contemptuous smile of unbelief. There are imaginings too unlikely for any kind of notice, too wild for indulgence itself, too absurd for a smile. Perhaps, had that seer of the future been a friend, I should have been secretly saddened. "Alas!" I would have thought, looking at him with an unmoved face, "the poor fellow is going mad."

Give me the right word and the right accent and I will move the world. What a dream for a writer! Because written words have their accent, too. Yes! Let me only find the right word! Surely it must be lying somewhere among the wreckage of all the plaints and all the exaltations poured out aloud since the first day when hope, the undying, came down on earth. It may be there, close by, disregarded, invisible, quite at hand. But it's no good. I believe there are men who can lay hold of a needle in a pottle of hay at the first try. For myself, I have never had such luck.

Joseph Conrad (1857–1924) was a sailor and an author of many short stories and books, including *Heart of Darkness, Chance, Under Western Eyes,* and *The Book of the Homeless.* Known primarily for his stories about the sea, he became a highly acclaimed writer who greatly influenced the style and technique of the modern novel. This memoir is excerpted from *A Personal Record,* first published in 1912.

How to Write Like Tom Robbins

Michael Dare

FIFTEEN YEARS AGO, the phone rang and it was Tom Robbins, one of my all-time favorite authors. He had read a script of mine and liked it. He told me he was just getting started on a script of his own when he realized that he didn't know what he was doing. He had never written in screenplay format before, so he felt the need for someone like me to look over his shoulder while he wrote, just to make sure he didn't make any embarrassing mistakes. He would pay my way to La Conner, Washington, a small fishing village north of Seattle where he lived. He would put me up in a hotel for a month while he finished the project. I would pick up pages every afternoon and return them the next morning with comments. Was I interested?

I didn't have to think long. At the time, I was living in a photo studio above Frederick's of Hollywood, a location with advantages (living across the street from Musso & Franks) and disadvantages (street cleaners every morning at four). But the main disadvantage was the eviction notice from the landlord.

A year earlier, I had read in the L.A. Times that State Senator Alan Sieroty had passed a bill allowing artists to live in lofts that were zoned

for commercial use. This was in reply to the burgeoning artistic community taking over warehouses in downtown L.A.

Great, I thought, I'm an artist. I can move into my loft. It was a burden paying rent on two places anyway, so the next month I moved from my home to my studio. A year later, my landlord found out I was living there and decided to throw me out. When I got my eviction notice, it was signed by State Senator Alan Sieroty. I had never known that he was my landlord since I had always paid rent to a corporation.

I refused to move, citing his own bill back at him, and he took me to court. While there, I told Sieroty that I had only moved into the loft because of his bill. I asked him why he wrote it. "That bill says that landlords *can* let artists live in their lofts," he told me, "not that they *have* to." He went on to explain that the rest of the building was commercial, and that if word got out that I was living there, the whole place could turn residential. People would start sleeping in the toy store and camping out in Fredericks. Right.

The judge saw a hippie artist and a State Senator. Guess who he found for? I had no idea where I was going to move until La Conner beckoned, though my impending eviction was not my only motivation. I felt honored. Tom Robbins is one of those reclusive writers who simply hands in finished manuscripts that get published as they are. He gave up journalism years ago because he was tired of working with editors. The novel gave him complete control. He does not collaborate. I had absolutely no idea how he wrote his magical books, but if he was willing to learn from me, I was more than happy to learn from him too. I took the job.

Tom picked me up at the Seattle airport in a green convertible and took me to La Conner, nearly two hours past Seattle, into the Skagit Valley, one of the most fertile farmlands in the world. The whole landscape had been memorialized by Tom in his book *Another Roadside Attraction,* and it was fascinating to see it for real. Like he said, it was distinctly Chinese, vast plains interrupted by sudden mountainous lumps of forest surrounded by clouds, the Cascades far to the east, giving an Alpine backdrop to the whole lush panorama. The only problem was Tom's

insistence on listening to tapes of Billy Eckstine, his favorite singer of the moment, but not mine.

We drove through miles of blooming tulip fields until arriving at La Conner, which turned out to be more tourist trap than fishing village. The main street gave new meaning to the word quaint. If you are wondering where all the calico has gone, it has probably relocated to La Conner. Sure there was a local yacht harbor, but the main industry of La Conner is selling knickknacks to the thousands of tourists flocking to the tulip fields. Most of the tulips are not sold but cut down and dug up for the bulbs. La Conner calls itself the seed and bulb capital of the world, and residents pride themselves on it. They repeat the apocryphal story of a local woman who ordered some tulip bulbs from Holland, only to discover a "grown in La Conner" label on the bag when it arrived.

We stopped at the only hotel in town to check in. It crossed the line from quaint into dilapidated. One night was enough. The next day I called a local real estate agent who found me a furnished apartment. It was on the edge of a mammoth cabbage seed farm. The cabbages were perfect, ready to eat, but they would never be picked. I moved in that day, and for the next month I saw the cabbages grow giant stalks until they turned to seed. I'd never seen anything like it. I felt like the ultimate Hollywood city slicker in the country. The next day, I headed to Tom's for my first day of work.

Tom lived a couple blocks away from the main drag. The first thing I noticed was the lack of curtains in the windows. People walking by could see into the house. Tom told me he didn't like curtains. The house was surrounded by trees, and when they were full of leaves, they provided adequate coverage to the windows. It was only when the leaves fell that he suffered from lack of privacy, though suffer is the wrong word. Tom didn't seem to mind that his life was open to the world, that people driving by could see who he was having dinner with. He had nothing to hide.

First we socialized, sharing drinks and cigars. He mentioned that one of the pleasures of living in La Conner was the giant flocks of snow geese that settled there during the spring. He told me he had just seen a new

flock in a nearby field, and that it would be worth my while to seek it out, though of course they changed location all the time.

The next morning on my way to his house, and every morning thereafter, I would take long scenic detours through the countryside, seeking the flock, but they always eluded me.

Finally, Tom briefly explained how he wrote his books. He treats writing like a nine-to-five job, writing eight hours a day, Monday through Friday. No writing allowed on weekends. He gets up in the morning, makes himself breakfast, lights a cigar, and sits at his typewriter.

When he starts a novel, it works like this. First he writes a sentence. Then he rewrites it again and again, examining each word, making sure of its perfection, finely honing each phrase until it reverberates with the subtle texture of the infinite. Sometimes it takes hours. Sometimes an entire day is devoted to one sentence, which gets marked on and expanded upon in every possible direction until he is satisfied. Then, and only then, does he add a period.

Next, he rereads the first sentence and starts writing a second, rewriting it again and again until it shimmers. Then, and only then, does he add a period. While working on each sentence, he has no idea what the next sentence is going to be, much less the next chapter or the end of the book. All thoughts of where he is going or where he has been are banished. Each sentence is a Zen universe unto itself, and while working on it, nothing exists but the sentence. He keeps writing in such a manner until he eventually reaches a sentence which he works on like all the others. He adds a period and the book is done. No editing or revising in any way. When you read a Tom Robbins book, you are experiencing the words not only in the exact order that he wrote them but almost in the exact order that he thought them.

"But wait a minute," I interrupted. "The first sentence of your first book, *Another Roadside Attraction*, is 'The magician's underwear has just been found in a cardboard suitcase floating in a stagnant pond on the outskirts of Miami.' Are you telling me you wrote that sentence having absolutely no idea where it was leading?"

"Yes," he said. "I knew I could explain it later. I like painting myself in corners and seeing if I can get out."

This way of writing was so foreign to all my past experience that I was frozen with fear. This was no way to write a book, much less a screenplay. I had never written anything in my life that I didn't rewrite—not a sentence at a time but the whole goddam thing. You always find yourself creating something in the end of a screenplay that needs to be set up better in the beginning. If you discover you need a gun in the third act, you have to go back and introduce one in the first act.

Not Tom. Tom handed in his pages every so often to a professional typist, and as soon as they were typed up, they were done. He had been working a week before my arrival, so he gave me the twenty or so pages of his screenplay that had already been written. But he didn't want any comments on them. They were done, period, set in stone, as would each day's work be. Once the pages were typed, they were history. No use talking about them. And no use talking about future pages either. Each day's work consisted of that day's work and no other. If today we were working on the robbery scene, there would be no discussion allowed of the setup to, or outcome of, the robbery.

This intense focus on THE MOMENT without any consideration of THE BIGGER PICTURE infuriated me. If he hadn't been the man who wrote *Even Cowgirls Get the Blues,* I would have slapped him silly. No wonder he never worked with anyone else. How could anyone else work like this? How could I work like this? It went against every instinct I had as a writer. I felt I really did have something to teach him, but who was I to give advice to someone who had sold several million more books than me? It was like discovering that he typed with his feet instead of his hands.

I decided that if this ridiculous writing method worked with his books, the more power to him. I'll gladly dote on his every word when I read the books. But a screenplay is another animal. Writing a script in this way, considering each scene individually, without any thought to what comes before or after, is like doing a jigsaw puzzle by starting in the upper left hand corner and putting the pieces in—one row at a time.

That's just not how it works. You put a puzzle together by first gathering all the pieces with straight edges and building the frame. Similarly, a screenplay needs some sort of underlying structure before filling in the details.

Problem number one was the ending. We were adapting one of Tom's books, so the story was all there, though with Tom's characteristic anarchy throughout. I thought the climax, while satisfactory in the book, was too literary to work in the film. I came up with a new ending that was completely visual and cinematic, one that would blow the minds of the viewers while also pleasing the readers of the book by bringing the film to a new level.

I tried to bring up the subject, but Tom would have no talk of the ending until we were actually working on it. We scheduled a discussion of the ending for our last day together. The problem was that my ending needed to be set up correctly or it wouldn't work. I figured out places in the script where we could foreshadow the new ending, but once again Tom would tolerate no debate over work that was weeks away. We could only discuss the scene before us. I sublimated my natural work style and worked his way.

I had to be sneaky. Throughout the month, I managed to surreptitiously insert subtle clues to my ending in various unrelated scenes. When that final day arrived and we were actually discussing the ending, I summoned up all my acting ability and said, "You know, I just thought of something. How about if it ended like this?" And I told him my idea.

His eyes lit up, and he immediately delineated all the clues that I had previously laid. They all added up. "You know," he said, "it just might work." He asked me to type up a version of the end, and I gave it to him the next day. He re-wrote it and used it. I felt justified.

I seriously doubt I had any further influence on Tom's writing method, and though his style will always be one of my most profound influences, his method is one I still shun. I love cutting and pasting, and what you are reading right now was most assuredly not written in the order you are reading it. The word processor has had more influence over my method than anything else.

So I departed La Conner, taking one last jaunt through the fields, and there they were, hundreds of geese settled into a field of cabbages. They took off and circled around towards Puget Sound. I smacked myself on the head. Why hadn't it occurred to me before? I was so stuck in the literal that I didn't even realize what Tom had done. He had sent me on a wild goose chase. One with a happy ending.

Michael Dare is a journalist whose work has appeared in *LA Weekly, Daily Variety, New Times, Billboard, Movieline, Interview, National Lampoon, Film Threat, L.A. Times calendarlive.com, L.A. Style, Parenting Magazine,* and the *Santa Monica Bay News.* He was an assignment editor for the book *A Day in the Life of Hollywood* and a writer/interviewer for *Movie Talk from the Frontlines.* He wrote for the TV shows *Steven Spielberg Presents Animaniacs* and *Histeria!,* and he co-produced the CBS Movie-of-the-Week *The Bachelor's Baby,* which was based upon his own life. (Scott Bakula played him because they couldn't find anyone as good-looking.) His video *Contemporary Extemporary* won *Video Review* magazine's First Annual Award for Best Home Video Ever Made, and his latest, *Angel Food,* has won numerous awards. He is a member of the WGA, the MPAA, and the Los Angeles Film Critics Association. Please keep your arms and legs inside the vehicle while visiting his Web site at http://I.am/Michaeldare.

10

Streckfuss

Tom Bradley

> Mammon, the least erected spirit that fell
> From heaven; for ev'n in heaven his looks and thoughts
> Were always downward bent, admiring more
> The riches of heaven's pavement, trodden gold,
> Than aught divine or holy else enjoyed
> In vision beatific.
>
> MILTON—*PARADISE LOST* I.679

BACK IN THE mid-seventies I had a friend named Streckfuss who never fully recovered from the Vietnam war. He had a tendency in public to jump up and pin the nearest person, G.I. style, to the floor. Like a sizzling incubus with razor shinbones, he knelt on his victims' chests and aimed huge eyes deep into each orifice of their heads. "Somebody did something terrible to me as a child," he would often say. "What was it? Who did it? I don't know. . . ." Then he'd breathe in peculiar ways till the skin that covered his body went corpse-gray. He would repeat the process till everyone normal was frightened away.

Streckfuss didn't really fit into my crowd at the time, but I didn't care because there were Indians at the hotel where he lived. Occupying a semicircle of folding chairs in the tiny lobby, consulting an ancient television

with rabbit ears, they were displaced members of the Shivwit tribe—which meant Streckfuss was never without a big paper bag chock full of the plumpest, juiciest peyote buttons I've ever seen in my life.

Streckfuss and I used to go to various 7-Eleven stores for a Big Gulp root beer and a cheese dog with extra cheese to ballast his peyote stomach. I, myself, never needed to spend our scarce money on such things, because my whole, hefty metabolism was made for these little spineless cacti.

While waiting to be served at 7-Eleven, Streckfuss liked to browse through the reading material. Young people today find it hard to believe that serious literature was once hawked in such places, but it's true. I got my copy of Nabokov's *Lolita* off a twirly rack in a grocery store.

One day, Streckfuss came upon a particularly well-pitched item. It was a classic application of the famous "four-P's" in qualitative marketing theory: Product, Place, Promotion, and Price. Many handsome copies of a novel, with embossed and perforated covers, coruscating with foil, were neatly tucked in a special cardboard stand. This display gave potential buyers a sense of the product without their having to read a word. It was almost a reptilian appeal, zooming directly through the aperture of the eyeball into those suggestible nodes and nodules of the brain.

This stimulated what was left of Streckfuss' mind, which on that day was suffused with the phosphorescent green Eucharist of the southwestern desert. He was already engrossed in page three, when his cheese dog finally came steaming across the counter, trailing ropes and braids of cheese. As he balanced this confection on the display stand, it dripped a molten orange on the product, but Streckfuss was too absorbed to notice.

The book was printed on thick paper, with wide margins and big type to inflate the page count, an excellent example of marketing strategy. Streckfuss really liked it, because he could negotiate each grammatical construction without undue effort. It seemed to be one of those universally appealing works of art, satisfying the general public and the book-reviewing apparatus of its time. According to the back cover, the author was the recipient of a major critical award, and his books were selling like hotcakes all across the continent.

Streckfuss flipped through the chapters with his permanently discolored fingers. "This is quite the novel-book," he said, and took a deep draw on his Big Gulp root beer. He examined the black-and-white portrait on the back cover. It revealed a man with depths of unfulfilled longing in his eyes, and a dark brown beard, well-trimmed.

Amazingly enough, this individual was presently sojourning in our miserable town. To this day, nobody has ever explained to my satisfaction why such a celebrity, at the very peak of his terrestrial fame, would visit our backwater enclave. Perhaps the creator of Streckfuss' much-admired "novel-book" had come to seek peace and renewal among us simple and subliterate salts of the earth. Like a Hindu pilgrim, he must return to the Ganges to bathe. On the other hand, he could've been cruising for some sort of primitivistic kick that he imagined to be available here. But such a man would not waste his leisure time on the things my neighbors do for fun, like hanging around 7-Eleven parking lots till the wee hours with the likes of Streckfuss—which is what I did after he shoplifted our illustrious guest's novel. Had Streckfuss been arrested, the next eighteen hours of American literary history would have never taken place.

"You might not believe this, Bradley," Streckfuss said, scooting close to me on the concrete stoop and rolling the pilfered volume into an ever tighter tube, "but I found in this book whole chunks outa my life I can't even remember. My social worker told me that if it wasn't for the draft and Nam, I'd still be all doped up with thorazine and locked in a ward with bent people. Or else I'd be running loose, pulling ape-shit crazy stunts like—um, like—"

Streckfuss examined his tattooed hands and thought hard.

"Hey!" I cried, in a cheerful honk. With mental fingers I groped my gray matter for something to distract him before he could recollect stunts better left forgotten. "Know what? You ought to come along with me to the creative writing workshop. Your author is giving a talk to my class."

I was a college freshman, a barely matriculated back-of-the-classroom lurker, a mere arriviste teeny-bopper who had somehow found himself participating in this glamorous seminar filled with graduate students. My

classmates were the future creative writing industrialists of the Inter-mountain West, working on fictional dissertations laced with meta-fictional ideals. They were forging, in the smithy of their mimeographed literary magazines, the uncreated conscience of their guild. They were right on the verge of finding literary agents, for Christ's sake, and I can only assume that I'd been cast among them, like an earthworm among rainbow trout, through some simple clerical mistake. Sometimes at night I wonder if I actually earned my baccalaureate degree, or if it was ran-domly conferred by chance. I suppose it hardly matters now.

Streckfuss looked very excited and flattered at the prospect of going among the intelligentsia. He gestured through the darkness at the stolen book. "I bet he won't mind autographing this if I gently tear out the pages with the most cheese."

Streckfuss allowed himself to be provisionally persuaded to join the "shop," for, in fact, he was an author, too. He unzipped his habitual one-shoulder backpack and fished out imaginative works, one after another. "I'm gonna show this one to the shop today," he said, pulling a pile of paper from his sack.

Squatting on his heels in a lurid alley, he rearranged the papers between scarlet puddles of transmission fluid from some long-gone truck, acting as though no particular sequence was required. Streckfuss was simply putting the pages in the order that pleased him most at the moment. He had arrived at an ultra-poetic technique, approaching Bur-roughsian paste-ups in sophistication, and I was all the more impressed since my companion was virginal of theory.

I was expecting a combat story, a version of *The Red Badge of Courage* with civilian decapitations and lieutenant fraggings. But I was surprised to find something different: a peacetime reminiscence of an even earlier period of his immaturity.

To celebrate me on Sunday my old dad put me up inside the win-dow. In the end gate of our Rambler station wagon window. And my butt was on the edge of the window and my arms rest across the auto-top. And the back is full of Basket Balls my old dad, he

stealed from his church. The other kids racing on foot all around me. Eggplants, polaks, guinea bastards like myself, rice-negroes, zipper-heads, chinks, harps, papooses, and also young persons of the Jewish purse suasion. All one the same together, Americans. And I bounced them Basket Balls off top their head. My old dad chases a kid down like on TV, he squeals the tires, I bean him with my Basket Balls. My old dad says we are feeling power-full and political. The kids soon had their own ammo of Basket Balls and they some times hit me on the back or my sides. The kids on feet they were less uncordennated than myself. Because they wasn't saddled down with their old dad's Rambler station wagon. Which was faster than them though. Once I fell out, I landed on my side. I had to crawl for cover because both my legs was asleep. Because my butt it was always pressed down on the edge of that Rambler end gate window. The kids they buried me by Basket Balls that time. I was only one big old bruise that time. It was a pleasant uprising. Or so my old dad told it later.

"This should do fine," I said.

Streckfuss was following the pattern of a good many writers at the beginning of their careers, who exploit their personal histories like strip mines for narrative material. Later, he would ripen artistically, but for now it was boyhood. Huck Finn rolling on the asphalt rivers of Main-street, USA.

By the time we got to the school we were late. Normally, for a teen of my fashionably devil-may-care veneer, tardiness was no problem, and it never prevented me from bashing my way into any situation. Such is the headlong vitality of youth. But today the freakish juxtaposition of the classroom door with the sound of a famous voice coming from the other side made me cautious. Of course, it didn't help that my senses had been systematically deranged for about seventeen hours straight. I could have sworn it was Henry Kissinger talking in there, and not the illustrious idol of Streckfuss' novel-book. I thought I heard the words "ultimate aphrodisiac."

With Streckfuss hovering hungrily behind me, I cracked the door, ever so slightly. I prayed with success to the Shivwit Mother Bear Spirit for no hinge squeaks as I slipped part of the flange of my right nostril through, opening a tiny but serviceable line of sight. And, I must confess, for the first and last time in my academic career, I regretted my unpunctuality—because this was the legendary day the legendary author separated those much-photographed jaws and said something of consequence.

What we were bearing aural witness to was a home truth dear to the heart and methods of a successful artist. The air was thick with the sounds of ballpoints and pencils transcribing the pronouncement verbatim. He was propounding his personal creed and artistic manifesto—and Streckfuss and I had missed the first part. We'd arrived too late to burn the entirety of this revealed gospel onto the ventricled walls of our brains.

"—and so, if people are paying for nonfiction these days, you make up a nonfiction and falsify volumes of spurious documentation to back yourself up, and—"

I chose that moment to come barging in. The English Department never treated me the same after that day, and God only knows why I wasn't immediately expelled for interrupting their celebrity guest—because I caused the delivery of the oracle to stop in mid-phrase, never to be taken up again.

What made the famous writer clam up before bringing his unique pronouncement to full period? Why did he bury that heavily televised nose in his lecture notes, and freeze like a spaniel in the presence of a dead duck? I was briefly puzzled, until a possible explanation registered in my nostrils. It was the dioxin-drenched jungle mildew of my friend. My little Streckfuss was the only person in the room who'd ever killed someone, and he exuded the pheromones to prove it. Young Bradley's sidekick trailed an emerald-colored smog which caused all commentary to cease.

Undeterred by the stuttering silence of the class, Streckfuss took a moment to recognize the star whose autograph and benediction he

sought. He walked to the podium and slid the cheese-drenched book into the author's hand.

He got no reaction whatsoever. Our teacher budged neither face nor book. Like some graven image, he didn't even blink.

Anger started to grow in my little friend's eyes. Men with a background of selfless service to our country do not like being ignored, and it never occurred to him that such a mighty genius might be paralyzed with fear. By main force, Streckfuss wedged a few pages of his imaginative work onto the podium, impossible to ignore. The recipient was too terrified to flick them onto the floor—which, I can affirm, was much the better for all.

"Read that, whiskered possum," my partner sizzled through clenched lips. "And take some home to your kids and wife." He turned to his captured audience and recited his Basket Balls memoir from memory.

When he finished, just about everyone was petrified, and no one dared to utter a word. But one person busily grasped the silence to assert her dogmatic self. She could seriously talk, this LurLeen, and she launched an extended soliloquy at my friend.

"Your imagination," she began, "seems to work well enough for the current marketplace, but you use too many adjectives and adverbs! Restrain yourself, for writing is not just wallowing in pleasure like a medieval gothic mass. You need shorter sentences and more dialogue, especially when you throw basketballs at interracial children from the gate of your father's car . . ."

I froze, staring into Streckfuss's swollen eyes.

". . . Just show everyday experiences with everyday people chatting about whatever is in their minds, and let your modest sincerity, not your invention, hold the reader's interest. Don't show off. Don't manipulate the reader . . ."

Blood traced the hollows of Streckfuss' cheeks.

". . . This above all: my agent says you have to create characters that won't intimidate your reader. Make your story like a warm cup of cocoa in a clean, comfortable kitchen, with a few of your calmest friends sitting around and just being happy about their lives. And don't do anything

you're not prepared to do yourself, like take psychedelic drugs and gun down women in cold blood, just to mention a few of the more obvious examples."

Both of my buttocks took flight as I tried to anchor Streckfuss to a chair. But rather than allow himself to be lowered, gingerly, by me, into a seat among the degree seekers, he rolled his sleeves unabashedly past his tattooed wrists, beyond his forearms, clear up to the needle tracks, which I'd never seen before. They put me in the presence of a soldier for the first time. Mars made manifest, red, not green, stood at attention in our midst.

He scooped up all the manuscripts and textbooks, piled them in front of the door, and then set fire to them. Everything exploded at the first flick of a match, discouraging escape attempts.

Streckfuss hovered in the thickening grayness like a pollinator. He persuaded everyone to remain seated with loud gnashing sounds from the front of his face. Intent on producing an even abrasion pattern on each psyche in the "shop," he harangued the creative writers one by one. Smoke filled the room, but if anyone coughed or moved, he was dealt a karate kick. Streckfuss was a stern tutor.

He had been counting on a mini-series deal and at least one cherry-red vintage T-bird full of star-struck groupies, and he wasn't about to let his golden opportunity slip away without a struggle. And, who can blame the poor little guy? It's not as though his dreams were entirely of the pipe variety. In that epoch of American literary history, there were opportunities for writers to earn two million dollars as an advance. It was a flowering of literature, and Streckfuss wanted his rightful share of the nectar.

The pile of words in front of the door crackled and raged like a western hillside of sagebrush thunderstruck during a drought. The famous writer snouted and rooted ever deeper into Streckfuss' creative writing. Soldierly sweat was soaked into the scribbled-upon pages, and it helped filter out airborne toxins, preserving our novelist from asphyxiation, even as he curled back his nostrils and sneered at that very smoke.

He looked as though the only thing he wanted to do in the whole world was to go back to his humid home on the northeast coast of the

United States of America. He seemed so little and exposed there at the head of the table, and so full of unfathomable suffering, so eastern, so out of his element. I could almost see—no, I did see gills gasping on his neck. He looked a little green around them. I'd never felt sorry for someone quite that well-to-do. It was a fresh experience for me.

I scooted next to the unhappy man and attempted to deliver him succor. This was my big break, my chance to have a significant Manhattanite hear my voice, though filtered through the half-truth serum of the gods. I would raise that voice over the general discord, and make it glare like the sun bouncing off gritted, greenish teeth. I aimed sky-colored eyeballs into the man's sound-hole and decanted my decoction into Daddy's dark ear. It drew me in, this ear.

"Lift up your eyes, like a man, and look at my friend over there. Do you think I made him up, with spurious volumes of falsified facts? Old man, if people are paying for nonfiction these days, do you think they'll buy my Streckfuss?"

Such was not the succor I had planned to deliver. But such he got. In return for my act of human consideration, I received no recommendation or praise. Not even the phone number of his literary agent in New York. But I feel certain this is only because the man was in such emotional turmoil and was unable to unflex his jaw muscles to produce intelligible sounds.

Maybe it's just a coincidence, but I remain to this day unrepresented in the crystal canyons of the Big Apple. In whatever afterlife awaits us, I will be raking my anonymous lungs down into my un-bylined bowels, with a two-fisted gesture of remorse. On the other hand, things could be worse. Print-on-demand has worked out well. All five volumes of my *Sam Edwine Pentateuch* are stacked on the virtual shelves of Amazon Dot Com (Streckfuss is a major presence in the first book, and his old dad looms large in three of them). And no Bradley title has been remaindered or pulped. Or burned or mangled or smothered in cheddar, as some other books have fared. My name has been scratched on eternity's door.

And Streckfuss? I'm pretty sure I was the one who calmed our Enkidu down before they hauled him away. I caught my last glimpse as he sat in

the back of the campus cop van, manacled to the door. He was not breathing in peculiar ways, his skin was not corpse-grey, and he seemed to be remembering something terrible about his childhood.

As for the future of those creative writing industrialists of the Intermountain West, they're still cowering underneath their diplomas and charred manuscripts, listening to Lurleen. And that whiskered possum of a novelist? He's cranking out blockbusters as never before.

Various of **Tom Bradley**'s novels (*Killing Bryce; Acting Alone; Black Class Cur; Kara-kun, Fip-kun; The Curved Jewels*) have been nominated for The Editor's Book Award and the New York University Bobst Award. He was a finalist in the AWP Award Series, and his short stories have been nominated for Pushcart Prizes. His spurious nonfiction, bought and paid for, appears in Salon.com, while his unfalsified essays appear in *Exquisite Corpse* and *Milk Magazine*. Excerpts and reviews of Tom's work can be found at www.literati.net/Bradley, along with the complete story of Streckfuss, raw and unexpurgated.

"Littery" Men

Mark Twain

STANDING HERE ON the shore of the Atlantic and contemplating certain of its largest literary billows, I am reminded of a thing which happened to me thirteen years ago, when I had just succeeded in stirring up a little Nevadian literary puddle myself, whose spume-flakes were beginning to blow thinly Californiawards. I started an inspection tramp through the southern mines of California. I was callow and conceited, and I resolved to try the virtue of my *nom de guerre*. I very soon had an opportunity. I knocked at a miner's lonely log cabin in the foothills of the Sierras just at nightfall. It was snowing at the time.

A jaded, melancholy man of fifty, barefooted, opened the door to me. When he heard my *nom de guerre* he looked more dejected than before. He let me in—pretty reluctantly, I thought—and after the customary bacon and beans, black coffee and hot whiskey, I took a pipe. This sorrowful man had not said three words up to this time. Now he spoke up and said, in the voice of one who is secretly suffering, "You're the fourth—I'm going to move." "The fourth what?" said I. "The fourth littery man that has been here in twenty-four hours—I'm going to move." "You don't tell me!" said I; "who were the others?" "Mr. Longfellow, Mr. Emerson and Mr. Oliver Wendell Holmes—confound the lot!"

You can easily believe I was interested. I supplicated—three hot whiskeys did the rest—and finally the melancholy miner began. Said he—

"They came here just at dark yesterday evening, and I let them in of course. Said they were going to the Yosemite. They were a rough lot, but that's nothing; everybody looks rough that travels afoot. Mr. Emerson was a seedy little bit of a chap, red-headed. Mr. Holmes was as fat as a balloon; he weighed as much as three hundred, and had double chins all the way down to his stomach. Mr. Longfellow was built like a prize-fighter. His head was cropped and bristly, like as if he had a wig made of hair-brushes. His nose lay straight down his face, like a finger with the end joint tilted up. They had been drinking, I could see that. And what queer talk they used! Mr. Holmes inspected this cabin, then he took me by the buttonhole, and says he—

"'Through the deep caves of thought
I hear a voice that sings,
'Build thee more stately mansions,
O my soul!'

"Says I, 'I can't afford it, Mr. Holmes, and moreover I don't want to.' Blamed if I liked it pretty well, either, coming from a stranger, that way. However, I started to get out my bacon and beans, when Mr. Emerson came and looked on awhile, and then *he* takes me aside by the button-hole and says—

"'Give me agates for my meat;
Give me cantharides to eat;
From air and ocean bring me foods,
From all zones and altitudes.'

"Says I, 'Mr. Emerson, if you'll excuse me, this ain't no hotel.' You see it sort of riled me—I warn't used to the ways of littery swells. But I went on

a-sweating over my work, and next comes Mr. Longfellow and button-holes me, and interrupts me. Says he,

"'Honor be to Mudjekeewis!
You shall hear how Pau-Puk-Keewis—'

"But I broke in, and says I, 'Beg your pardon, Mr. Longfellow, if you'll be so kind as to hold your yawp for about five minutes and let me get this grub ready, you'll do me proud.' Well, sir, after they'd filled up I set out the jug. Mr. Holmes looks at it and then he fires up all of a sudden and yells—

"'Flash out a stream of blood-red wine!
For I would drink to other days.'

"By George, I was getting kind of worked up. I don't deny it, I was getting kind of worked up. I turns to Mr. Holmes, and says I, 'Looky here, my fat friend, I'm a-running this shanty, and if the court knows herself, you'll take whiskey straight or you'll go cry.' Them's the very words I said to him. Now I don't want to sass such famous littery people, but you see they kind of forced me. There ain't nothing unreasonable 'bout me; I don't mind a passer of guests a-treadin' on my tail three or four times, but when it comes to *standing* on it, it's different, 'and if the court knows herself,' I says, 'you'll take whiskey straight or you'll go dry.' Well, between drinks they'd swell around the cabin and strike attitudes and spout; and pretty soon they got out a greasy old deck and went to playing euchre at ten cents a corner—on trust. I began to notice some pretty suspicious things. Mr. Emerson dealt, looked at his hand, shook his head, says—

"'I am the doubter and the doubt—'

and ca'mly bunched the hands and went to shuffling for a new layout. Says he—

"'They reckon ill who leave me out;
They know not well the subtle ways I keep.
I pass and deal *again!*'

Hang'd if he didn't go ahead and do it, too! O, he was a cool one! Well, in about a minute, things were running pretty tight, but all of a sudden I see by Mr. Emerson's eye he judged he had 'em. He had already corralled two tricks and each of the others one. So now he kind of lifts a little in his chair and says—

"'I tire of globes and aces!—
Too long the game is played!'

—and down he fetched a right bower. Mr. Longfellow smiles as sweet as pie and says—

"'Thanks, thanks to thee, my worthy friend,
For the lesson thou hast taught,'

—and blamed if he didn't down with *another* right bower! Emerson claps his hand on his Bowie, Longfellow claps his on his revolver, and I went under a bunk. There was going to be trouble; but that monstrous Holmes rose up, wobbling his double chins, and says he, 'Order, gentlemen; the first man that draws, I'll lay down on him and smother him!' All quiet on the Potomac, you bet!

"They were pretty how-come-you-so, by now, and they begun to blow. Emerson says, 'The nobbiest thing I ever wrote was Barbara Frietchie.' Says Longfellow, 'It don't begin with my Biglow Papers.' Says Holmes, 'My Thanatopsis lays over 'em both.' They mighty near ended in a fight. Then they wished they had some more company—and Mr. Emerson pointed to me and says—

"'Is yonder squalid peasant all
That this proud nursery could breed?'

He was a-whetting his Bowie on his boot—so I let it pass. Well, sir, next they took it into their heads that they would like some music; so they made me stand up and sing 'When Johnny Comes Marching Home' till I dropped—at thirteen minutes past four this morning. That's what I've been through, my friend. When I woke at seven, they were leaving, thank goodness, and Mr. Longfellow had my only boots on, and his'n under his arm. Says I, 'Hold on, there, Evangeline, what are you going to do with *them?*' He said, 'Going to make tracks with 'em; because—

> "'Lives of great men all remind us
> We can make our lives sublime;
> And, departing, leave behind us
> Footprints on the sands of time.'

"As I said, Mr. Twain, you are the fourth in twenty-four hours—and I'm going to move; I ain't suited to a littery atmosphere."

I said to the miner, "Why, my dear sir, *these* were not the gracious singers to whom we and the world pay loving reverence and homage; these were impostors."

The miner investigated me with a calm eye for a while; then said he, "Ah! impostors, were they? Are *you?*"

I did not pursue the subject, and since then I have not traveled on my *nom de guerre* enough to hurt.

Mark Twain told this tale on December 17, 1877, at a dinner given in honor of the seventieth birthday of John Greenleaf Whittier. He considered it his most notorious speech, and so did his host. Twain's capacity for social satire is as relevant today as it was a century ago: *The Adventures of Huckleberry Finn* was immediately banned upon publication in 1886, and it remains one of the top-ten banned books today. Twain died, inexplicably happy, in 1910.

12

Congratulations! It's a Six Pound Eight Ounce Novel

Jane Eaton Hamilton

THE STORY CURLS inside you, hardly formed, just eight weeks along. Two months—still time for a miscarriage. Has anyone else ever had that happen? Told the world they were going to be a novelist and then had the damned book slide out slippery as a dead fish? It's true what they say—you need a good counselor. It breaks your goddamned heart.

There's only one thing you can do. Toss. Take a helluva big breath. Start again. Like the doctor said: You're not too old. You can have another novel.

You don't think it should be so hard.

Your mother says anything worthwhile should be a little hard.

Your husband is worthwhile, and sometimes he's a little hard.

Which is why you tell him to get home from work while you're ovulating. You can't do this alone. You need every one of the ideas that shoot out of him. Conception is no easy business. The circumstances have to be just

right. Precisely right. Basal thermometers. Pillows under your hips. OED on the bedstand. You are not the kind of woman who conceives easily.

You don't tell anyone you're pregnant. You're afraid of jinxing it. You don't want to have to say: No, I'm sorry. I'm not. No. I lost it. I know. Thanks for the sympathy. Really. I'm sorry too. I'm heartbroken.

You don't want to be put in that position again.

There are other concerns: what if somebody else tries to make a novel that looks like yours? If someone copies you? Tells the story and acts like it was theirs all along? You know it can happen, especially these days with the Internet. Actually, it has happened to you, and more than once. A friend called up one time and said, I just read a story you told me in Alice Newbold's new novel. Page 172.

You found Alice Newbold's new novel and damned if it wasn't a good-looking thing. A little thin, in your opinion, but gripping. And there on page 172, just like your friend said, your story. The central conceit of your gestating book.

And once you told a writer friend something about yourself that you'd never before confided. You swore her to secrecy. Weren't you shocked when it ended up in one of her stories? In a story that won a prize? And the worst thing was you couldn't tell anyone. You couldn't trash her the way she deserved, because then you'd have to admit this private thing.

Plus, plus, the title of her book was a phrase you said, that you might have used as a title yourself in the future. You searched her acknowledgments page—nothing.

Forget it. You're not going to mention anything prematurely. You could miscarry. You could hemorrhage, die and then your story would get adopted by someone else. Get their last name tattooed on its spine.

You long to push the new one out before it's ready. You've lived with it for months, for god's sake, and you're tired. You can't sleep on your stomach. You can't smoke. You can't drink. All your friends are deserting you. They didn't realize you could be this boring. No matter what the doctors say, you're not getting any younger. You have gray shooting through your

hair, and wrinkles (laugh lines). You have to get it out of you. All the hip young authors are under thirty-five. They just are. It's not fair, but it's a fact. You have someone take an author photo in soft light.

You have pains. For god's sake, you tell your husband. Just get me to the hospital.

The doctors examine you. They tell you it's too early. The contractions are probably Braxton Hicks, and even if they're real, the docs are going to give you something to hold them back. This story needs another six weeks. Minimally. This story isn't ready to breathe on its own, they say. It's intensely premature. Is that what you want? the doctors ask, mumbling through their masks. A story that can't breathe on its own? A story with immature lungs? Lifelong learning problems? A story that won't sell more than a thousand copies?

You don't, of course. You want a famous story. A beloved story. A story that makes Oprah's Book Club. But christ you're sick of being pregnant. You feel like a cow. And anyhow, can't they resuscitate a peanut these days? You've seen stories sixty pages long published as first novels. Sure, it's true, they have tubes attached, cerebral palsy, they won't ever walk. Just get it out of me, you say.

Go home, the docs tell you. It's not your time. Get plenty of bed rest. See me in my office. We need to check your weight, your blood pressure. You need to get rid of some of those adjectives. I'm sorry, no. There isn't any medication. It takes talent, skill, self discipline. No more adverbs. And straighten out that plot line. While you're at it, wasn't that piano on page 150 a guitar earlier on? Any swelling of the ankles? Any faintness on sudden rising?

You're bloated. Your breasts are so sore you weep if someone so much as looks at them. Only why would anyone? You're ugly. You're fat and you're ugly and there's never going to be a story, anyhow. There isn't. It's all flatulence. It's all wind.

Things they said the last time: "You have what it takes to be a good writer." "This is good, but it's not fully developed." "There are several awkward places." "Numerous spelling errors. In addition, several state-

ments that seem unnecessarily obvious." "It doesn't seem likely to us that the protagonist would murder her husband. Yet, we like it. We think the story has great possibility." "Intriguing characters and situation." "Maybe the next one."

The first couple postpartum months are rumored to be brutal. Numerous strange hotel rooms are involved, so alike that you're said to forget where you are and say to a Milwaukee crowd: I'm thrilled to be nursing my novel in St. Louis tonight. You won't have had enough sleep. Your hormones will be wildly swinging—you're as liable to break into tears as laughter.

But those are concerns for women who have finished their books. For books who've scored a ten on the Apgar scale. For books with publishers. Your novel won't ever have a publisher. Because the stupid novel is never even going to get here. Never. You're going to be waddling like an elephant until you're sixty and it's too late.

You've already passed your due date. After those contractions early on, fighting to keep the damned thing from being born too soon, now you can't get rid of it. Two days, a week, two weeks. If it's not done soon they're going to have to induce you.

C-section. Your worst nightmare. They'll have to rip you open to get the book out.

But then it happens. They said it would happen and now it happens. It happens and there's no way you're prepared. There's no way this is what you want. Uh-uh. Stop the boat. I'm getting off. The novel can stay but I'm getting off. I've changed my mind.

Your water breaks all over your typewriter, ruining the climax. And oh no. There's trouble. Meconium. Black flecks that look like the words you already edited out. You know what that means. All the how-to books you've read have drilled it into you. This story has taken a life-threatening breath of its own excrement.

The buzzer has gone off. You're out of time. You have to get to the hospital. No turning back now. If you wanted to turn back, you should've considered abortion. This was your choice. You let it get this far.

You beg your husband to tell you things will be all right. Just say you love me, you beg. Just say I'm the best thing since cell phones. Just tell me my story is going to survive this. We'll both survive this.

He's good. He says all that. He whisks you to the car, props your feet in his lap under the steering wheel, says all the right things. But what does he know? What the hell does he know? He's a fucking journalist.

And anyway. Why do they say labor doesn't hurt? It hurts like a sonofabitch. You want drugs. Why shouldn't you have drugs? They say no drugs, a natural birth, it's what you wanted, you told them to ignore you when you changed your mind. Your asshole husband puffs in your face like a bellows. He's useless, useless! Why did you sleep with him to begin with? What the hell were you thinking? He said, Stay home and take nine months to write. Hah! Hah! Shows how little he knows.

You can do it, your husband says now. You've got what it takes. Way to go, honey. Good job.

You're nine centimeters dilated. Just wait, wait a minute. You feel like pushing? Don't push. Honey, I said, Don't push. The doctor says she's gotta move the lip of the cervix away from the novel's cover page. It's gonna hurt.

Scream.

Sometimes it's all you can do.

You could push the Empire State Building out your twat, you swear you could. You grunt and bear down. You leave bruise marks on your husband's arm.

But fuck it. Fuck it. Who cares about delicacy at a time like this? You're crying, and then a few minutes later, when the doctor says she can see the title page, you're laughing.

Okay, hold on. The acknowledgments page is out. The dedication to your husband. Hang on. Here's the text, wailing its newborn lungs.

They're passing you the novel, now, and it's beautiful. She's beautiful. You can't stop crying, but the tears are tears of joy. Your husband kisses your face. He's the greatest husband. Didn't he stand by you, thick and thin? He's whispering to her. He's stroking the five little pages of her denouement. He's smitten. Look. He's starting to cry.

She looks just like you, your husband says. She's got your font.

No wonder he's weeping. She's the most magnificent novel you've ever seen. You don't care what anyone else says, because you're in love. You're head over heels.

Congratulations! says the doctor. I'm pleased to say you have a healthy, six pound, eight ounce novel.

Jane Eaton Hamilton is the author of a children's book, *Jessica's Elevator;* two poetry books, *Body Rain* and *Steam-Cleaning Love;* a volume of short fiction, *July Nights;* and a comic novel called *Undertaking Daddy.* Her books have been shortlisted for the Pat Lowther Award and the VanCity and BC Book Prizes. Short work has won the Yellow Silk fiction award, the Paragraph fiction award, the Event nonfiction award, the Prism International fiction award, the Belles Lettres essay award, the This Magazine fiction award, and The Canadian Poetry Chapbook Contest. Her work has also been cited in *The Pushcart Prize* and *Best American Short Stories.* You can check out her Web site at http:// persweb.direct.ca/jahamilt/jane.htm.

13

Confessions of a Humorist

O. Henry

THERE WAS A painless stage of incubation that lasted twenty-five years, and then it broke out on me, and people said I was It.

But they called it humor instead of measles.

The employees in the store bought a silver inkstand for the senior partner on his fiftieth birthday. We crowded into his private office to present it. I had been selected for spokesman, and I made a little speech that I had been preparing for a week.

It made a hit. It was full of puns and epigrams and funny twists that brought down the house—which was a very solid one in the wholesale hardware line. Old Marlowe himself actually grinned, and the employees took their cue and roared.

My reputation as a humorist dates from half-past nine o'clock on that morning. For weeks afterward my fellow clerks fanned the flame of my self-esteem. One by one they came to me, saying what an awfully clever speech that was, old man, and carefully explained to me the point of each one of my jokes.

Gradually I found that I was expected to keep it up. Others might speak sanely on business matters and the day's topics, but from me something gamesome and airy was required.

I was expected to crack jokes about the crockery and lighten up the granite ware with persiflage. I was second bookkeeper, and if I failed to show up a balance sheet without something comic about the footings or could find no cause for laughter in an invoice of plows, the other clerks were disappointed. By degrees my fame spread, and I became a local "character." Our town was small enough to make this possible. The daily newspaper quoted me. At social gatherings I was indispensable.

I believe I did possess considerable wit and a facility for quick and spontaneous repartee. This gift I cultivated and improved by practice. And the nature of it was kindly and genial, not running to sarcasm or offending others. People began to smile when they saw me coming, and by the time we had met I generally had the word ready to broaden the smile into a laugh.

I had married early. We had a charming boy of three and a girl of five. Naturally, we lived in a vine-covered cottage, and were happy. My salary as bookkeeper in the hardware concern kept at a distance those ills attendant upon superfluous wealth.

At sundry times I had written out a few jokes and conceits that I considered peculiarly happy, and had sent them to certain periodicals that print such things. All of them had been instantly accepted. Several of the editors had written to request further contributions.

One day I received a letter from the editor of a famous weekly publication. He suggested that I submit to him a humorous composition to fill a column of space; hinting that he would make it a regular feature of each issue if the work proved satisfactory. I did so, and at the end of two weeks he offered to make a contract with me for a year at a figure that was considerably higher than the amount paid me by the hardware firm.

I was filled with delight. My wife already crowned me in her mind with the imperishable evergreens of literary success. We had lobster croquettes and a bottle of blackberry wine for supper that night. Here was the chance to liberate myself from drudgery. I talked over the matter very seriously with Louisa. We agreed that I must resign my place at the store and devote myself to humor.

I resigned. My fellow clerks gave me a farewell banquet. The speech I made there coruscated. It was printed in full by the Gazette. The next morning I awoke and looked at the clock.

"Late, by George!" I exclaimed, and grabbed for my clothes. Louisa reminded me that I was no longer a slave to hardware and contractors' supplies. I was now a professional humorist.

After breakfast she proudly led me to the little room off the kitchen. Dear girl!

There was my table and chair, writing pad, ink, and pipe tray. And all the author's trappings—the celery stand full of fresh roses and honey-suckle, last year's calendar on the wall, the dictionary, and a little bag of chocolates to nibble between inspirations. Dear girl!

I sat me to work. The wall paper is patterned with arabesques or obelisks or—perhaps—it is trapezoids. Upon one of the figures I fixed my eyes. I bethought me of humor.

A voice startled me—Louisa's voice.

"If you aren't too busy, dear," it said, "come to dinner."

I looked at my watch. Yes, five hours had been gathered in by the grim scytheman. I went to dinner.

"You mustn't work too hard at first," said Louisa. "Goethe—or was it Napoleon?—said five hours a day is enough for mental labor. Couldn't you take me and the children to the woods this afternoon?"

"I am a little tired," I admitted. So we went to the woods.

But I soon got the swing of it. Within a month I was turning out copy as regular as shipments of hardware.

And I had success. My column in the weekly made some stir, and I was referred to in a gossipy way by the critics as something fresh in the line of humorists. I augmented my income considerably by contributing to other publications.

I picked up the tricks of the trade. I could take a funny idea and make a two-line joke of it, earning a dollar. With false whiskers on, it would serve up cold as a quatrain, doubling its producing value. By turning the skirt and adding a ruffle of rhyme you would hardly recognize it as—vers de sociéte—with neatly shod feet and a fashion-plate illustration.

I was expected to crack jokes about the crockery and lighten up the granite ware with persiflage. I was second bookkeeper, and if I failed to show up a balance sheet without something comic about the footings or could find no cause for laughter in an invoice of plows, the other clerks were disappointed. By degrees my fame spread, and I became a local "character." Our town was small enough to make this possible. The daily newspaper quoted me. At social gatherings I was indispensable.

I believe I did possess considerable wit and a facility for quick and spontaneous repartee. This gift I cultivated and improved by practice. And the nature of it was kindly and genial, not running to sarcasm or offending others. People began to smile when they saw me coming, and by the time we had met I generally had the word ready to broaden the smile into a laugh.

I had married early. We had a charming boy of three and a girl of five. Naturally, we lived in a vine-covered cottage, and were happy. My salary as bookkeeper in the hardware concern kept at a distance those ills attendant upon superfluous wealth.

At sundry times I had written out a few jokes and conceits that I considered peculiarly happy, and had sent them to certain periodicals that print such things. All of them had been instantly accepted. Several of the editors had written to request further contributions.

One day I received a letter from the editor of a famous weekly publication. He suggested that I submit to him a humorous composition to fill a column of space; hinting that he would make it a regular feature of each issue if the work proved satisfactory. I did so, and at the end of two weeks he offered to make a contract with me for a year at a figure that was considerably higher than the amount paid me by the hardware firm.

I was filled with delight. My wife already crowned me in her mind with the imperishable evergreens of literary success. We had lobster croquettes and a bottle of blackberry wine for supper that night. Here was the chance to liberate myself from drudgery. I talked over the matter very seriously with Louisa. We agreed that I must resign my place at the store and devote myself to humor.

I resigned. My fellow clerks gave me a farewell banquet. The speech I made there coruscated. It was printed in full by the Gazette. The next morning I awoke and looked at the clock.

"Late, by George!" I exclaimed, and grabbed for my clothes. Louisa reminded me that I was no longer a slave to hardware and contractors' supplies. I was now a professional humorist.

After breakfast she proudly led me to the little room off the kitchen. Dear girl!

There was my table and chair, writing pad, ink, and pipe tray. And all the author's trappings—the celery stand full of fresh roses and honeysuckle, last year's calendar on the wall, the dictionary, and a little bag of chocolates to nibble between inspirations. Dear girl!

I sat me to work. The wall paper is patterned with arabesques or obelisks or—perhaps—it is trapezoids. Upon one of the figures I fixed my eyes. I bethought me of humor.

A voice startled me—Louisa's voice.

"If you aren't too busy, dear," it said, "come to dinner."

I looked at my watch. Yes, five hours had been gathered in by the grim scytheman. I went to dinner.

"You mustn't work too hard at first," said Louisa. "Goethe—or was it Napoleon?—said five hours a day is enough for mental labor. Couldn't you take me and the children to the woods this afternoon?"

"I am a little tired," I admitted. So we went to the woods.

But I soon got the swing of it. Within a month I was turning out copy as regular as shipments of hardware.

And I had success. My column in the weekly made some stir, and I was referred to in a gossipy way by the critics as something fresh in the line of humorists. I augmented my income considerably by contributing to other publications.

I picked up the tricks of the trade. I could take a funny idea and make a two-line joke of it, earning a dollar. With false whiskers on, it would serve up cold as a quatrain, doubling its producing value. By turning the skirt and adding a ruffle of rhyme you would hardly recognize it as—vers de sociéte—with neatly shod feet and a fashion-plate illustration.

I began to save up money, and we had new carpets, and a parlor organ. My townspeople began to look upon me as a citizen of some consequence instead of the merry trifler I had been when I clerked in the hardware store.

After five or six months the spontaneity seemed to depart from my humor. Quips and droll sayings no longer fell carelessly from my lips. I was sometimes hard run for material. I found myself listening to catch available ideas from the conversation of my friends. Sometimes I chewed my pencil and gazed at the wall paper for hours trying to build up some gay little bubble of unstudied fun.

And then I became a harpy, a Moloch, a Jonah, a vampire, to my acquaintances. Anxious, haggard, greedy, I stood among them like a veritable killjoy. Let a bright saying, a witty comparison, a piquant phrase fall from their lips and I was after it like a hound springing upon a bone. I dared not trust my memory; but, turning aside guiltily and meanly, I would make a note of it in my ever-present memorandum book or upon my cuff for my own future use.

My friends regarded me in sorrow and wonder. I was not the same man. Where once I had furnished them entertainment and jollity, I now preyed upon them. No jests from me ever bid for their smiles now. They were too precious. I could not afford to dispense gratuitously the means of my livelihood.

I was a lugubrious fox praising the singing of my friends, the crow's, that they might drop from their beaks the morsels of wit that I coveted.

Nearly every one began to avoid me. I even forgot how to smile, not even paying that much for the sayings I appropriated.

No persons, places, times, or subjects were exempt from my plundering in search of material. Even in church my demoralized fancy went hunting among the solemn aisles and pillars for spoil.

Did the minister give out the long-meter doxology, at once I began: "Doxology—sockdology—sockdolager—meter—meet her."

The sermon ran through my mental sieve, its precepts filtering unheeded, could I but glean a suggestion of a pun or a—bon mot—.

The solemnest anthems of the choir were but an accompaniment to my thoughts as I conceived new changes to ring upon the ancient comicalities concerning the jealousies of soprano, tenor, and basso.

My own home became a hunting ground. My wife is a singularly feminine creature, candid, sympathetic, and impulsive. Once her conversation was my delight, and her ideas a source of unfailing pleasure. Now I worked her. She was a gold mine of those amusing but lovable inconsistencies that distinguish the female mind.

I began to market those pearls of unwisdom and humor that should have enriched only the sacred precincts of home. With devilish cunning I encouraged her to talk. Unsuspecting, she laid her heart bare. Upon the cold, conspicuous, common, printed page I offered it to the public gaze.

A literary Judas, I kissed her and betrayed her. For pieces of silver I dressed her sweet confidences in the pantalettes and frills of folly and made them dance in the market place.

Dear Louisa! Of nights I have bent over her cruel as a wolf above a tender lamb, hearkening even to her soft words murmured in sleep, hoping to catch an idea for my next day's grind. There is worse to come.

God help me! Next my fangs were buried deep in the neck of the fugitive sayings of my little children.

Guy and Viola were two bright fountains of childish, quaint thoughts and speeches. I found a ready sale for this kind of humor, and was furnishing a regular department in a magazine with "Funny Fancies of Childhood." I began to stalk them as an Indian stalks the antelope. I would hide behind sofas and doors, or crawl on my hands and knees among the bushes in the yard to eavesdrop while they were at play. I had all the qualities of a harpy except remorse.

Once, when I was barren of ideas, and my copy must leave in the next mail, I covered myself in a pile of autumn leaves in the yard, where I knew they intended to come to play. I cannot bring myself to believe that Guy was aware of my hiding place, but even if he was, I would be loath to blame him for his setting fire to the leaves, causing the destruction of my new suit of clothes, and nearly cremating a parent.

Soon my own children began to shun me as a pest. Often, when I was creeping upon them like a melancholy ghoul, I would hear them say to each other: "Here comes papa," and they would gather their toys and scurry away to some safer hiding place. Miserable wretch that I was!

And yet I was doing well financially. Before the first year had passed I had saved a thousand dollars, and we had lived in comfort.

But at what a cost! I am not quite clear as to what a pariah is, but I was everything that it sounds like. I had no friends, no amusements, no enjoyment of life. The happiness of my family had been sacrificed. I was a bee, sucking sordid honey from life's fairest flowers, dreaded and shunned on account of my stingo.

One day a man spoke to me, with a pleasant and friendly smile. Not in months had the thing happened. I was passing the undertaking establishment of Peter Heffelbower. Peter stood in the door and saluted me. I stopped, strangely wrung in my heart by his greeting. He asked me inside.

The day was chill and rainy. We went into the back room, where a fire burned, in a little stove. A customer came, and Peter left me alone for a while. Presently I felt a new feeling stealing over me—a sense of beautiful calm and content, I looked around the place. There were rows of shining rosewood caskets, black palls, trestles, hearse plumes, mourning streamers, and all the paraphernalia of the solemn trade. Here was peace, order, silence, the abode of grave and dignified reflections. Here, on the brink of life, was a little niche pervaded by the spirit of eternal rest.

When I entered it, the follies of the world abandoned me at the door. I felt no inclination to wrest a humorous idea from those somber and stately trappings. My mind seemed to stretch itself to grateful repose upon a couch draped with gentle thoughts.

A quarter of an hour ago I was an abandoned humorist. Now I was a philosopher, full of serenity and ease. I had found a refuge from humor, from the hot chase of the shy quip, from the degrading pursuit of the panting joke, from the restless reach after the nimble repartee.

I had not known Heffelbower well. When he came back, I let him talk, fearful that he might prove to be a jarring note in the sweet, dirge-like harmony of his establishment.

But, no. He chimed truly. I gave a long sigh of happiness. Never have I known a man's talk to be as magnificently dull as Peter's was. Compared with it the Dead Sea is a geyser. Never a sparkle or a glimmer of wit marred his words. Commonplaces as trite and as plentiful as blackberries flowed from his lips no more stirring in quality than a last week's tape running from a ticker. Quaking a little, I tried upon him one of my best pointed jokes. It fell back ineffectual, with the point broken. I loved that man from then on.

Two or three evenings each week I would steal down to Heffelbower's and revel in his back room. That was my only joy. I began to rise early and hurry through my work, that I might spend more time in my haven. In no other place could I throw off my habit of extracting humorous ideas from my surroundings. Peter's talk left me no opening had I besieged it ever so hard.

Under this influence I began to improve in spirits. It was the recreation from one's labor which every man needs. I surprised one or two of my former friends by throwing them a smile and a cheery word as I passed them on the streets. Several times I dumbfounded my family by relaxing long enough to make a jocose remark in their presence.

I had so long been ridden by the incubus of humor that I seized my hours of holiday with a schoolboy's zest.

My work began to suffer. It was not the pain and burden to me that it had been. I often whistled at my desk, and wrote with far more fluency than before. I accomplished my tasks impatiently, as anxious to be off to my helpful retreat as a drunkard is to get to his tavern.

My wife had some anxious hours in conjecturing where I spent my afternoons. I thought it best not to tell her; women do not understand these things. Poor girl!—she had one shock out of it.

One day I brought home a silver coffin handle for a paper weight and a fine, fluffy hearse plume to dust my papers with.

I loved to see them on my desk, and think of the beloved back room down at Heffelbower's. But Louisa found them, and she shrieked with horror. I had to console her with some lame excuse for having them, but I saw in her eyes that the prejudice was not removed. I had to remove the articles, though, at double-quick time.

One day Peter Heffelbower laid before me a temptation that swept me off my feet. In his sensible, uninspired way he showed me his books, and explained that his profits and his business were increasing rapidly. He had thought of taking in a partner with some cash. He would rather have me than any one he knew. When I left his place that afternoon Peter had my check for the thousand dollars I had in the bank, and I was a partner in his undertaking business.

I went home with feelings of delirious joy, mingled with a certain amount of doubt. I was dreading to tell my wife about it. But I walked on air. To give up the writing of humorous stuff, once more to enjoy the apples of life, instead of squeezing them to a pulp for a few drops of hard cider to make the public feel funny—what a boon that would be!

At the supper table Louisa handed me some letters that had come during my absence. Several of them contained rejected manuscripts. Ever since I first began going to Heffelbower's my stuff had been coming back with alarming frequency. Lately I had been dashing off my jokes and articles with the greatest fluency. Previously I had labored like a bricklayer, slowly and with agony.

Presently I opened a letter from the editor of the weekly with which I had a regular contract. The checks for that weekly article were still our main dependence. The letter ran thus:

DEAR SIR: As you are aware, our contract for the year expires with the present month. While regretting the necessity for so doing, we must say that we do not care to renew same for the coming year. We were quite pleased with your style of humor, which seems to have delighted quite a large proportion of our readers. But for the past two months we have noticed a decided falling off in its

quality. Your earlier work showed a spontaneous, easy, natural flow of fun and wit. Of late it is labored, studied, and unconvincing, giving painful evidence of hard toil and drudging mechanism. Again regretting that we do not consider your contributions available any longer, we are, yours sincerely,

THE EDITOR

I handed this letter to my wife. After she had read it her face grew extremely long, and there were tears in her eyes.

"The mean old thing!" she exclaimed indignantly. "I'm sure your pieces are just as good as they ever were. And it doesn't take you half as long to write them as it did." And then, I suppose, Louisa thought of the checks that would cease coming. "Oh, John," she wailed, "what will you do now?"

For an answer I got up and began to do a polka step around the supper table. I am sure Louisa thought the trouble had driven me mad; and I think the children hoped it had, for they tore after me, yelling with glee and emulating my steps. I was now something like their old playmate as of yore.

"The theater for us to-night!" I shouted, "nothing less. And a late, wild, disreputable supper for all of us at the Palace Restaurant. Lumpty-diddle-de-dee-de-dum!"

And then I explained my glee by declaring that I was now a partner in a prosperous undertaking establishment, and that written jokes might go hide their heads in sackcloth and ashes for all I cared. With the editor's letter in her hand to justify the deed I had done, my wife could advance no objections save a few mild ones based on the feminine inability to appreciate a good thing such as the little back room of Peter Hef-no, of Heffelbower & Co's. undertaking establishment.

In conclusion, I will say that today you will find no man in our town as well liked, as jovial, and full of merry sayings as I. My jokes are again noised about and quoted; once more I take pleasure in my wife's confidential chatter without a mercenary thought, while Guy and Viola play at

my feet distributing gems of childish humor without fear of the ghastly tormentor who used to dog their steps, notebook in hand.

Our business has prospered finely. I keep the books and look after the shop, while Peter attends to outside matters. He says that my levity and high spirits would simply turn any funeral into a regular Irish wake.

O. Henry is the pen name of William Sydney Porter, born in Greensboro, North Carolina, in 1862. In 1894, Porter was accused of embezzling bank funds and was committed to a federal penitentiary, where he began his writing career. Although he published fourteen collections of stories and garnered worldwide fame, his life ended in poverty and alcoholism in 1910. In 1918, the O. Henry Memorial Awards were established, given annually to the best magazine stories of the year.

14

I Am a Writer

Kelly Cherry

I AM A WRITER. I write those words—"I am a writer"—just like that, as if it were as easy as that, or as if it mattered. It has not, in truth, been easy, but it does matter. I *trust* that it matters *literarily,* but I *know* that it matters *literally.*

The house in which I am writing is set in the middle of an arboretum; if you don't know to look for it, you're not likely to find it. The postman refuses to deliver packages to the door: too long a hike, too many mosquitoes. I don't mind. I welcome the solitude, the temporary lull in my life.

Why do I sit here writing? What earthly purpose does my writing serve? For a moment, let's set aside the conventional answers. The conventional answers include communication (as of an idea), aesthetic gratification (the reader's, or just the writer's), even art for art's sake. Let's even set aside the work's own demand to be brought into being. All of these are true answers but do not go beyond the specific case. We're seeking something deeper, something broader on which the whole of literature is based. Well, as you can guess, it's not for money. Some few writers do earn newsworthy incomes, of course; not very many serious ones do, and hardly any innovative ones do. A few more earn sufficient incomes because they were brought along by publishers when the publishing industry was willing to think of an advance not as a down payment on subsidiary rights but as an

investment in an author's career; these writers were given time to develop a steady readership. Most of us, if we depended on our writing for an income, couldn't keep body and soul together.

Not long ago, as I was feeling very tired, I decided to figure out how many words I'd written in the past ten years alone. It came to one million finished words, or minimally five to ten million draft words, or one million draft words every one to two years, not counting personal and professional correspondence and research notes. I teach full time. When I teach fiction writing, I average, per semester, three thousand pages of student manuscripts to read and mark in sentence-by-sentence detail. That is excluding non-degree students, independent study tutorials, and the odd novel in the anonymous knapsack. Like most writers, I also give readings, serve on panels, do workshops, apply for grants—a series of time-consuming steps that might be called The American Literary Soft-Shoe Shuffle.

Looking at those figures made me proud, but also tireder. I kept thinking how, if I were a different kind of writer, or perhaps Joyce Carol Oates, they would have added up to 730 books, all published, instead of 9½, of which 4 have been published and 5½ are in my desk drawer. But my case—this specific case that is mine—is no different from any other writer's; what I do and experience professionally is no different from what other writers do and experience. This is not just my life; it's a writer's life, and after all, a writer doesn't just choose it; clearly, she does anything she can to be allowed to live it, including—frequently with the secretly compelling sense of being a bit of an adventurer—throwing the rest of her life completely out of alignment.

So. The question returns. Why?

Why does anyone consent to the emotional, financial, spiritual, and even physical contortions that are necessary in order to lead the writer's life in America today? There are almost no grants. Only a few serious writers receive large advances; often, there are no advances at all. But we are blockheads, Dr. Johnson, who would write, who do write, for free! We would give our work away! Yet all too often, manuscripts filed in our desk drawers remain in our desk drawers. We write, most of us writers,

without hope of publication or comprehension, happy and grateful when they come but not daring to assume either. We give our lives to our work. Even my dog, who wishes I'd stop this thing I'm doing and come play with him, puts his front paws in my lap and looks up at me, asking, Why?

The answer's as close on the question's heels as Duncan is on mine.

The answer is, *For the same reason I am telling you what my life as a writer is like.*

You had, most probably, no idea who I am; now, like it or not, you're stuck with an idea of me. Not necessarily—though possibly also—an idea of mine, but necessarily an idea of me. You now know that there exists at least one person with the inner dimensions I have described. You may or may not be interested in my life, but that's not the point; and I might have lied—but I haven't. The point is simply that you are now obliged to recognize the writer of this piece as a conscious being.

We are all of us poets and storytellers, making literature of our lives, and when we listen to one another, we learn, through that exercise of the imaginative faculty, that this planet is a reality in at least more than one mind.

A writer is someone who makes the tracks of her mind's thinking visible for anyone who wants to follow her. This doesn't mean she is limited to autobiography; far from it. She *can* imagine the imaginations of others, even the imaginations of imaginary people, called characters or personae.

Critics, we may say, are census-takers.

But the writer knows that these imaginary constructs are dependent for their being on language. Therefore she agonizes over her verbs; she frets over her nouns; she restructures her sentences, paragraphs, scenes—and still she can't help knowing that no matter what she finally decides, everything hinges on whether it's Tuesday or Wednesday, and what she ate for breakfast. The only way I can say I sit *here* writing is *by* writing. Writing locates the *here,* and by unavoidable implication, a *there.*

I stand and stretch, look out the kitchen window. With the porch light on, I can see black oak, white oak, bur oak, black cherry, and shagbark hickory. Arrowwood and elderberry bushes are clumps of shadow;

flowering raspberry surrounds the house. Asleep or skittering at the edges of the lawn are possums, foxes, rabbits, woodchucks. I can hear the shy whistle of the phoebe and the evening flute concerto of the woodthrush, and in the distance, the low thrum of Beltline traffic.

I turn back to the kitchen. The lighted fish in the aquarium are living their silent lives. Do you know that the female swordtail has no tail? That, deprived of a mate, she may change her sex?

Black oak, white oak, bur oak, black cherry, and shagbark. These trees, whether or not they grow *really,* independent of perception, now grow in your brain. I've planted them there; my words are seeds. We are rooted in our language. Whether or not this world exists independently of our consciousness is a question for the idealists and the empiricists still to debate; but your consciousness of my consciousness has unquestionably grown. It buds; it will leaf.

The world is populated by people who become human through their imaginative awareness of others' inner lives. It is the writer who works hardest to heighten, provoke, prod, even create, germinate and engender that awareness. What joy, what privilege!—to be so essential to existence. This is the writer's earthly purpose and her cause, which she serves gladly, in any circumstances, with a sense of its utter and transcending importance. That's why I said "matters." That's why I said "literally." In the beginning *is* the word.

Kelly Cherry is the author of more than a dozen books of fiction, poetry, and creative nonfiction, including *Writing the World, The Society of Friends: Stories,* and the critically acclaimed memoir *The Exiled Heart.* Her fiction has been represented in *Best American Short Stories, Prize Stories: The O. Henry Awards,* and The Pushcart Prize. She has received the James G. Hanes Poetry Prize of the Fellowship of Southern Writers and is Eudora Welty Professor Emerita of English Literature and Evjue-Bascom Professor Emerita in the Humanities at the University of Wisconsin, Madison.

15

Writing as Practice

Connie Zweig

I NEVER DREAMED of becoming a writer. I didn't fantasize about creating the great American novel or winning a Pulitzer for investigative journalism. But life or fate or the gods, whatever we call the great mystery, led me by the nose to the writing life.

In 1981, after having left a spiritual community in deep disillusionment, I met Marilyn Ferguson, recently crowned queen of the Aquarian conspiracy, and we felt an immediate kinship. Although I had no writing experience, she hired me to be the editor of her publications, _Brain/Mind Bulletin_ and _Leading Edge,_ which explored innovations in consciousness research.

I vividly recall the first day on the job: I sat at the terminal, blank mind facing blank screen—paralyzed. But as I began to take assignments, become engaged with research, and articulate exciting ideas, I found that journalism fit my temperament: I fully enjoyed gathering information, seemed to have a gift for synthesizing it, and thrilled to the thought of transmitting it to others.

Then I submitted it to my editor. Marilyn took a red pencil and deleted or altered every word. The text returned to me unrecognizable. My heart sank. She demanded a dense and telegraphed style in order to jam information into a small space. But it could not remain abstract and

remote; the verbs needed to carry it off the page. And it could not show a trace of me; in the objective voice, the subject disappears.

As a novice, I was eager to learn. So, I submitted and rewrote . . . and rewrote . . . and rewrote. Finally, an article was accepted. And the process began again on the next piece. I heavily researched a topic; synthesized various sources; quoted a range of points of view; uncovered a key conclusion. And she marked it up in bright red.

One evening, at the terminal for a typical ten-hour day, tears running down my cheeks, I was about to give up. I felt hopeless: I would never become a journalist, and I certainly would never please this woman. And yet . . . I had felt such joy in finding just the right word to make a sentence fly. I had felt such gratification in hearing from satisfied readers.

Suddenly, I remembered a story from the Tibetan Buddhist tradition: a solitary monk named Milarepa lived in the woods on nettle soup and practiced meditation day and night. For many years he tried to attain realization, but his fasting and prayers were not enough. One day another man, Marpa, emerged from the woods and their eyes met: Milarepa felt an instant kinship and recognized Marpa as his teacher.

Marpa asked him to build a small stone house in a certain corner of the woods, "over there," then disappeared among the trees. For the next year, Milarepa gathered stones, one by one, lifted them slowly and carried them to the site. Then with painstaking attention he fit them together until they formed a sturdy structure.

Marpa emerged from the woods, glanced at the stone house, turned his back on it and, pointing in another direction, said, "Oh, no, over there!" Then he wandered off into the forest. Milarepa's heart sank. But he set about his task as if he had no choice. He began to take apart the house stone by stone, carry each one to the other site, lift it and fit it into place. A year later, he stood back and viewed the house with a sense of satisfaction at completing the task.

Just then, Marpa returned, approached the house, shook his head, and proclaimed, "Oh, no, over there!" as he pointed in a third direction.

Again, Milarepa submitted. Again, he took apart what he had built and carried the stones to the new area. Again he fit them together until

the house stood once more. And again Marpa appeared, shook his head and pointed "over there."

After Milarepa rebuilt the house that time, the story goes, he became enlightened. I stared at the terminal, tears dried, smiling. I had believed that only my meditation was spiritual practice. But clearly the work of writing and rewriting could also teach me about unattachment, impermanence, and discrimination. I began to write as if setting words in a sentence were setting stones in a house. I wrote as if my awareness of the writing process were more important than the content of the writing. To my surprise, I saw fewer red marks; the writing got better!

Soon I discovered another key: I would do intensive research, then sit down to meditate for an hour, emptying my mind, relaxing my body, letting go completely of the writing project. When I would return to the terminal, words would flow from me in an easy river, no struggle. Slowly, I learned to trust this process: filling the mind, emptying the mind, getting out of the way. And the red marks disappeared.

This cycle of life was over. But the writing life had just begun.

Connie Zweig, Ph.D., coeditor of the best-selling *Meeting the Shadow* and coauthor of *Romancing the Shadow,* is a Jungian-oriented therapist in West Los Angeles. Her forthcoming books, *The Moth to the Flame* (fiction) and *The Holy Longing* (nonfiction), explore the human yearning for the divine.

16

Writing as a
Healing Art—
Two Stories

Laura Cerwinske

I AM A WRITER, artist, teacher, dancer, and student of psychology and metaphysics. An insatiable communicator, I am always seeking reflection—in language, imagery, and movement. I thrive on creativity and exploration. I've built my life and my career around these pursuits.

At the age of forty-five, however, after decades of prolific production, relentless financial struggle, and an exceptionally arduous single motherhood, my ambitions loomed tantalizingly near, but perpetually out of reach. I found myself dispirited and debt-ridden, frustrated and fatigued. Seeking comfort under a blanket of futility, I took to bed.

Months later, I unintentionally found myself taking a course on shamanism. A friend had shoved the money for the first class into my fist and said, on the spur of the moment, "Go!" Long interested in intuition and power—the foundation of shamanism—I enrolled. Only after I was completely won over by the teacher did I realize the twelve others in the class believed themselves to be taking a writing class.

As a professional writer, I had already published a dozen books and hundreds of magazine articles. Writing had always come naturally

and easily to me. Writing was how I made my living. Big deal—a writer. Writing meant hours at a desk, pain in my shoulders, paltry income, endless hustling, and relentless deadlines. The last thing I was interested in was a writing class.

The teacher—the shaman, to be precise—was an exquisitely literate and vivacious Cuban woman named Alina Pantera. She taught a stream-of-consciousness writing technique that was non-documentary and far more focused, narrative, and exaggerated than the journal-type writing that many of the other students had, at one time or another, already practiced. Listening vaguely to their instructions, I rolled my eyes wearily, thinking, "It's no use," an expression that had become my mantra.

"Write about 'It's no use,'" said Alina.

"Why bother?" I shrugged. "It's no use." And for the entire first year of her class, I refused to write. The day Alina said, "Your power is in your anger. Your anger is money in the bank. Your anger is your gold," was the day I started writing.

Anger was something I knew a lot about. And something I'd seldom been allowed to express. My mother, a virtual Doris Day full of smiling radiance and understanding, had raised me in the school of "If you don't have something good to say, don't say anything at all." And when I did manage to vent some venom, I'd be compared to my aunt, the one who was a walking reservoir of negativity and bias.

An intelligent woman with great wit, a green thumb, and an enormous love for animals, this aunt was also a devoted writer whose greatest dream in life was to publish her regrettably maudlin children's stories. Unhappily, she preferred venting her negativity to developing her social skills and, as a result, managed to alienate, at one time or another, just about every family member, neighbor, and friend who ever came near her. She also suffered from chronic fatigue and an ongoing psychosomatic virus and lived an enormous amount of her time in bed.

The specter of being just like my aunt loomed heavily, and I spent a good deal of my life subconsciously resisting becoming her. But the truth was that I was a churning, burning cauldron of suppressed rage and paralyzing fatigue. Whereas my aunt was a noxious gas leak, I was a steam

engine ready to derail in a toxic explosion. And like all good girls and boys who swallow their rage, I subconsciously drew exactly the people and circumstances into my life that would vicariously express it for me.

Anger = power? Anger = money in the bank? Anger = gold! Alina had snared my interest. The one thing I was more than willing to write about was rage. I wrote for days and weeks and months about chronic financial pressures, PMS, my son's temper, my perpetual edginess, my relentless annoyance with my mother, my guilt about my perpetual annoyance with my mother, more about money pressures, frustration with my publishers, exasperation with men, and on and on and on. A lifetime's worth of little girl/teenage girl/young woman/single mother's rage, fear, grief, need, desire, and confusion. No wonder I had been afraid to vent. Once started, I feared it would never stop.

So where did all this wallowing in the mire of a lifetime's emotion get me? Wouldn't I have been better off spending that energy putting on a sunny face, doing volunteer work, or just getting on with life?

The answer lies in two words: *truth* and *liberation*. The result is manifested in *healing* and *power*. The more I wrote out my suppressed feelings, the more I gained insight, detachment, and an increased sense of power over my life. I noticed that with the writing, I breathed deeper and was growing more aware of how the anger sabotaged my body. The more imagination I allowed to pour into the written scenarios, the stronger I felt. Eventually, the pervasiveness of my anger and confusion diminished, and I developed a clearer sense of direction in my life. My problems didn't necessarily disappear, but their hold on me diminished. I became more able to appreciate the privilege of my life and gained a more confident view of the future. My creativity flourished, and I was able to enjoy it in a way I'd never been able to before.

* * *

In the summer of 1996, I sat down to begin a passionate book about the transforming power of self-expression and conscious descent into inner chaos, *Writing as a Healing Art*. Soon, however, I realized that I needed to get away from my desk, my studio, and my house in order to

concentrate. Each of these stations had long and well served my various careers as artist, writer, and teacher, but, for this particular project, I needed remove. I needed my own private Yaddo.

With one phone call—to the architect Michael Graves, a longtime friend—I secured the ideal retreat. Michael was going out of the country for several weeks and his entire Princeton two-story house, known as The Warehouse, could be mine for the duration. I packed up everything but my dogs and cats and headed north.

The Warehouse was constructed as a storage facility in 1926 by Italian stonemasons. By the time of my encampment, it was renovated by Michael into a gracious villa with wisteria-covered terrace, beautiful library, and, best of all, rooms filled by day with sunlight and a soft, quiet darkness by night.

I chose a second-floor bedroom as my sleeping sanctuary and established my writing desk in the breakfast room, under a two-story-high skylight. For hours on end my improvised writing table was bathed in a shadowless ambiance. This was extremely fortuitous, as I was returning to the deep shadow work of inner chaos and the psyche, and the atmosphere literally kept me alight. The Warehouse was a gentle prism of skylights and divided lights.

Princeton has, I believe, some of the most beautiful trees in America—willows bending like ballerinas *en reverence*, statuesque elms, and magnificent centuries-old poplars and oaks. I remember a summer road trip from my childhood, when, as we passed near Princeton, my mother pointed out the Joyce Kilmer National Forest and recited the poet's words, "I think that I shall never see/A poem lovely as a tree." I could easily perceive his inspiration in the sweep of leaves and branches extending from Michael's garden through the public park adjoining the property. Thus, when I tired of words, I could walk outside to savor the dappled illumination. ("Thank God for dappled things," said another poet, Gerard Manley Hopkins.)

As the days of writing went by, I grew nomadic, moving with my laptop from one room, one corner, one chair, one light to another. Each location provided a different surge of energy or soothing of spirit. When

the weight of thoughts and meanings grew too heavy, I sought the leafy canopy of the garden outside the kitchen. When I needed animation, I sat under the wisteria-twined pergola to enjoy the parade of linear shadows cast by an alleé of sycamores.

By the end of my stay, I had accomplished all I'd intended. *Writing as a Healing Art* was begun—the structure formulated, the tone established, my confidence intact. Now the heat of composition lay ahead. The subtropical Miami light that fills my own house is suited for exactly that.

Still, it was hard to leave The Warehouse—the blond Beidermeier furnishings, the silk embroidered rugs and polished wood floors, the bathtubs where I could stretch full length. Throughout my stay, I had been pampered with the grace of quiet illumination, and I was grateful.

Laura Cerwinske is an author and artist. She has published more than fifteen books on art and design, including the recent *In a Spiritual Style: The Home as Sanctuary* and *Writing as a Healing Art,* which she teaches in workshops throughout the world. Her forthcoming book, *The Choreography of Healing,* explores the healing and inspirational powers of dance, yoga, sex, figure modeling, and riding horses. Her body of artwork—primarily sculpture—is entitled *The Art of Fulfaggotry* and celebrates the worship of Beauty, Sensuality, Creativity, The Voluptuous, The Extravagant, and The Ridiculous. Visit her Web site at www.lcerwinske.com and enjoy a gallery and library of her work.

Of Goods and Goodwill

Celeste Fremon

As a journalist, I write primarily about social issues for magazines and newspapers, a career choice that certainly hasn't made me rich. I can pay my bills, but that's about it. Yet, I love what I do and, on occasion, I know I've genuinely made a difference. Not too long ago, however, my son informed me he wishes I had another job—any other job—as long I made a lot of money. "Why do you always want to save the world?" he began in a tone that could only be described as quarrelsome. "Why can't you write a book or something that, you know, makes a million dollars?" I started to tell him, if it was that easy everybody'd be doing it, but I stopped myself. This really wasn't the point.

The discussion took place when we were shopping at IKEA—one of those giant, discount furniture and household accessory stores—and Will was pointing out various items that he was positive we needed, each of which I declared beyond our budget. After a while, Will turned our request/refusal routine into a comedy act. "Oh great!" he'd wail after having spotted yet another swell IKEA product. "Here's another thing that would make our lives so-o-o-o-o much better, but we can't afford it because we're too po-or." (For dramatic effect, he pronounced "poor" in two elongated syllables.) That particular day, our quarrel was melted

away by humor. Other times, the fiscal bickering does not end on quite so chipper a note.

This past holiday season, for example, my son drove me somewhat round the bend with his conspicuously consuming tendencies. By mid-November, he'd begun campaigning for a gaggle of high-ticket gift items—a BMX Dyno bike, new snowboarding pants and jacket, and an absurdly expensive calculator. Moreover, he explained to me in earnest detail why such things were, in fact, not wants but needs.

"Next year, in the 9th grade, I'll be required to have a TI86," Will assured me with a completely straight face. (TI86 is the model number of the aforementioned overpriced calculating gadget of his dreams.) "Is that so?" I growled testily, then informed him I seriously doubted that the Los Angeles Unified School District forced its students to buy $120 calculators. "If I'm wrong," I added, "I'd be happy to consider home schooling." The conversation went downhill from there.

My grumpiness in the face of Will's ever-expanding wish list was not helped by the fact that, this particular Christmas, Ms. Santa found herself on a particularly tight financial tether, scrambling to produce even modest presents for my son and other family members—nieces, nephews, grandmas, and the like. Rest assured, I know how the non-neurotic parent would have handled the situation. The non-neurotic parent would calmly and lovingly explain to her adolescent offspring that, while she would always make sure his needs were filled, she was not on the same holiday budget as, say, Steven Spielberg. Secure in the knowledge that granting a child's every whim is rarely the road to good character, this non-neurotic parent would feel fine about denying her son a stupidly expensive calculator even though he was positive half of his friends had already gotten it for Hanukkah.

But I'm not the non-neurotic parent. In fact, it's lucky I don't have more blankety-blank money because, if I did, I probably would spoil my kid—to some degree anyway. My rationale would have to do with the fact that Will's dad, my ex-husband, had a cerebral aneurysm a few years after we divorced. The resulting damage to the left frontal lobe of his brain makes it unlikely that he will ever again hold a completely coherent

conversation with his son. No amount of increased buying power is going to magically fill this fundamental gap in Will's life. I know that. But when your child is hurting, it's hard not to try to smooth the fissures with whatever mortar you have at hand. Years ago, I used to scoff at divorced, weekend fathers who over-indulged their progeny's every whim. Now I understand. Oh, how I understand.

Okay, so here I was, smack in the middle of a near-terminal Christmas funk when two things occurred to change my perspective. Number one, a couple of my best friends reminded me that my birthday was fast approaching and offered to organize a festive lunch or dinner in my honor. I declined their kind offer with extreme prejudice, mainly because—and I don't pretend for a moment this is healthy—the thought of getting presents when my own cash flow was so anemic, made me feel even more depressed and irritable. Enter occurrence number two: the reality check.

This latter requires a little background: Over the last decade I've written a book and a series of articles about Mexican American street gangs. In the course of my research, I've befriended scores of homeboys—even going so far as to become the godmother to a couple of their kids. I've also come to know and care about many of their girlfriends, sisters and mothers.

So just as I was explaining to my own friends why I again intended to ignore the anniversary of my birth, I got an alarming telephone call. It seemed that one of the young women I knew best had completely disappeared. For months prior, Sophie had been having problems keeping herself afloat both emotionally and financially. Then on Friday, Sophie had asked another young woman to look after her children for the weekend. "So I can make some extra money," she said. But when Sunday rolled around, Sophie never came to reclaim her kids, nor did she call. As each subsequent day passed with no word, it was hard not to draw scary conclusions. To further complicate matters, Rose, the young woman caring for the three boys, was on the barest kind of public assistance and had by then run almost entirely out of money. In a panic, Rose called me for help. All three children had only the clothes they were wearing, she said, and the two-year-old was out of diapers. Was there any way I could send some cash?

Twenty or thirty dollars—the amount I could afford—was obviously not going to go very far. So what to do? Should I completely sacrifice my own kid's Christmas? Or should I turn my back on boys who might conceivably never see their mother again? (Did I mention that the diaperless two-year-old is one of my godchildren?) In truth, my son and I have all the basics: a nice house of our own, a nice car, a dog, a cat, and more computers than any two people need. These kids have nothing.

After a night of handwringing, I had an unlikely idea. I would go ahead with the birthday party—a potluck at my house. But instead of bringing presents for me, my friends could fork over money, clothes or toys for the three boys.

Although I was still terrified for Sophie, this notion of two-birds-with-one-party renewed my energy. Likewise, my friends responded with enthusiasm. In a season of mall and e-commerce fever, people seemed positively gaga at the opportunity to give where there was truly a need. Even Will got into the spirit of the thing. For a day and a half prior, he cheerfully helped me polish the silver, and whip up a snazzy array of hors d'oeuvres.

The evening itself was champagne-laden and joyful. The morning after the party, I loaded my car with giant bags of clothes and toys and drove to Rose's house in East Los Angeles, bringing with me an envelope stuffed with an impressive amount of cash. (Champagne, I learned, leads to generosity.) By that time, Sophie had surfaced, strung out and frightened—but not dead, thank you God. She agreed to enter a residential drug treatment program, and we got a line on some ongoing financial assistance for Rose so she can care for the kids while her friend gets well. "Sophie's been there for me when I needed it," Rose said when I told her I found her heroic.

Even my own monetary situation improved. One of my belated paychecks finally turned up in the mail and, by December 23, I was the proud possessor of a GT Dyno VRF bike with all the bells and whistles, including the de rigueur chrome finish. Hallelujah. In addition, I managed to locate some decent looking, hand-me-down snowboarder pants that actually fit my son. I learned that the new snowboarder jacket he's

been lusting after would go on sale in January, so I agreed to buy the thing then—on the condition that Will pay for half with funds he'd saved from his allowance. Interestingly, the process of finding solutions within our means seemed to please him. "That's what I'm talkin' about!" was, I believe, his exact comment as he gazed contentedly at a catalogue photo of his jacket-to-be.

Now that my bank account was healthy again, I picked up something for each of Sophie's boys, plus our other godbabies. It was Will's job to wrap those presents on Christmas Eve. The TI86 calculator would wait for some other year.

So what does all this add up to in the long run—morally and financially? Oh, I don't know. I'm probably raising a Republican. (And, for all you Republicans out there, I mean that in the nicest possible way.) But, then again, maybe not.

The other day, Will and I were having another one of our philosophical go-rounds. "Here's the deal," I said to him at one point. "I get paid to do what I love to do most, which is to write about things that I believe really matter. I'd like to make a lot of money, and maybe I will someday. If I don't, frankly that's okay with me." I also told him my writing had grown far deeper, better, more committed since he was born—because the mere fact of having him in this world helped me separate what was significant from what was not. I said I realized my choices sometimes made things hard for him. "But don't expect me to change any time soon."

Will was silent for a while. "Well, I'm going to do things differently," he said finally. "I'm going to make a lot of money doing work I really like. And I bet I even make the world better while I'm doing it!"

Flooded with motherlove, I slung an affectionate arm around my recently taller-than-I-am son. "May it be so, honey," I said. "May it be so."

Celeste Fremon is an award-winning journalist and the author of *Father Greg & the Homeboys*. This memoir first appeared on MSNBC, for which she is a monthly columnist.

At Its Best

Gail Ford

Below the me that pays the bills and does the wash
there is another me that swims in roiling waters.
I dip and roll and race and dive
and hurt and cower and hope.
Writing, at its best, paints in ink on paper
the currents and the waves where I can see them
and they can see me
as we shine or stink,
bulge or shrink
in the light of day.

In the normal course of days,
the sound of birds can go unnoticed.
Sometimes I stop. Go quiet.
Relax the muscles in my throat and solar plexus.
Listen with both ears. And the birdsong enters in.
Their music lands lightly on my tortured spirit.
Peeks and pecks and cleans away myriad knots

and seeds of pain. Writing, at its best,
reminds me where I've been.

When I take the time to let my shoulders drop,
relax the muscles below collar bone,
roll my pelvis slightly forward to effortlessly sit up
I find myself in the center of my chest,
rising and falling on each breath,
home again after having been long gone.
Writing, at its best, takes the wisdom
of my centered heart
and plants it on the page.

Mother, spouse, worker, daughter of an aging mother
I always have too much to do. And I have a body and mind
and soul and heart that each need careful tending.
Writing, at its best, is tiger's balm
worked gently deep and warm
into neck and shoulders gone as hard as rock.

Writing is a fishing line to catch my food.
A gadget box that holds my various
precious and unmatched pieces.
A way of breathing out.

A little bit like blinking.
Writing, at its best, washes out the grime,
gives my eyes a new and shiny surface,
enables me to look, then see
what's right there—there—in front of me.

Gail Ford is a poet, novelist, and short-story writer. She has been published in *The Ghost at Heart's Edge,* the *Crazy Child Scribbler, Northern Contours,* the *Baker Street Irregular, Chain of Life,* and the *Crockett Signal.* Gail is the founder and editor of *Broken Shadow Publications,* a small literary press. She lives in Oakland, California, with her husband, writer, and teacher Clive Matson, and their three-year-old son.

Of Starships
and Dragons'
Claws

Jeffrey A. Carver

TWO QUESTIONS READERS invariably ask me are "What kind of science fiction do you write?" and "How do you come up with these strange worlds?" They're surprisingly tough questions to answer, because interesting science fiction can be hard to categorize—and have unexpected origins.

Hard science fiction. Fantasy. Science fantasy. People want to know, which flavor of fantastic fiction do I write? And I'm left wondering: what do these terms really mean? Over the last dozen years, I have written novels containing elements of all of those flavors: *Dragons in the Stars*. (Fantasy? No, science fiction—but inspired by fantasy, and with real dragons.) *The Chaos Chronicles*. (Hard science fiction, inspired by chaos theory—but with a sharp focus on the inner life of the main character—and on the alien who becomes a part of him.)

So here's a question: Do spaceship consoles and dragons' claws really have anything in common? Can a book with spaceships and dragons truly be science fiction, much less hard SF? I'll tell you a bit about how I came to write these stories and let you decide for yourself.

The Star Rigger Universe is where it all began for me. I first fell down this particular rabbit hole more than twenty years ago, and I'm still writing about it today. It began with a short story, "Alien Persuasion"—my second professional sale, to *Galaxy*, a science fiction magazine. To my surprise, it became my entry into a new world, the universe of star rigging. (I don't remember for sure where the idea of rigging came from, but I may have been influenced by some early works of Samuel R. Delany. A friend, author Jane Yolen, once told me that she loved the idea of star rigging because it was such a clear metaphor for the creative, artist process. She was absolutely right!)

Starship rigging takes ships and people across the gulfs of interstellar space by traveling through a continuum known as the "Flux." In the Flux, space itself moves in currents and streams, and the rigger ship rides these streams like a sailing ship of old—all the while bypassing the staggering distances of normal space. The pilot or rigger must use visual imagery, in a process more art than science, to navigate the currents of the Flux—across oceans, through atmospheres and cyber-matrices, and even through mountains and vales—all as a way of riding the streams of space.

"Alien Persuasion" became the basis of a novel, *Star Rigger's Way*. In the novel, I gave far greater breadth to the art of starship rigging, and to the life of one Gev Carlyle, a bright but painfully innocent young man. I also wrote a scene set in a spaceport bar—typical SF scene, I suppose. A nameless rigger is drinking and bragging about "dueling with the dragons" along a certain route of the Flux. (Once again, memory is hazy. But I believe that the spark for this idea was the Cordwainer Smith short story, "The Game of Rat and Dragon," about the life of pinlighters, who kept starships safe from dragons during the planoforming period of star travel. If you haven't read Cordwainer Smith, you really owe it to yourself to find his stories.)

Why did I write that scene? I don't know; it was just a bit of local color to add realism. The assumption, at least by the characters in the story, was that these dragons were mere figments of the rigger's imagination.

As it turned out, that assumption was wrong. A couple of years later, I sat down to write a story about dragons for an anthology. The bar scene

came back to me—and before I knew it, I had the essence of a story in my head: the fateful encounter of a real dragon and a young woman starpilot, rigging along a forbidden route where dragons were said to lurk. That story, "Though All the Mountains Lie Between," so caught my own imagination that I later wrote another novel, *Dragons in the Stars,* delving deeper into the realm of these dragons who lived in the Flux. The sequel, *Dragon Rigger,* took me into the viewpoint of the dragons themselves, and also led me into a writing territory that melded science fiction with certain elements that *felt* like fantasy, even if they weren't. The books were science fiction—no question. But they were also mythical and fantastic, and interwoven with a great struggle of good versus evil.

And now? I've recently completed a new star rigger book that is much more like hard science fiction—bringing me full circle back to more familiar SF ground, with interstellar pirates, deep-cyber romance, galactic conspiracies, quantum physics, and . . . oh yes, a "Flying Dutchman" spaceship, lost in a strange limbo among the stars.

And yet this is not my hardest SF. To look at that, we need to move into a different universe, a realm of . . .

Chaos and Confusion

I began *The Chaos Chronicles* while casting about for a change of pace—and a shift to shorter novels. (The marathon of writing *Dragon Rigger* and several other very long novels had been exhilarating but exhausting.) What to do? Well, it seems I am both blessed and cursed by a storytelling mind that spins complex tales, and doesn't want to take "Keep it simple!" for an answer. And yet, "Keep it simple!" was exactly what I intended to do.

While browsing through some magazines, I came across an article in *The Planetary Report* about the chaotic movement of asteroids and comets under the gravitational influences of the planets. Aha! The seed of an idea was planted, and from there it was only a matter of fertilizing, weeding, and plenty of exposure to warm sunlight. (Well, okay, it was a

lot of dogged hard work and plenty of false starts, but you get the idea.) In the end, I had a story outline so complex it would take no fewer than four or five novels to tell it.

But what about my goal for simplicity? Well, if I found a way to tell the story in a number of shorter, more linear novels, I could have alien worlds galore, and still keep my vow to write short, write simple. I could have my complexity and eat it, too!

At least, that was the theory.

Maybe it was no coincidence that this storyline was inspired by another theory, the one called chaos. Chaos seemed to be at work in my own mind as I caromed through the possibilities, as I wrote the first novel of the series, *Neptune Crossing*. Chaotic movement of asteroids . . . deadly peril to the home planet if one of them should be flung Earthward . . . aliens of mysterious origin drawing an unwilling hero into sacrificial rescue of Earth. And some hero. The inside of John Bandicut's mind was practically a working definition of chaos. Partially disabled by a neurolink accident, the poor man was prone to hallucinatory interludes of "silence fugue"—and that was *before* the alien got into his head.

Simplicity . . . chaos!

A tug-of-war had begun that took us in the second novel to a bizarre alien structure outside our galaxy. That novel was titled *Strange Attractors,* drawing upon one of the most evocative images yet to come out of twentieth century chaos theory.

In the third book, we landed deep in an alien ocean, in *The Infinite Sea*. And the tug of war continues today, as I work on Volume Four of a series that now weighs in at six novels.

Six novels! (Keep it simple, Stupid.)

That'll be the day. I've got enough material here to keep me working well into the new millennium, and that's just what I intend to do.

Jeffrey A. Carver lives in a small part of the universe known as Arlington, Massachusetts. He is the author of fourteen science-fiction

novels, including *Eternity's End* and the novels of *The Chaos Chronicles*. He has taught science-fiction writing through satellite-broadcast television and in computer software. At his Web site (www.starrigger.net), you can learn more about him and his books, essays, short stories, recommended readings, advice for aspiring authors, and more.

20

True Sentences

Joe Balay

> One generation passeth away, and another
> generation cometh; but the earth abideth forever . . .
> The sun also ariseth, and the sun goeth down, and
> hasteth to the place where he arose . . . The wind
> goeth toward the south, and turneth about unto the
> north; it whirleth about continually, and the wind
> returneth again according to his circuits . . . All the
> rivers run into the sea; yet the sea is not full; unto
> the place from whence the rivers come; thither they
> return again.
>
> —ECCLESIASTES

as a young man growing up in los angeles, i lived on the top floor of a yellow dormitory. i got up in the mornings and went to class, studying faulkner and hemingway and joyce.

in the nights i would come home early to my typewriter and struggle with true sentences. i sat near the grey window and i smelled the thin los angeles sea and looked down below at the parking lot with pink lamps

and small bodies and spare trees. i studied the trees and i wrote short precise prose in their style.

it was difficult becoming a young writer in los angeles. the beauty surrounding me was different than it is in other places. it was urban and smoke-coloured and dirty. and i spent many days deciding whether to perceive the bums as insects or angels.

<p align="center">* * *</p>

tonight as i returned from the grocery store, i sat down on the sidewalk outside my apartment, and in the false light i made a picture. i used the dry summer leaves and the purple violets and a found piece of toilette paper. i made a face and with the wet stalk of the flowers i painted shadows and tears on it.

later, after i had come back up to the room, i struggled to write true sentences about the sidewalk. i struggled as hemingway had done in paris. but as i looked out my sad dented-in window, onto the familiar parking lot that existed below, and at the little lamps that bared pink, and on the trees that wrote spare prose, i knew that i was not in paris at all, and that i was struggling with something new. i was in los angeles at the death of an era.

i felt like a child sitting there in my grey pajama pants, on that sidewalk. i had not bothered to dress properly to go to the store for cigarettes. i examined the textures and the colours and the veins of the leaves. i touched a cigarette butt in the brown gutter. and when it was all done, i was sad i could not take it with me and i wondered if anyone would notice that little thing i had made on the sidewalk.

i do not know what i shall do tomorrow. in the morning the streetcleaner will come and wash it all away, like perhaps the waves, or the rain, or even death itself. and i fear that one day a giant will wash me away, before i can ever write a story or truly love a woman.

Joe Balay is a philosophy and writing student at Pepperdine University. The recipient of numerous writing grants, his work has been published in a variety of literary journals and anthologies. He is completing a book of poetry, to be published by Black Sparrow Press, but his true ambition is to wander the streets of Paris and London, living a writer's life.

Part Two

Memories and Inspirations from the Past

I write to understand as much as to be understood.
Literature is an act of conscience. It is up to us to
rebuild with memories, with ruins, and with moments
of grace.

—ELIE WIESEL

Much of my writing is energized by unresolved
memories—something like ghosts in the psychological
sense.

—JOYCE CAROL OATES

My student job was to file books away. . . . so I read
what I was filing. My great teachers (the best thing
that can happen to a writer) were Scheherazade,
Homer, Virgil, and Boccaccio; also the great Sanskrit
taletellers—just what a kid from the sticks, from the
swamp, in my case, needed.

—JOHN BARTH

From the time I was nine or ten, it was a toss-up whether I was going to be a writer or a painter, and I discovered by the time I was sixteen or seventeen that paints cost too much money, so I became a writer because you could be a writer with a pencil and a penny notebook.

—FRANK O'CONNOR

A would-be writer is supposed to have either a rich inner life or a rich outer one. I had neither. Still, I had to get material from someplace, and so I stole it, piecemeal, from my family.

—ELIZABETH MCCRACKEN

WHAT ARE THE SEEDS from which a writer's yearning grows? For the vast majority, the inspiration to write emerges from three formative stages in life: early childhood, early adolescence, and the first few years of young adulthood when a person leaves home, explores the world, or immerses oneself in education. Through all of these stages lies an urge to explain and understand our past, for all of our memories become more organized and clear when we place them into a narrative context.

For many authors, especially those who write fiction, a penchant for writing begins in their early years of life. Romance writer Collette Caron, for example, says that she became a storyteller at the age of four, when she recounted a tale to her mom. "She *laughed*," Collette recalls, "and so, at a very young age, I got a powerful message about the capacity of the story—words and imagination united—to relieve pain, to heal, and to bring hope." According to Newbery award-winning author Zilpha Snyder, she considered herself a writer at age eight. "I began as most children do with poems and very short stories, and I was fortunate to have a fourth-grade teacher who took an interest in what I was doing. She collected my works, typed them, and bound them into a book. I loved it—and her." In the case of Susan McBride, she actually completed three novels by the time she turned ten. "All I knew was that words came easy for me," she writes. "I actually looked forward to book reports and essays, and, if you started me talking about similes and metaphors, I wouldn't stop." To inspire young children to write, as the essays in this section make clear, all it takes is a little encouragement from an appreciative parent, teacher, or friend.

A traumatic experience can also induce a person to write, especially if one's freedom to speak is suppressed. Under such circumstances, as Lia

Scott Price reveals, writing can become an effective means for healing one's sorrow and pain:

> As a child with no voice of my own, in a country where children were to be seen and not heard, where the value of a child was determined by his or her sex, I turned to writing as my testimony to the cruelties of life that I suffered, to give a voice to such events and especially to my mother. I wrote down what I wished she would say, what I wished she would do, and how much I hated father. I wrote to God. I bargained with God. I made a list of promises and prayers. The pages of my diary were smeared with ink mixed with tears.

Fictional writing can also provide an outlet for overcoming repressive fears, as Freud pointed out nearly a century ago. "Every child at play behaves like a creative writer, in that he creates a world of his own, or, rather, rearranges the things of his world in a new way which pleases him," he wrote, which brings "a liberation of tensions in our minds." Because writing is primarily a private act, it affords us with a safe environment in which to express uncensored feelings and thoughts. By reflecting on the past, we reevaluate critical turning points in life—events, which if left unexamined, can impair our functioning in the world.

Reading other people's diaries can also be psychologically enriching, for it offers us a window into a writer's unconscious processes that are often similar to our own. Thus, it comes as no surprise that many authors trace their interest in writing to their adolescent years when they were exposed to the journals of Anaïs Nin, Anne Frank, Virginia Woolf, Sylvia Plath, and others. In this section, Janet Fitch's and Jenny Davidow's memoirs exemplify this influential force.

Poets, too, often trace their interest in writing to adolescent memories and events. Take, for example, John Fox's recollection, to which he credits the direction of his career: "I was thirteen years old, watching a girl skate at a rink in Shaker Heights, Ohio, and I decided to write my first poem—a torrent of words related to beauty, attraction, and risk. I wanted

my words to skate on the page and I sensed so much joy as I wrote." Tony Barnstone credits his family of writers and the poetry games he played growing up, while his father credits the Spanish poets he read and met in his early college years. "The chance mix that led me to poetry," Willis Barnstone adds, "contained four necessary ingredients. A notion of poetry. Loss of word and self. Wakening to soultalk recorded as a poem in order to conceal the terror of nothingness. And cheers of a few friends at my first pieces of verse." Essays by both Tony and Willis Barnstone are included in this section, providing a rare glimpse into the poetic person-alities of a father and his son.

Today, the use of diaries, journals, and poetry writing has become an integrated part of psychotherapy, for it offers individuals a unique oppor-tunity to reintegrate troublesome memories from the past. "Through the autobiographic process," Tristine Rainer writes in *Your Life as Story,* "you restore the 'romance' and 'fictional flair' of story to your own life, and you replace old stories of powerlessness with stories of consciousness and revelation in which you are the protagonist." Tristine is a television pro-ducer and the author of two books that encourage people to write about their inner lives, but when I asked her to write an intimate exposé for this volume, she balked. "Oh, I can't do that," she stammered. "That's way too vulnerable for me!"

I was shocked by the reaction of Tristine, who teaches autobiographical writing at several universities. "But it's what you're famous for," I replied.

"Yes it is, but I discovered on my path that I don't like to write about myself."

"I'd love you to include that in an essay," I suggested, "since most writ-ers *love* to write about themselves."

"It's too embarrassing."

"Great! Include that, too."

"I can't."

"Why not?"

She paused for moment then spoke. "Because somewhere inside there's still a little girl who has nothing to say or write. A little girl who felt so empty as a child that she compared her life to a fly."

"*That's* the story I want," I said, and so she agreed, using her auto-biographical technique to demonstrate how a person can use writing to work through shyness and fear.

Writing is a wondrous act—vulnerable but liberating as well. As you read through the stories that follow, think about struggles that each author has to face, and the thousands of pages—the false beginnings, the trite finales, and the mediocre middles—that lay scattered on the floor. These, too, are part of a writer's journey and life, a life—like everyone's—that is colored and shaped by the past.

21

My Grandmother
on My Shoulder

Erica Jong

A MEMORY FROM childhood drifts back through the synapses. I am lying in the big bed between my parents. Perhaps I am four or five. I have awakened with a nightmare and my sleepy father has carried me into bed and placed me between himself and my mother.

Bliss. A foretaste of heaven. A memory of the amniotic ocean—the warmth of my mother's body on one side and of my father's on the other. (Freudians would say I am happy to separate them—and maybe they are right—but let us shelve that question for now.) Suffice it to say that I am happy to be here in the primeval cave. Suffice it to say that I am bathed in the radiance of paradiso.

Back, back in time. I lie on my back and the ceiling seems a kaleido-scope of diced peas and carrots—nursery food—comforting and warm. My parents' mingled smells and mine. Family pheromones. Familiar smells out of which we are born. For the moment, there is no world but this, no siblings, no teachers, no streets, no cars. Eden is here between my sleeping parents and there is no banishment in sight. I deliberately hold myself awake to savor this heaven as long as I can. I fight off sleep to

savor the moment of *paradiso* threading through the *purgatorio* of every-day life, the *inferno* of school and sisters, of competitive sandbox wars, and the cruelty of other children.

This is where we all begin—in the paradiso of childhood. And it is to this place that poetry seeks to return us. Poetry and love. We seek them all our lives. The poles of our being—love and death: the parental bed and the grave. Our passage is from one to the other.

My grandmother on my shoulder is upset. She doesn't want me to write these things. She believes the course of wisdom in a woman's life is to keep silent about all the truth she knows. It is dangerous, she has learned, to parade intimate knowledge. The clever woman smiles and keeps mum. My problem is that books don't get written that way. Especially not books containing truth.

So we come back, inevitably, to the problem of women writing the truth. We must write the truth in order to validate our own feelings, our own lives, and we have only very recently earned those rights. Dictators burn books because they know that books help people claim their feelings and that people who claim their feelings are harder to crush.

Patriarchal society has put a gag on women's public expression of feelings because silence compels obedience. My grandmother thinks she wants to protect me. She doesn't want to see me stoned in the market-place. She doesn't want me pilloried for my words. She wants me safe so that I can save the next generation. She has a matriarch's interest in keeping our family alive.

Hush, Mama, the world has changed. We are claiming our own voices. We will speak not only for ourselves but also for you. And our daughters, we hope, will never have to kill *their* grandmothers.

Erica Jong, poet, novelist, and essayist, has authored twelve books and six award-winning collections of poetry. She has been awarded the Bess Hoskins Prize of Poetry, the Borestone Mountain Award for Poetry,

and many others. She has been awarded the Premio Internationale Sigmund Freud in Italy and the United Nations Award of Excellence. Known for her commitment to women's rights and free expression, Jong was named Barnard College's Woman of Achievement in 1987. Visit Erica Jong's Web site at http://www.ericajong.com.

Extracts from a Journal

Mike Minehan

I AM SITTING at the desk with the late afternoon light filtering through bamboo, the prism my mother gave me spinning rainbows in the warm drafts of sea breeze. Three dogs are sitting, waiting, eyes half closed, ready to stir at my next move. It is nerve wracking. Dare I reach out? I will die of thirst before I go to the kitchen bench and make coffee. I am waiting for the next interruption. I am so highly strung I may snap. Ping!

I cannot find the way to words. I am like the country I live in . . . dry. Parched. I am waiting for the storm.

* * *

If I had any courage at all I would go out there into the world of real people and read the poems aloud. But I cannot. No one seems to understand this. But you are a broadcaster—It must be easy for you!

How can I explain what the fear nearly did for me each time and that I ran home like a baby and shut the gates and crawled into my bed to hide?

* * *

Boredom. I am sick of myself and this relentless sitting. I walk from room to room. Out into the garden again to sit and look longingly at mountains. It is all too perfect. Too 'right.' A dream catcher hangs from a branch high in the pine tree, swaying lightly. And the birds did not take to the dripping this year. The sky is too blue. The tree surgeon says the poplars are 'perfect' and will last a few more years yet. And a daffodil pushes up through the rock hard earth. I would rather work up a storm than this fugue like state I'm in. I want a tempest. I want to rage. There is a poem working its way inside me. How can I free it? I long to scream but it would shake the universe and I may go mad. Madder?

* * *

I have decided I want to be an old woman in white sandshoes and a cardigan. That's that.

* * *

My mother hid her head when I wrote about her. But I can't stop. It was such a very strange time growing up amongst them all, stretched between two families. The only daughter of an only daughter belonging to no-one.

All those strong, mad women. And one gentle man . . . and I can never work out even now whether there is true strength in that kind of silence which turns away from anger. Or whether it is cowardice. It must have driven my grandmother crazy, all fired up as she was only to have my grandfather retreat back to the garden, the shed, the bush or lake. That frustration she felt would be directed first towards my mother, then later me. It bonded us when we at last felt able to talk about it. The convent for both of us was a refuge.

It is dangerous to move into this territory. It still sits like a canker.

Why then, do I long so for that grandmother of mine? And him, my rock?

Is it that I have never, will never grow up? That when I write of feeling five years old I really mean it?

* * *

Today is the day I write! Look! No hands!

I tell them to read, read, read. All the ones who would write. Look, I say . . . soon there will be no point at all in brave souls publishing poets. All there will be is a few museum pieces left. If you want to write, please read first! One day you may want, be good enough, brave enough to publish a book. Imagine how you will feel if no-one buys it! Libraries are killing poets up and down the country. Don't borrow . . . buy! I want you to read my poems. I am telling you something, wanting to share something very important about me, you, about us all. It's a very intimate thing, this. Don't you feel it too? (I actually don't beg them to buy but I feel like it! I feel like going down on my knees and praying that every woman who bought a woman's 'weekly' would buy one book of New Zealand poetry a year and save us all from the certain purgatory of remaindered copies.)

* * *

The person from Porlock comes. Actually a crowd of Porlockians plague my life. And dogs from Porlock too determined to quiet the writing urges.

But when I was left alone a few weeks ago I nearly went mad and couldn't write a word! I made lists. Each day was planned around writing. Music. Everything set and ready. The moment my husband left, and the car slowly disappeared up the road, I felt abandoned and I stayed that way, lost and fretful until he returned days later. I have lost the knack of being alone, and I need to have control.

The past is ours. Our place. I write of the past because I need to reclaim it for myself and my daughter and granddaughter. I am also making a claim for the women of my family who had no one to speak for them and who could not pen their lives except in letters now lost. I gave my mother a journal when she became very ill. Please, I said, write in this for me so that I can understand and know who you are, who you were. Through this long time of her dying she has written diligently in

the small curled writing I know so well. Stories and poems, songs and memories flow from my mother's pen until she has filled not one but many books. And amongst the pages, photos, death notices, and reviews she's kept of my scattered career, are souvenirs I never knew existed. One day a new parcel arrived and inside the covers of the journal was my grandmother's sea ticket from Capetown to Auckland in 1916 and my mind flipped backwards through time to imagine this real young woman so brave, traveling half way across the world to meet once more her soldier boy in a strange, strange land. Minus breasts, minus soon her womb. Fifteen siblings left in Durban and no child to be her own until she adopted my mother much later. I know why she went crazy now. And looking at the face of this pretty dark haired girl I can understand why, with her size three feet and bone china hands and soft smile, my grandfather fell for her and never strayed even when she became a shrew.

I write from the past into the present of my life knowing they are twinned and that I am as much a part of their lives as I am my own. The women of my family. The women who have been part of my life as friends and lovers. Somewhere in this is the answer to some profound question. Not who am I but *"why?"*

* * *

The first poems were written at a do-it-yourself desk which I made with help from my mother. I painted it lilac. (There is a story about lilacs. My grandmother always planted lilac outside the doors of the homes she lived in. I didn't know this until I was much older. My father wrote of this after she had died. It meant something to him. And to me, who had always planted lilac and been drawn towards it and I was then looking for some synchronicity with that elusive woman.) So there I sat at my homemade desk, reading from *Other Men's Flowers* and Dylan Thomas, and the *Oxford Book of English Poetry*—hardly a female voice among the lot. But feeling a kinship. Knowing my place at fifteen. A poet. But I was a still a girl and hiding the words in the end, tucking them into drawers, scrunching paper, chewing my pencil, dreaming of words, sentences, ways of saying and knowing even then, the chill of silences.

Later, when marriage had silenced me even further and that first touch of madness had descended I knew that writing could save my life. So in the twilight wards, in communes and houses up and down the country, I would pen into Saxon exercise books the addled thoughts that laid siege to me. They were miserable poems but they anchored the pain and transferred it. Safe on paper they could do me no harm. For years I carried the books around with me until, unable to bear the sadness of it all, & the grief I felt for that young woman, I burned them. I moved on.

* * *

This is the myth: That somehow out of a blank page words will appear. All that is required is time and perseverance. It is true though that you can only write by writing.

Mike Minehan is an award-winning poet, published widely in New Zealand and Australia. Her books include *No Returns, Embracing the Dark, Suicide Season,* and *Writing Lives—Ending Silences.* Mike lives in a small coastal village with her husband and two Jack Russell terriers.

23

The Capes of
Anaïs Nin

Janet Fitch

I GUESS YOU could say I'm a poster child for the endurance end of this venture/adventure of getting things down on paper. It took me twelve years to publish my first short story. Twenty-one to see my heart's desire, a literary novel, between hard covers. Somewhere along the line, I wore out my initial reason for becoming a writer, and found another.

What did it mean to me to become a writer in the first place? I was 21, taking my second junior year in England, and had already decided I would become an historian—history in fact containing most of the elements of good fiction writing: character, narrative, vividness of language, suspense. However, adventure seemed to be the missing note in the historian's life. Writers, on the other hand, (to my 21-year-old mind) lived the vivid life of their characters. I wanted to *live*.

Of course, I was thinking of Anaïs Nin in her capes and eyelashes, her lovers and friends, the multi-continental sweep of her life. Anaïs Nin, to me as to most bookish girls of my generation, represented the Woman Writer at her most glamorous and creative. She was our permission slip to enter the halls of literature with our dreaminess and our sexuality intact.

I was in junior high when I first discovered Nin. We'd had a substitute one day who insisted that there were no great women writers. (Unfortunately, at that time I was in the grip of a feverish Dostoevsky obsession, and had not yet heard of Virginia Woolf, or Edith Wharton, even Willa Cather, and I had not the wit to think of the Brontës.) But there was a girl in the front row, I'll always revere her frizzy ash-blond head, who raised her plump hand and said, "What about Anaïs Nin?"

The class fell silent. The substitute frowned, and suddenly turned a mental page, as adults will always do when confronted with unexpected information from children, telling us to open to page 201 of *20,000 Leagues Under the Sea.*

"Who is Anaïs Nin????" I sent a note up the line to Saint Femme. "Read her Diaries, they're so cool!!" the note came back.

And so cool they were. A woman not only living the most glamorous life, the kind we loved to experience through the biographies we greedily devoured, but more than that, a woman who wrote about it *herself.* A woman who was not somebody's model or girlfriend or actress-protegee, but an artist in her own right.

My friends and I worshiped Anaïs Nin. She made it possible to imagine being a woman writer, as Georgia O'Keeffe had made being a woman artist thinkable. You didn't have to write like a man, Anaïs said (this in the pre-feminist 60's when "thinks like a man" was still a compliment). Women had something to say that men had not yet thought about. She opened up the legitimacy of an entire subterranean world.

Yet I did not entertain the possibility of becoming a writer myself in those years. I had had a terrible experience when I was about nine, having written a long imaginative work entitled "Diamond, Horse of Mystery" told in a style blending my two favorite writers, Edgar Allen Poe and Marguerite Henry (of *Misty of Chincoteague* fame). I gave it to my fourth grade teacher, who never liked me much, as I was in the habit of finishing her sentences for her (she was a slow thinker and transparent as a guppy). She took a red Marks-a-Lot and corrected all the grammar, all the spelling and handed it back to me without a single comment on the narrative, the beautiful illustrations, the nicely developed characters.

I did not attempt creative writing again until my decision that rainy English winter I turned 21.

However, following Nin's example, I became a diarist. I commented on my life, being the only one in the least interested in it. I was an angry, alienated schoolgirl and massively read. In college, I gravitated to history, rather than English, because English seemed very analytical, where history was much more engaging, with its giant characters, its sweeping narratives, much more like *fiction*—though at the time, I was not aware that my interest in history was primarily literary.

I had pretty much determined I would become an historian—Russian history was my field, and Soviet particularly. But in my fourth year, I became restless. I still had to return to the US and write my senior thesis, and then face another four years at university, after which I would settle into teaching, and research, and writing things on notecards, and a lifetime of footnotes. *Ibid. Op cit.*

The desire to be a writer, meaning a fiction writer, meaning Anaïs Nin, welled up inside of me and finally blew its top. Here I was, finally having made it to Europe, and where was I? Sick, at school in the Industrial Midlands, with a superego nattering about my overdue papers. I woke up in the middle of the night and realized I didn't want to be an historian at all. I wanted to be a writer! I wanted to have Henry Miller as a lover, I wanted to be a character in my own novel. I wanted to make a mark on life, rather than making the mark for others, handmaiden of history.

I returned to the States for my senior year a budding writer. Because I had enough credits, I had only to take three classes: thesis in history, Math for Morons (sort of a math appreciation class for the Non Science Major) and Creative Writing. The writing class, taught by an affable, supremely lazy middle-brow poet I'll call Pete the Beat, did no harm and no good, the first of many such ventures. There were only two other fiction writers, so we formed our own cabal. All I can really remember of the course was that one of my brother fiction writers stated, "You can't be a novelist until you're 40," quoting some indisputable genius like Tolstoy. I wanted to disembowel him. Forty! It was a death sentence. I was 22, what the hell was I supposed to do in the meantime?

My passions, even as a small child, had always revolved around issues of memory. I wanted to be remembered, although I was an unremarkable person who was generally first to be forgotten in any situation. Part of my obsession with history as a field had been its mission of preserving the past, keeping things from oblivion. My diaries were a constant attempt to preserve my life from the maw of universal indifference. In choosing to write, I'd found an avenue where I could make a mark on the world, to key its elegant sedan if nothing else, to write Kilroy Was Here on a bomb-crater at Montecassino. "Without a trace" was the phrase to send me into shockwaves of narcissistic terror.

The problem with my attempts to Be a Writer, in those early years after college, was that in the midst of having adventures and romantic complications and imbibing a variety of substances, I was usually too emotionally overwrought or whacked-out to create anything substantial. It was a paradox. I could live the Writer's Life as I saw it, gaining material for art, or I could sit down and write. But where was the transition between the Writer's Life and writing?

Eventually, I had to release the idea of the glamourous Writer's Life in favor of a steady boyfriend and more disciplined writing, but now the stories I did write all came back. Off I sent my little stories, off to school, hopeful, socks falling down, like a stream of first-day-of-kindergarten children, fearful and eager to be loved, only to have them return, crying and snotful and bullied, hating the world. I came to hate and love the distant priesthood of the literary journals, their mysterious criteria, acceptance periods, unseen editors and readers. What writer doesn't know the scene of fetching his or her precious story from the mailbox and then brooding over the rejection slip, analyzing it with a heightened sense of meaning that borders on the Kabbalistic—how long it took, the wording, was there a handwritten message? Rereading cryptic notes, wondering, *what does it mean?* "Good story," one editor wrote, "but what's unique about your sentences?" My *sentences?* What did he want, all the adjectives at the end?

Someone suggested I should try screenwriting, it was easier and you got paid. I tried it. I even went to film school for a half of one semester. It

was not easier, not for me—my stories were nothing if not digressive—and I never got paid. So I went back to fiction, scrying the entrails of my rejection notes.

The years went on. The mediocre writing classes, the groups of variously talented writers. The desire to make that mark heightened to desperate pitch after two, four, six years of failure. I had to justify my sufferings and to get revenge on those who have deprived me and make it up to those who have suffered along with me.

The frightening fact remains that aside from one's writer friends, *nobody cares if you write or not.* And that is the truth. Nobody but you cares whether you will ever make your mark. Nobody else gets to make their mark—what makes you think you're so goddamn special?

Of course, if I try to be fair, when I contemplate the hysteria and depression and angst involved in being a writer at the point of constant rejection, the paranoia and anger and then the acting out in a million negative ways, I think it's understandable that the people closest to you secretly *do* wish you'd quit. Then you'd maybe be more cheerful, and get a decent job, and be more available to meet their needs, instead of being so morose and furious and paranoid, not to mention under-employed. But from the writer's point of view, it doesn't make it easier to know the whole world is against you.

Let's talk about those years of feeling like a worthless piece of crap, of telling people I was a writer and then being asked, "Oh? What have you published?" and have to lie, or just punch them in the face. For twelve years, at a clip of a rejection a week, I endured.

I finally got it about year nine or ten that there was a very distinct possibility I would never sell anything as long as I lived. That I would never make a mark, that I would live and die and disappear without a trace, like everybody else. It was Dante's dark wood, the black night of the soul.

If I was never going to be published, why bother to write? What was I killing myself for, if nothing was ever going to happen for me? Because I was used to it? Because I knew how to do it?

Because in a weird and oddly masochistic and obsessive way, I *liked* it. Because what would I do with my obsessions and unlived lives if I couldn't exorcize them on the page? Go quietly insane?

So there it was. Somewhere in those years, I had become a writer. What had started out of ambition, a means to an end, had become the end. The desire to write had outlasted the need to live a glamorous life, and my own raging ambition. I wrote because it was what I did. I wrote because I had free will and this was the way I chose to exercise it, whether anybody wanted me to or not. Even if I never sold anything as long as I lived, I could at least live my life doing what I wanted to do, and what was that worth?

I can't say it took all the angst out of writing. I still wanted to get into print, but it brought me to value myself and my writing above the product. I started to look at what I still needed to learn, rather than feeling self-righteously outraged about being better than many writers who were being published regularly. I began to be published. I stretched. I failed. An agent offered to represent me, when and if I ever had a novel. *But what's unique about your sentences?* I wrote a novel. It failed. I wrote another novel. I still owe the publisher money on it. At last I found a teacher, a good woman and a hard one, let's call her Bloody Mary, who set me to wrestling with the angels of language and let me know in no uncertain terms exactly how, where and when my sentences stunk. Rather than poring vengefully over my rejection slips and drawing unflattering features onto editors' faces in *Poets & Writers*, I worked, and continue to work, to become a writer worth reading.

I once admired the great prodigies, the blazing geniuses of youth who emerged from the womb crowned and sandaled. I used to judge my success or failure by that very short ruler—I'm 25, I'm 30. Rimbaud had already stopped writing at the age I'd had my first short story published. By the time I finished *White Oleander*, I could no longer even qualify for Granta's Best American Novelists under 40.

Now my heroes are the artists who just continue to work through the years, riding out the whims of favor and fashion. I periodically watch the Beatrice Woods film *Mama of Dada*, simply to appreciate her attitude toward herself as an artist and the way her art continued to evolve until her death at age 105. I'm a Neil Young fan, the ultimate rock survivor, who keeps doing his thing, changing, growing, branching out, coming

back to center, constantly renewing his art. I love Georgia O'Keeffe, Imogen Cunningham and Vladimir Kandinsky, who all built their artistry over decades of trial and error, awkwardness and grace.

And of course, there is Anaïs Nin, who opened the path and then walked it to the end, and whose metaphorical cape I still enjoy trying on now and then, for old time's sake.

Janet Fitch is the author of *White Oleander,* which became an Oprah Book Club selection. The story upon which this novel was based was named a Distinguished Story in *Best American Short Stories 1994.* Her short fiction has appeared in literary journals, including *Black Warrior Review, Room of One's Own,* and *Rain City Review.*

24

My Life as
a Fly

Tristine Rainer

I DIDN'T FEEL the urge to make narrative sense of my life until I turned 40. I even know the day it began. It was a sweltering July morning and I was camped outside the Santa Rosa county courthouse. It was the last day of the trial of a jealous fifteen-year-old who had stabbed to death her more popular classmate. I was waiting for the victim's mother so I could talk to her about the movie rights to the dead girl's story.

This was not the kind of movie I'd produced before. I'd developed movies based on true life stories, certainly, but they'd been comedies and social dramas. In the late 80's the networks had abruptly stopped buying those. They only wanted "hard edged" true crime, rrrripped from the headlines, and if I was going to stay in the game and keep my six figure salary, I had to get some. The grieving mother had not answered my mailgram or phone calls, but I'd spoken with her attorney and he'd encouraged me to try to talk to her in person. I already knew if I could get her to give me the rights, I would have a deal at ABC.

There! Coming out the door! A slender, chiseled woman in a navy dress with a white collar, her tall, athletic husband holding her arm.

I rush up. I ask for fifteen minutes to tell her that her story is impor-
tant to share and why. Her head tilts up to her husband's face.

"It's up to you," he demurs.

Off his non-response, she nods to me, compliant, helpless against the
force of events that are carrying her reluctantly into her fifteen minutes
of fame. She agrees to meet me at her lawyer's office at 4:30.

The room is like a stage set, large and empty, a carpet, a couch, a
chair, tall sealed windows evenly filled by a dimensionless sky. The
mother and father of the murdered girl sit side by side on the couch,
clasping hands.

"Your daughter's story is not just about her tragic murder. It's about a
crisis in values and the failure in our schools." I lean forward toward the
mother, my gaze steady, my voice even, explaining that the personal
tragedy of her daughter's murder contains themes that we all need to look
at, that something valuable can come out of their terrible tragedy . . . if
only they will let me purchase the rights . . . no, no, we don't need to dis-
cuss money now, though I think this story would bring $100,000. "I
understand that you don't want to profit from your daughter's death. You
could arrange to have the money contributed to your chosen charity."

I am well rehearsed. I make my peroration.

". . . It will be a way for your daughter's life to have meaning to so
many others."

The mother takes a Kleenex from her purse. Stanches the tears that
leak down her face. Composes herself. Reclasps her husband's hand.

"No."

What!? But . . .?

"No."

I look into her tired blue eyes. I see steel. I see that nothing I say will
change her mind. I see that not only will I not get her rights—no one will
get her rights. I see myself through her eyes. I am transported into her
grief. I see myself as she sees me, this intruder, this alien creature in a
business suit, this, this *ambulance chaser*. Who are you—you without
tragedy, how dare you come here now while the earth on my daughter's

grave has yet to settle, while I am still in the center of my mourning, you who do not know what it is to lose a child, you who can get up the morning as if the world still continued, *you* who want to make a *movie!*

I leave my card. I back out the door. I rush to the elevator.

I cannot do this! I tell myself. I can't do this.

*　*　*

I loved working with people's true life stories, but only if *they* wanted to tell them, only if they came to me. With television movie companies in escalating bidding wars and tabloid reality shows joining in hot pursuit, no one was going to drop salable true story rights on my doorstep like a foundling baby. "So you haven't the stomach for the TV movie chase?" I goaded myself, "So *now* what are you going to do?" I had changed professional directions so many times, there were skid marks all over the road. Could I really take another sharp turn? I started to have nightmares of careering along a mountain pass, of speeding blindfolded through a freeway interchange.

This is where my autobiographic process began and with the disturbing reflection that though I had been making story from other people's lives for over a decade, I could not see any story in my own. My life was too fragmented, haphazard, unstructured to make a satisfying narrative. Rather than a heroic or even unheroic journey to a longed-for goal, my life had been a desperate improvisation in response to what had been thrown my way. Diary writing had served my constant and ongoing self-invention, but I no longer wanted an episodic life; I wanted it to have a coherent flow. I wanted to recognize my *daemon,* that unique but continuous spirit which, according to psychoanalyst James Hillman, gazes from the eyes of the child and the adult unchanged.

As if to prove how impossible it would be for me to find a line of continuity in my life, I listed in my diary the steppingstones of my so called career: I'd been a waitress, a receptionist, a job counselor, an amateur actress, a university English Lit and Women's Studies' instructor, an author and advisor on journal writing, an editor, a writer of fiction, non-

fiction, screenplays and teleplays, a network television movie producer, a film company executive. As I reread the list, though, I was surprised to detect my fascination with other people's stories—listening to, observing, and making story out of other people's lives.

Other people's lives. That was still the problem. An abstract interest in other people's stories was hardly promising material for finding story in my own. If I'd jumped off a building just then, I'd probably see someone else's life flash before my eyes.

With a Viennese accent I heard Herr Freud pronounce the kinky, accusatory sentence, "You're a voyeur encouraging exhibitionists."

I sassed him back, "Like you."

Faced with my own peculiarity, my own uniqueness, yes, my own eccentric obsession with even obscure life stories, I now had to choose. I could either walk forward outside my own shoes or put them on.

I put the odd shoes on and, as in a fairytale, I was metamorphosed into a new identity, that of a "memoir coach" who guided other people to see and write their life stories, the perfect profession to satisfy my obsession. I wasn't making six figures, but I was surviving, barely, and I was in voyeur's heaven.

Yet my constant engagement with making narrative from other people's experiences increased my frustration over being unable to do it for myself. Like the psychic who can intuit another's fate, but not her own, I was no closer to seeing my own life as story. I'd seen a thematic thread, but it wasn't a story with a clear problem, desire, conflict, and climax such as I could identify in my clients' lives. So one day, I decided I should coach myself. I'd go to my diary and ask how my obsessive interest in story had started. An answer came immediately:

When I was eight years old and reviewing my fame fantasies— writer, explorer, movie star—I realized the only one immediately within my power was famous writer. Like all my fame fantasies it involved revenge upon my parents. They would be sorry they had not given me more attention when they'd had their chance, for

when I became famous I certainly would not share my coveted time and riches with them.

The only problem was that in order to become a famous writer I first had to write the great American novel. Well, that wouldn't be a problem; I had plenty of time to fill during my empty afternoons in the Encino suburbs, alone in the wood-paneled den with only the asthmatic breathing of the Dalmatian to measure the hours. I had the title, "The Autobiography of a Fly," a story of the realities of life in America in the 1950's, told from the perspective of a fly on the wall that nobody notices. It would tell the truth of people's lives behind the closed walls of tract houses. Shocking stories, heartrending stories. The book would have a surprise ending. The fly would get swatted and die with all that had been told buried in his heart. At eight my temperament leaned toward Beckett and Camus.

"I am a fly," I began with a surge of creative power: "No one notices me, but I notice all. People think I am ugly."

Hmm. I had a problem. If people thought I was ugly they would have had to notice me, and if they noticed me they would swat me dead and my story would be over. It would be too short, like my short brutish life as a fly.

I could not solve the problem that first afternoon of writing, but I kept trying, day after summer day, until after three weeks of never getting more than three or four beginning sentences, I gave up. Instead, I decided to read my way through the World Book Encyclopedia.

It was a summer of failures. I never finished the encyclopedia nor my next project—reading through the Bible—and I was never able to finish my story. I had writer's block long before becoming a writer.

Finding myself, forty years later, contemplating in my diary the origins of the pesky writer's block that has bugged me much of my life, I realize that my inability to see my story now is somehow related to my inability to write the story then. With one difference; now I know the necessary

ingredients of a story; I wrote a book on how to structure story; I teach other people how to do it. Suddenly I get the idea of coaching my lonely eight-year-old self to help her write her unproduced tale.

"Trissy," I write as coach, "You can't have a story without a protagonist who wants something. Since you have called this Autobiography of a Fly, the protagonist is the fly. What do you think the fly wants?"

"He wants someone to see that he's not ugly and dirty and nothing."

"Good. Now, who is the antagonist, the person who keeps him from getting what he wants?"

"Why it must be the little girl alone in the study."

"OK, so let's see how can it begin."

The Autobiography of a Fly

I buzz around the girl's silky hair. She swats at me absently. She is absorbed in her book.

I land on a page and stare at her with my hemispheric eyes. I can see her from every angle.

She slams the book shut. I escape by the breadth of my insect's leg. She is no different from the others. She loathes me.

How can I get her attention? I cannot speak to her.

I buzz around her head. I touch her mouth.

"Pthah!" she spits, disgusted. Still my touch has left a tingle on her lip. I have her attention.

I land on a word on the page, "Talk." I move to another word, "to," and another, "me."

She turns the page.

I fly around, then land on the word, "please."

"Hello, fly," she says.

"Hello," I spell the word out letter by letter on the page.

* * *

"Good, Trissy. You now have a protagonist and an antagonist. What are the turning points of the story?"

"That's the problem, I don't know."

"Well, to find that out you may have to track backwards from the last turning point which is the climax at the end of the story."

"When the fly dies?"

"Yes. At the climax something dies so something can be born. So when the fly dies what is born in him?"

"Hope, because he's been seen and loved by someone just before he's killed."

"OK, so now you just need to make a list of what needs to happen in the story for that ending to happen. Write the fly's steppingstones."

1. *I get the girl to speak with me, but she's still disgusted by me.*
2. *We realize that we both feel that no one loves us and that we are ugly.*
3. *We agree to be friends.*
4. *She tells me what is beautiful about me, my all seeing, iridescent eyes and my ability to fly.*
5. *I tell her that she is lovely; she has hair like threads of brown silk; almond eyes with perfect arched eyebrows, flawless young skin and an adorable pout.*

"But I need braces. My father says I have an overbite," she protests.

"That doesn't make you ugly," I tell her, "an overbite is cute on little girls. I'm the disgusting one. People shun me because I have to eat garbage."

The little girl gets up. I shouldn't have reminded her of my repulsive eating habits. She leaves the room and goes into the kitchen. I follow her and fly around while she makes herself a peanut butter and jelly sandwich and cuts it in half. She brings it back into the den with a cold glass of milk. God that peanut butter looks so yummy I don't know if I can control myself from grabbing an armful. The girl notices me buzzing round the room like a crazed wasp, and she holds out half of the sandwich to me.

She puts it on her paper napkin, "For you."

My own sandwich! I dive into the golden goo of the peanut butter and rub my face in the glistening, sweet jelly. Both my front legs shovel big bite-fulls into my mouth at once. Oh glorious!

"At this point in the story the unexpected must happen," I prod as coach.

Oh oh, I hear the front door opening. The girl's mother has gotten home, and she opens the den door to see how her daughter is. The mother's plump arms are full of packages and when she turns and leaves I follow her to a bedroom. I watch as she places one package under a blanket at the bottom of the closet. She hides two full shopping bags under the bed. I fly back to the den to tell the little girl what I saw.

"Oh no, there's going to be a big fight. Whenever my mother buys things my father gets mad and they yell and scream and break things. I pull the covers over my head and plug my ears. The next day I see my mother glue the wooden clothes-horse back together."

"I'm sorry," I say, "I could stay with you and make you laugh."

The mother comes back into the den.

"Who were you talking to?" the mother asks.

"A fly," says the little girl.

"Where?"

The little girl points to me trying to look inconspicuous sitting on a copy of Jane Eyre. *"Don't move," the mother orders as she goes into the kitchen. She reappears with a flyswatter in her hand!*

I leap up in alarm and buzz around the room.

"Don't kill him!" cries the girl. "He's my friend."

"They're nasty," her mother says chasing after me with her teeth gritted.

"I love him!" says the girl.

I'm overwhelmed. I fly to her ear wanting to tell her, "I love you."

"Ewh!" the mother brushes me away from the girl's face with the back of her hand. With the agility of a warrior she swipes at me. I'm a hero, a bomber pilot, circling and diving! No one can catch me! Oh no, here comes a wall of flesh coming at me. I'm caught midair inside the mother's fist. I

throw myself at the cracks of light I see between her fingers, but fall back blocked by the soft walls of my prison.

"Don't kill him! Don't kill him! Please." I hear the girl crying. I feel the hand tighten around me. I'm going to be squeezed to death!

I hear the squeak of the back door from the den. The fist opens. I am stunned by the light. I start to fall. The door slams shut. I try my wings. They are sore, but, yes, they hold me.

I see the little girl's face at the window. She presses her cheek to the glass. I fly to her and bang against the clear wall that separates us. I crawl along the pane to where the girl's flattened cheek is wet like a peach in the rain. She sees me and puts a kiss on her two fingers, then presses them to the place where I cling, before she disappears from view.

As I fly away I see elms and walnut trees, grass, aluminum garbage cans, sky, muddy shoes, clotheslines, swimming pools, crumpled towels on chairs, TV antennae, a Dachshund playing with a Spaniel, asphalt, sprinklers, cars, mailboxes, cracked sidewalks, a man in a wheelchair, blackberry vines twined on a chain-link fence, birds perched on telephone lines, a field of dry weeds, all at once beautiful.

Well, my goodness, I hadn't expected "Autobiography of a Fly" to have a happy ending, though as a memoir coach I know that the ending of a story rarely turns out to be the one planned. Having finished this self-prescribed journal exercise, I can see it's become a story of how important it is to see and be seen, to appreciate and be appreciated, not through disguising yourself, but through revealing yourself as you are. In wanting to write "Autobiography of a Fly" my eight-year-old self had been trying to work out her sense of self as "ugly and nothing" like a fly.

I also see how prescient I was at eight. "Autobiography of a Fly" could be an apt title for my memoir now. When I was researching contemporary diaries for *The New Diary*, I was accused of feeding off other people's garbage, their scribbled refuse usually hidden and thrown away. In writing *Your Life as Story* I was trying, like the fly, to touch my original, frustrated writer self. As a memoir coach I've become a fly on the wall to other people's dramas, my happiest, whether as coach or TV producer,

when working on many stories at once, witnessing a multitude of narratives unfolding simultaneously—my vision working like a fly's parabolic eyes, with thousands of tiny lenses capturing different scenes at the same time.

How embarrassing. My daemon, the continuous spirit in both the child I was and the woman I am, is a FLY. Yet like a patient who is relieved finally to have a name for her ailment, I feel a certain peace in accepting my insectoid nature. It's given me a great vantage for spying on the truth of people's lives behind the walls of tract houses. The compassion I've developed through spying has dissolved my inauthentic fame-and-vengeance fantasies. At last, through knowing myself as a fly, I see a meaningful narrative in my own life. The girl who didn't know how to write a story became a woman who struggled to understand story structure so well, that she could show others and herself how to make a story out of even the most insignificant life.

Tristine Rainer is the director of the Center for Autobiographic Studies in Pasadena, California (www.storyhelp.com) and author of *The New Diary* and *Your Life as Story.* She is a screenwriter and producer and teaches writing at the University of California, Los Angeles, and the University of Southern California.

25

Without Wings

Lia Scott Price

SHE BURIED THE stillborn child underneath the roots of the mango tree, in the far corner of the forest. There, the servants claim to have seen the apparition of a lady in white, a woman with no facial features, who glided towards them in the dark, hovering above the ground.

The servants may believe such stories, but not my grandmother, Asuncion, and certainly not tonight. The two men who had accompanied her on her silent journey trembled in fear. They were especially alert, waiting for the lady in white. It is said that she announces her appearance with a heart-wrenching cry, a sound that brings death or disaster to anyone who listens to her call. But to Asuncion, it did not matter. Her heart was emitting its own silent cries.

The great house seemed miles away, and the glow of its candles had grown faint. Asuncion stood quietly before the finished grave and prayed upon her rosary, her pale face wrought with agony. She wiped the earth from her hands and turned to face her servants.

"My son, had he lived, would have been master of the house," she said in Spanish. "Now he will be master of the forest." The Filipino servants, although they did not understand her words, felt her pain and nodded respectfully. They fixed a crudely hewn crucifix upon the mound, mur-

muring amongst themselves to appease the spirits. The tall mestiza made
the sign of the cross and the sorrowful group returned to the hacienda.

This was how my grandmother's first and only son died, or so I heard
from the stories surrounding our Laguna plantation, tales that would one
day draw me into the writer's life. Today, the wooden crucifix is gone—
rotted away, perhaps, or carried off by spirits. The mound of earth has
long been covered up by roots and leaves, but Asuncion's sorrow never
left, and she died of grief long before I was born.

Why did Asuncion choose to bury her child in the forest instead of the
ancestral cemetery outside of town, with its marble mausoleums, fat
cherubs and poetic statuary? Perhaps it was just a legend, a family folk
tale that my elders were fond of telling on rainy nights and sleepy after-
noons. Or perhaps the truth was too ugly to be known, for according
to Marietta, the old midwife, Asuncion's husband, Don Francisco, had
cursed the child. Asuncion pleaded with him to keep the baby, but Don
Francisco secretly ordered Marietta to place abortive herbs in Asuncion's
drink. That night, her blood flowed heavily and the child was lost. By
midnight she was wrapping the fetus in her shawl as she faced the cold
words of its father. The child, her husband sneered, did not deserve a
mourning. It was not a child in his eyes, not a lost member of the family.
It did not deserve a place in the family grave or in his memory.

Asuncion was determined to honor her child, but since a Catholic
burial was not allowed, the servants, under the guidance of the midwife,
took mother and son into the woods. According to Marietta, this particu-
lar forest was sacred, and she believed that its resident spirits would wel-
come the child's soul.

The old servant Miguel shared this story with me one summer night,
when I was playing beneath a mango tree. It was said to have been grown
from cuttings from the original burial tree in the forest, nourished to new
life and planted on the hacienda grounds to provide shade and sweet
fruit. During the day it was my imaginary playground, full of branches to
swing from and cradle me in its limbs. At night, however, Miguel claimed
that the branches took on the shape of human arms and legs, crying

mournfully when its leaves rustled in the wind. I would get up to listen, but I never heard any such sound.

As time went on, I began to believe that the mango tree did have a soul of its own. I felt as if eyes were watching me as I walked past it in the late afternoons, when the branches cast shadows on the ground. Children would run by and yell, "May multo diyan! There are spirits here!" The older folk claimed that this particular tree was home to a Tik-balang, a mythical creature with the body of a man and the head of a horse. The Tikbalang came out only at night, at the stroke of midnight, smoking a big cigar, with eyes that glowed like burning embers. It begged food from passers-by, startling them but never causing harm. Miguel claimed that if you caught and tamed it, a Tikbalang would make a great worker, clearing whole rice fields of their harvests in less than a day.

"To catch him you must first take him by surprise and hop on his back," Miguel explained. "Grab him around the neck, grip his mane and hang on for dear life, for he will do his best to throw you off. Then he will fly through the night sky, over the tops of the coconut trees, the church steeple, over the mountains, and high enough to brush the stars. But you must not let go. Then he will finally settle down on the ground and kneel before you. He will pledge to be your loyal servant for life."

We called this particular mango tree *Tikbalang Diego,* the name my grandmother had supposedly given her dead child.

* * *

Two years after the death of her child, Asuncion gave birth to my mother, who would one day inherit the great hacienda with its coconut, rice and pineapple fields. My father, who was Chinese, hoped to acquire the vast plantation for himself, and so, like the Tikbalang, he pledged to be my mother's loyal servant for life. His own family opposed his desire to marry a non-Chinese woman, holding stubbornly to its traditions and beliefs. Despite threats of being disowned from the clan, father declared his love for my mother.

My grandfather took the couple in and brought my father into the family business. But their conjugal harmony did not last long. Although

he loved my mother, he carried the guilt of disloyalty to his clan. His businesses also began to fail, for my father had never been out on his own, having relied solely on his family's advice. Grandfather, unsympathetic, pushed him to make the hacienda prosperous, but his attempts often ended in frustration.

Even my birth was not enough to hold them together. My father's mood, once loving, became a torrent of anger and criticism. He accused her of ruining his life by tricking him into marriage because she was pregnant. My mother, not understanding this change, would protest, only to be thrown to the floor, with my father kicking her stomach in rage. He would leave her there, her face wrapped in a black flood of hair and tears, with lips trembling and murmuring novenas to the Blessed Mother.

I watched my mother slowly become a physical and emotional slave, having to endure his gambling, drinking, and cavorting with Asian prostitutes. He blamed my mother, and then he blamed me. It was only a matter of time before I would fall victim to his rage.

Mother's face grew pinched, desperately clinging to whatever sanity she had left. She was slipping fast. Father's rantings had taken on a feverish character, and often he cast dark, brooding looks at us. Nothing we did appeased him, and his presence haunted my dreams. Each night I prayed, wondering if my mother and I would live.

As my father squandered the family fortune, my refuge became the mango tree. I spent many days pretending that the Tikbalang was a savior, a hideous guardian angel who would, one night, break down the great wooden doors of the hacienda and drag my father somewhere far away. I would picture the look of terror on his face and the sweat on his brow as Diego, the spirit of my grandmother's child, reached for him. I hated my father that much.

Every night I would clench my fists and wish that my fantasy would come true. Yes, Diego could save my mother. He could save us all. Those nights were restless and filled with dreams, nightmares in which I ran through the house, throwing open bedroom doors. Behind each door I saw horrifying scenes, like visions of terrible things to come. In one room,

I saw dead infants with their umbilical cords still attached, and in another, I found a woman lying on the bed, her shriveled body turning gray. I could not tell if she was dead or alive. I started to scream and she turned her face towards me. It was Asuncion, my grandmother! I panicked and ran to the next room, facing an even more disturbing scene. I saw my grandmother, young and beautiful but dressed in a blood-covered gown, covered in blood and apparently in distress, cradling my mother's body in her lap. She was nothing more than skeleton. I awoke in a sweat and ran into the yard where I curled up on the ground underneath the mango tree. There I slept until morning, my face caked in mud and tears.

It was at this point I decided to keep a diary, my very own secret record of events that I carefully wrapped in plastic and hid in the trunk of the mango tree. As a child with no voice of my own, in a country where children were to be seen and not heard, where the value of a child was determined by his or her sex, I turned to writing as my testimony to the cruelties of life that I suffered, to give a voice to such events and especially to my mother. I wrote down what I wished she would say, what I wished she would do, and how much I hated father. I wrote to God. I bargained with God. I made a list of promises and prayers. The pages of my diary were smeared with ink mixed with tears.

Soon father renounced his marriage and made plans to return to his family. I heard him sputtering to my mother that had I been born a boy he would have taken me with him. But I was a girl, and in his eyes I was of no value to him. Terrified that he would change his mind and take me with him, I ran into the coconut groves to hide, and when he left, I marked that day in my diary as a day of rejoicing. Finally, I could have a voice of my own, no longer confined to paper.

I felt sorry for my mother, who was left on her own, alone and pregnant with her second child, and I remember the empty, glazed look in her eyes as she watched my father drive away. She stood there in silence, powerless and shriveled like the woman in my nightmare. One night, after the Angelus bells had rung, I heard my mother scream. The servants came running, then froze, watching my mother as she raised her

chemise and howled like a madwoman. There it was, lying in a pool of blood, so tiny, so blue! The whole house was filled with the scent of death. A doctor was summoned, and mother was taken to her room as I stared at the drying blood on the floor. Another nightmare relived.

Marietta took on the responsibility of running the household and caring for me. Peering from behind a wooden door, I watched her one afternoon, scurrying around the kitchen and muttering to herself. She did not see me, or if she did she completely ignored my presence. Her mutterings turned into a chant that I could not understand—neither Spanish nor Tagalog. She was holding up the roots of plants freshly plucked from the earth and examining them closely. Then she would pound them in a small stone mortar and pestle, chanting softly and waving all sorts of strange, unfamiliar objects over the brew. I took out my diary and wrote down the ingredients one by one. It was as if she was dictating to me: how much water to pour, how much powdered leaves to add, how long to boil. The smell of earth was intoxicating, a sign of what was to come.

Hours went by and afternoon tea was served. I longed to see my mother but her doors were locked; inside I could hear faint weeping. Then Marietta swept past me and into my grandfather's room. I heard him ranting and raving about his tea being late. I saw Marietta's figure moving back and forth, picking up soiled linens, pouring water, and then I heard the tinkling of spoon and cup.

Grandfather ranted for almost an hour, then suddenly all was quiet. Too quiet. Marietta emerged with her tray and walked past me without a word. I crept up to grandfather's room and the smell of stale urine assailed my nostrils. He was lying quietly in bed—asleep, or so it seemed—but he never woke up again. She had poisoned him to avenge Asuncion's death, and she wanted me to know, to remember how much grandmother had suffered. Marietta the *bruha,* the town's secret witch.

That night, all one could hear was the sound of the wind in the trees. After grandfather's funeral I went into his room, looking for evidence that Diego, the Tikbalang, had come to claim this distant and unhappy old man. I cursed Diego for not taking my father instead, for not protecting us, for being just a imaginary savior to a ten-year-old child.

I did not mourn grandfather's passing. I lit no candles and said no prayers. As his only grandchild, I reluctantly became heir to the hacienda and its bitter legacy. Several years later, I buried my mother in the ancestral tombs. History was being erased.

I had settled in the city of Manila, keeping my diary under lock and key. I feared that if I opened it, all the tragic memories would come out. There were no therapists in those days, and matters of the heart were best kept to one's self. This was a society where problems were conveniently swept under the rug, where it was a sin to speak against one's parents, where absolute filial loyalty was expected. But the diary wasn't hidden for long.

I began to write once more, but it wasn't easy. I struggled with my conscience, with fears of becoming an outcast for being so vocal. This time I wrote in fictional terms, but using real experiences and feelings. I wrote for the freedom from the oppression I had felt in all my childhood. I wrote about my anger, my frustration. But still I had no voice.

My relatives laughed at my writing. "Why waste your time on dreams, when all you're good for was marrying and having babies?" I should behave, they said, or no man would ever want me.

Unconsciously, my father continued to shape my world, and as his memory haunted me, I began to have a string of bitter relationships. I allowed men to take control, both physically and emotionally, and I almost always ended up with abusive men. I could not stand up to them, always wishing and waiting for a savior, dependent on miracles and hopes. Still, I wrote. Of my wish to stand up and take control. Oh, how I wished that the words themselves would fly off the paper and into my father's face.

In school, those very same words were bringing me recognition as a writer, but people could not believe that the stories were real. They were *novellas,* dramas dreamed up by an overly emotional kid. My writing had saved me in the most trying times of my life and I wanted to set the record straight. I wanted people to know, to open their eyes and their minds.

My diary prompted me to return to the hacienda, which had gone into the care of grandmother's younger sisters. As I walked the grounds I

fought back tears and memories. I felt bitter, betrayed by my own child-
hood, betrayed by the savior in the mango tree, betrayed by my own
inability to trust men. I needed safety and security for my tortured mind,
but I felt the need to face the demons of my childhood home.

I returned to find my father dying of venereal disease. Shunned by his
family, he retreated to grandfather's old room. Much as I dreaded seeing
him, I was also struggling with questions I wanted him to answer. But he
had not changed, and he did not recognize me as I walked in.

"What are you? Another prostitute? Let me be. Your kind has destroyed
me," he gasped.

"No, father. It is you who have destroyed yourself," I shot back,
amazed at my surging anger and resentment. Here before me was a bro-
ken figure dying of a disease he so richly deserved. Now it was mother's
turn to be avenged. But I used no poison, no secret herbs, no chants. I
did not summon Diego through the window. I stood there and screamed,
screamed at father with all my breath until my voice was hoarse. I do not
remember the words but they were filled with hate, with anger, with
vengeance. I became Diego. I became the savior incarnate, the furious,
nightmarish angel of the mango tree. And I saw what I finally wanted to
see: father's eyes growing wide with terror, the sweat on his brow, his
mouth open wide and gasping for air. I must have screamed at him until
he stopped breathing, his eyes staring lifelessly into space. The nuns had
to pull me away.

I sat trembling in my old room, cursing my childhood. Cursing my
mother for not having the strength to stand up to my father. Cursing
my grandmother, and my own culture which taught the women in my
family to tolerate and forgive, but never avenge. I had broken the trend, but
I cursed myself for not doing it sooner. I could have saved my mother's life.

Perhaps I, too, had the witch's blood inside. I sank into a fitful sleep,
and, as the clock struck midnight, the dreams began. I was drifting
towards the mango tree, dressed in a long white gown. Glancing down, I
noticed that my feet were not touching the ground. Something was
crouching beneath the tree, perched on a curious mound of earth. My
heart beat faster and I saw the silhouette of a horse's head framed in the

light of the moon. Diego. Without a moment's hesitation I leapt onto his back. Startled, the Tikbalang convulsed, wildly jerking his neck. I clung to his neck, feeling the sting of his coarse mane as it whipped across my face. Diego leapt into the air and stars began to explode.

An eternity passed before Diego touched ground. I rolled off his back, and as I gazed up I found him sitting cross-legged and panting, his tongue hanging out like a limp piece of meat. To my surprise he got up and kneeled before me. I knew what he was going to say.

"Stop," I said. "It is not necessary that you speak. I just wanted to see if you were real." He gave me a quizzical look.

"Do you understand? You're still free," I said.

The Tikbalang tossed his head back and replied in halting English, "No," he said. "I believe it is you who are free."

"I don't understand."

As the birds begin to chirp, a rooster crowed in the distance. "I did watch you," Diego began. "I saw your fear."

The sun broke through the clouds and Diego sank slowly into the shadows. "It is one thing to believe that someone will save you," he continued, "but you must also believe in yourself if you want to conquer your fear. You write but you do not act. Set yourself free." The glow in his eyes faded, and the Tikbalang disappeared into the forest.

I awoke to find that my hands were clutching the roots of the mango tree—I had walked into the garden in my sleep. I picked myself up and climbed into the tree, as if I was a child once more. From the highest branch I could see the massive iron bells of the steeple in the distance. And as they rocked back and forth, my heart began to ring with a new found hope and awakening. So loud was my heart that it drowned out the morning bells of the church.

My yearning for freedom, for expression, led me to leave the Philippines for good. I tried not to look back, but the painful memories followed me to the United States. I continued to write, to seek redemption and validation, to find an outlet for my burdened soul. I wanted my writing to be a testimony to the pain and oppression I felt as a child, as a woman, and what I experienced in this third-world feudal country where

outward appearances counted the most, where emotional well-being is ignored.

Now I realize that Asuncion, mother, Marietta and I were one and the same person, raised in the same society where women suffer for love, where sacrifice is seen as divine, as ideal. I am all of them. Father and grandfather, ex-husband and ex-boyfriends, these were nemeses of my life, of everything I hated in a Chinese-Filipino man. My writing became a mission to reveal the dark side of that culture. I wanted people to read my words and learn of my sufferings, yet I preferred the safety of metaphors. The metaphor of the Tikbalang, the metaphor of loss, and finally, the birth of a writer.

It was time to set my words free, to embrace writing as my savior, pledging to be my own loyal servant for life.

Lia Scott Price is a writer, journalist, artist, and singer/songwriter. She is the author of five books, including *Sacred Places, The Job Hunter's Survival Kit,* and *How to Self-Publish Your Own Book.* She has also released two alternative CDs. Lia runs Pumpkin Publishing and Entertainment, which features her works at www.pumpkine.com. She resides in Palos Verdes, California.

26

The Leaf Shape Remains

John Fox

WHEN I WAS EIGHTEEN my right leg was amputated just below my knee. I had numerous surgeries since the age of five to save a deformed leg from the ongoing ravages of a genetic disorder called neurofibromotosis, and before the amputation I had spent that year as a university freshman in Boston struggling with a leg I could barely walk on. The poems I wrote during that time of emotional distress and physical pain made an enormous difference to me.

My work as a poetry therapist and teacher is deeply influenced by that particular experience. Yet that year of suffering wasn't when my enchantment with poetry began. Something I experienced much earlier in my life fed the deepest root of my instincts as a writer, the root that keeps me growing. It was the pure desire to create, to make. It preceded everything. I was thirteen years old, watching a girl skate at a rink in Shaker Heights, Ohio, and I decided to write my first poem—a torrent of words related to beauty, attraction and risk. I wanted my words to skate on the page and I sensed so much joy as I wrote.

I made books of poems in my adolescence and gave them away to people, mostly women: a girlfriend whose love I wanted to win, a teacher

who valued my perceptions. I wrote and I wrote, and looking back, it's clear I was giving voice to, as John Keats understood, my heart's affections and the truth of the imagination.

This deeply rooted connection to something beautiful and to the range of feelings surging within me, gave me a sense of my own internal richness and of life's essential mysteries. Writing poetry became a direct link to the unknown, and it felt real. Nothing else would be more important as I entered the country of grief.

Although I walked on a prosthesis within a month after the amputation (I even played on a softball team of former high school friends that summer—a friend ran for me as I stood up to hit), the pain remained intense. For years, doctors prescribed strong pain relievers but to no avail. Nothing alleviated the pain that burned like streamers of fire in my now-absent leg.

Someone who experiences the death of or separation from a loved one may imagine that person smiling or walking around a corner or hear their voice say "hello" when answering the phone. What they discover is that sunlight has hit upon a stranger's face at a certain angle leaving a shadow of hope, or that a familiar vocal inflection is only an unknown person's wrong number. Similarly, phantom pain is an exquisite metaphor for loss. What you lose never really goes away.

After I lost my leg, I wanted to get beyond the physical and emotional pain, but my sense of shame was deeply entrenched and the unexpected intensity of the phantom pain unsettled me. When I returned to school the following autumn, I sought counseling, meditated at a Buddhist center in Cambridge, and attended a poetry workshop with George Starbuck. They were all helpful, but I was still unable to wholly confront my deepest grief and fear.

Injuring my stump finally provided the circumstance that led to a turning point in my writing and in my life. Because of a relatively small contusion, I could not wear the prosthesis, and for two or three days I holed up in my dorm room trying to gather the courage to venture out onto Commonwealth Avenue and into my classrooms—with the right leg of my pants pinned up. I couldn't do it. I couldn't make a move out of my room. But I did write a poem of aching truth, of deep longing:

Even to This

What my thoughts have troubled about
all through the night after night!

It's so very scary
 sometimes
 I feel
 would rather. . . .

what's the worst that could happen?
because it just hurts too much

or having had enough of my own hatred
against myself, lonely is

nowhere else to go—
time to stop feeling sorry
for myself,

time to open my heart
even to this
and call to God.

What does one do with grief? Poetry can enter into the severed places
in life that explanations and reason do not touch. The open nature of
the blank page allows you to experiment with releasing that hurt. Poems
of grief can offer a diamond-like truth, an insight-surprise that is sheer
gift. "Hard won" is often the nature of these poems. Yet they neither
exhaust me nor outgrow their usefulness; rather, they continue to teach
generously over time. Sometimes I come in contact with an essential
joy behind the pain. Writing poems that reveal this unexpected light feels
like receiving grace. And very often such poems seem to write themselves.

I did not know what my next step would be until I wrote the above poem. My experience was only of writing, like throwing fragments of my troubled thoughts onto the page. I let my thoughts appear in seemingly unconnected pieces and wrote the shape of my hurt. In my willingness to show and say what I feared, I discovered that my next step was not to get rid of the pain but to acknowledge it. The pain of losing my leg was like a guest I hadn't invited but who nonetheless had to be received.

Accepting the loss of my leg seemed more possible—and more trans-formational—after writing this poem. I began to put my attention and care into acknowledging my loss, rather than medicating myself and dulling the pain. My poem told me: making a place in my heart for the loss of my leg could help. If I didn't do this, something else less healthy would move into that space of loss and claim my life energy.

My grief about the loss, my fear of the future, the self-hatred and loneliness woven into my turbulent feelings and thoughts—all of these asked not for painkillers but for opening—for opening "even to this." There was nothing else for me to do. First I had to tell myself there was "nowhere else to go. " If I refused to accept my loss, I would be trapped by something even more debilitating than physical pain: self-pity. Self-pity had no point, no message. Its only function was to keep my heart tightly contracted and my soul hopeless. Feeling sorry for myself allowed no room for seeing what is—or for letting God into my life.

The more I looked at my poem, I realized that a deep relationship existed between accepting what is and help from God. Coming to an emotional awareness of what I needed made my last four words "and call to God" feel true, unexpected, deeply felt, natural. I experienced a powerful sense of breaking through—without disowning myself. Writing made this possible!

After writing the poem, I tried healing exercises in place of painkillers. I visualized velvety rose petals floating down over my stump. Using this vibrant image eased the pain considerably and opened my heart to the reality of my loss. I did this with actual rose petals. How beautiful to see my stump strewn not with hot embers of rejection and self-pity but the velvet petals of letting go.

My experience at thirteen of being inspired by a skater—by a grace that opened my life to poetry—also taught me more than I knew at the time about the courage to both live and to write. Thinking back on that initial vision of the skater, I wrote this poem in 1999:

Poetry

It skates boldly onto
the page, tips one vulnerable foot
back and forth slowly, till finally
the edge of a toe
cuts a simple, sharp line
through the world's cold resistance
and with that plain courage,
a statement of intention begins;
and you can't turn back any longer
from the weight of feeling and letting go
into the flow that follows.
Poetry is a choice to feel it all,
not all at once but gradually to sink down
within ourselves, to give what fear
we hold behind our knees
to gravity and grace,
to discover what makes
our whole world turn;
the place our necessary weight
lifts to lightened joy.

John Fox is a poet, certified poetry therapist, and workshop leader. He teaches at John F. Kennedy University and the Institute for Transpersonal Psychology. He is the author of *Finding What You Didn't Lose: Expressing Your Truth and Creativity Through Poem-Making* and *Poetic*

Medicine: The Healing Art of Poem-Making. John is the recipient of the National Association for Poetry Therapy's 1995 Distinguished Service Award. John's workshop schedule is available through his Web site, www.poeticmedicine.com, and you can contact him at JFoxCPT@aol.com.

Discovering the
Habit of Poetry

Willis Barnstone

THE CHANCE MIX that led me to poetry, rather than to more reason-
able habits like medicine or crime, contained four necessary ingredients.
A notion of poetry. Loss of word and self. Wakening to soultalk recorded
as a poem in order to conceal the terror of nothingness. And cheers of a
few friends at my first pieces of verse.

The notion of poetry happened in a meadow in Vermont, in 1947
when I was nineteen and a student enrolled in the Middlebury College
Summer School. I was an outsider who had just come up from Mexico
City, where I'd been close to my Mexican stepmother, a young Sephardic
Jew, who after my father's suicide was living in an ancient slum apart-
ment near the Gran Catedral. I had a cot in an orphanage for refugee
students from the Spanish civil war. I got my meals of beans and potato
tortilla and a room up on the roof in exchange for giving English lessons.
Then suddenly here I was in the green pastoral north, astonished by the
pretty village of Middlebury, a splash of colonial white buildings built of
chaste wood and Protestant nails.

This was to be a summer of Spanish poets.

I'd left the University of Mexico to enroll in the French School at Middlebury, but also took a course in the Spanish School where I was allowed to take my lunch. Morning and evening in the Château, chatting in French, noon meal in Hepburn, babbling in Spanish. A saturation program. We talked and talked to everyone, to tapes machines, in class, at meals, in hallways; and the English language was banned in thought, revery, and dream. But the intellectual and artistic mafia of Spain was there, exiles from the Spanish war. I attended lectures by Pedro Salinas, one of the major poets of the extraordinary Generation of 1927 poets, including Rafael Alberti, Federico García Lorca, Jorge Guillén, Luis Cernuda, and Vicente Aleixandre. One evening Guillén and Cernuda came to visit Salinas and to hear him give a public lecture on Castile and the Generation of '98. In that cottage room in Vermont were surely the three most important Spanish poets ever to spend an evening chatting and gossiping together outside of Spain.

This instant in '47 was the only time I had a glimpse of Luis Cernuda, who had been a year at Mount Holyoke and was about to return to Mexico, where he passed the later years of his exile. I admired the dark work of Cernuda as I did the sardonic gravity of his Peruvian counterpart, César Vallejo—*"Nací una noche cuando Dios estaba enfermo / grave."* (I was born a night when God was sick / gravely.) Pedro Salinas's son, Jaime Salinas, took me to the small reception after his father's talk. Cernuda was standing alone, an introspective statue. When I shook the hand of the shy, arrogant, cranky poet, whose work only grew in importance after his relatively young death, he was wearing a white sport jacket. I see him now shining elegantly and apart among his fellow poets.

In the evenings Jaime, who became my best friend, and Edouette Quillivic, my young French language instructor and girlfriend, and I walked for hours in the hills, sometimes going almost to dawn. I spoke Spanish to Jaime, French to Edouette. Our common language was French, which Jaime, born in Algeria, spoke natively. One night about four in the morning, the waning moon like a yellow buffoon suddenly rose over the hills, dimming the stars. I stared at it so long Edouette asked me

whether I was having a mystical fit. Jaime, given to dramatic statements, was complaining about the role of being the son of a famous poet. He claimed not to have read any of his father's books, yet at the same time said his father read him each new poem as he wrote it. I said something to cheer him, and he shot back, "*Willis, en tu caso es distinto, porque tú eres poeta.*" (Willis, in your case it's different, because you're a poet.)

"*¿Qué dices? En mi vida nunca he escrito un poema. Ni lo he pensado.*" (What are you saying! I've never written a poem in my life. Nor thought of doing so.)

But Jaime was almost right. The presence of the Spanish poets and Jaime's emphatic intuition about me made poetry less than a year away. When Jaime got back to St. John's College, Anapolis, he sent me a copy of Rilke's *Letters to a Young Poet,* as if this habit of verse were already a fact.

In the fall I was at Bowdoin, a senior, studying mainly philosophy. One cold evening a good friend urged me to come to his poetry class. We went to an eighteenth-century sea captain's house, knocked, and the professor formally led us into his den. By the fire were ten or twelve bright English majors, all in three-button suits, arguing about Robert Lowell's "whale blubber" and "light in the dead eyes of the drowning sailor." I had never read anything like *gobbets of blubber spill to wind and weather* or *Light / Flashed from his matted head and marble feet.* I was in awe. After class, Professor Stanley Chase, gray and distinguished, took me aside quietly. "We have our quota of students. I have to ask you not to come to any more classes."

I began to read poetry very seriously on my own.

The year was strange. I sought answers in the philosophers. I found systems, each one plausible, but in contradiction to every other. Had I read Jorge Luis Borges at the time, I might have believed that there were no absolutes, no keys to unlock the universe or the coffin, no flawless algebras for language or thought. There was the paradoxical journey of Heraclitus the Obscure to find the truth about truth's absence. I kept a diary. I became increasingly introspective. I read many novels and examined not only what I saw in them but what I saw in my seeing them. This consciousness of consciousness became a shifty game of doubt. Hume the

pragmatist of the psyche said, "You can be aware of being aware of being aware, and after three times there's nobody at home."

After all those self-awarenesses, the process descends into mere grammar. When no one is at home, there is desolation. This awful absence is hard to describe, because mind is elusive and can only be evoked metaphorically. Mind is not a number or a stone. It is a spirit in a living shell. The shell can be identified externally or seen through with x rays. The mind too can be measured electrically, but it can't be captured by sight or photo and has no visible shape or weight. When you try to see the invisible, the activity is mysterious, but also empty. There is nothing to see.

As you move to the site of thought, the way breaks down. Doubt sets in. You try to see the mind thinking. You become two persons. One looking at the thinking being, and the one being looked at. The seer and the seen, as Plotinos calls the inhabitants of illusory life. The psychological payment for the search for mind is a fear blur, a paralysis of doubt, and the mind goes blank. I did not doubt my existence. I was not a Buddhist. But I doubted the nature of my existence, doubted words and consciousness.

I spoke about all this to my blind professor of philosophy. "Mr. Leure, what can I do? I want to get out of this."

"Go see a movie."

"I did, but it didn't work," I told him. "I couldn't keep my mind on the screen. My mind got in between and blurred away the people."

Nevertheless, I went to see "Spellbound," a beautiful and bad choice. As the skier neared the edge of the cliff, I almost fell off.

Months rolled on, and the pounding experience of detachment was a nightmare of nonbeing, with none of the colorful vision that the mystics make of the arid night. I needed something to hang on to. As I dropped down inside myself, the winter got blacker and blacker.

Finally, I spoke to a confidant, an older student, Slava Klima, from Prague. He was a central European, who made me laugh when I was weary of introspection and otherness.

"Have you read Christopher Isherwood's *Prater Violet?*" Slava said.

"What is it?"

"A novella about an Austrian filmmaker. Read it."

I did. Slava's chance remark changed things. At one moment the film director wakes in the morning and decides to write a poem. It was unsentimental and perfectly natural, like drinking orange juice as if it were the sun. "Sun in the morning at the window. / A bird on the windowsill. / Bird, you wake me with your singing. / Keep singing. You make me happy." Those lyrics astounded me. It was the process. The fact of waking and writing a poem because the director felt like it.

On a nondescript evening in December or January—I wish I knew whether it was 1947 or '48—I went to sleep around midnight in my dorm room. I lay under a mound of blankets under the Maine winter. About two o'clock, my roommate, Bret, was having a terrible epileptic attack. I woke as I usually did when he was going through this hell, put on a robe, went into the next room and sat at my desk. I was freezing. I wrote the first poem, a love poem. Then I went back to sleep. About a half hour later I woke and wrote a second poem. I took it to the bed, and with my flashlight and a pencil worked on it. Then I went to sleep.

That morning I showed these lyrics to Slava and to Olaf Hanson, a Dane. Also to Bertrand, who was from Paris. To my surprise they took my first attempt at poetry seriously. Slava mentioned Rilke and Valéry and mumbled something about these poems being in a similar vein. Bertrand nodded his head in affirmation. I was overwhelmed by the association with other poets. I wrote poems the rest of the week. With no fuss or doubt or even a feeling of discovery, I was there. I was a poet, only a poet and, like the post office downtown or night and day and the sun in the sky, thereafter I never questioned that poetry was my central identity, that its secrets were there, waiting to be overheard. Of course it had a prehistory and a soft landing. There was Mexico, a Vermont meadow, a winter of despair in Maine, and a waking at the moaning of a roommate's epilepsy. And then the waking of the poem, which came as a gift and unforeseen. It was the luckiest night of my life.

Willis Barnstone was born in Lewiston, Maine, and educated at Bowdoin, Columbia, and Yale. He taught in Greece at the end of the

civil war (1949–1951), in Buenos Aires during the Dirty War, and during the Cultural Revolution went to China, where he was later a Fulbright Professor of American Literature at Beijing Foreign Studies University (1984–1985). His forty-three books include *Modern European Poetry, The Other Bible, The Secret Reader: 501 Sonnets,* a memoir biography *With Borges on an Ordinary Evening in Buenos Aires,* and *To Touch the Sky.* His literary translation of the New Testament is forthcoming with Penguin Putnam. A Guggenheim Fellow and Pulitzer Prize finalist in poetry, Barnstone is a distinguished professor at Indiana University.

28

Kill the Buddha— What I Learned from Chinese Poetry

Tony Barnstone

Po Chüi, dead these many years—ah, he's not dead.

Agnew is dead.

What we've got to reach in America is some
understanding of the great Chinese.

—JAMES WRIGHT, FROM AN INTERVIEW
WITH MICHAEL ANDRÉ

Place Is Only and Always Place

William Carlos Williams was upset with T. S. Eliot most of the time,
but one thing that really irked him was Eliot's statement that "Place is
always and only place." For Williams, the task of the poet was to find "the
universal in the local," to write poetry in American, not in English, and to
find a way of expressing in verse the world in which we actually live.
Eliot, an expatriate most of his life, who became an English citizen and

joined the Anglican church, was a model for Williams of the poet who runs away from America out of stuffiness and snobbishness. Williams was a cantankerous type, so we should forgive him if he wasn't fair to Eliot most of the time.

This is a roundabout way of coming to my lifelong romance with the rest of the world. I have lived for extended periods in Spain, China, Africa, and in Greece, and early on decided that I would follow Hemingway and Fitzgerald and Eliot and the rest—fifty years too late—and be an expatriate. It is, I suppose, a strange self-conception for someone raised in Bloomington, Indiana, where we used to swim in the old limestone quarries, listen to an awful lot of country rock, and where the 60's and 70's bred a peculiar hybrid of redneck hippies (long-haired, drug-taking, gun-wielding, venison-eating, idealistic pioneer fanatics, living in the scruffy woods and slowly discovering the wonders of soy). My models for the international life are my New Yorker father and my Greek mother, who spent years in their youth living across Europe, learning languages, practicing their arts, and leaping and swaying through the tango, flamenco, and the Greek butcher dance.

A turning point for me came during the year after I graduated from college in California. I was so foolish and unprepared for living that I actually looked at the want ads under "writer," and found only that disheartening gap between veterinarian and zoologist. After a stint as an assembly-line worker in a granola and candy factory (really, I'm not making this up) and then another washing windows in Silicon Valley, gazing in at the excesses of corporate wealth like the Little Match Girl, I landed a gig teaching in China for a year.

China was a gift. Four of the five books I've written have something to do with China. But China also taught me a hard lesson about my original poetry. While living in Beijing, I tried to write my first book of poems. It didn't go well. I came to the realization that I was writing "travel poems," and that I didn't like travel poems. Ultimately, I realized that I would have to live in America if I wanted to be a writer. I would have to make peace with my home, and I would have to live close to my roots.

What I Learned from <u>The Book of the Dead</u>

Though I returned to the United States and gave up the expatriate dream, in some irremediable way China had come to reside underneath everything, as if on some internal map the two countries had been super-imposed. In the east a great city flickers in and out of existence. It is New York and it is Beijing. In certain slants of light, the spires of San Francisco shiver, shift, and become the red towers of the Potala in occu-pied Tibet. China continues to infiltrate and transform—to translate—my imagination. It is hard, though, to trace exact influences. How can one say that this phrase came from Borges, and that image from Parra? How can one say that this narrative leap was learned from *The Book of the Dead,* and that conceptual riddle from the Japanese Zen poets? All these books by the dead enter into the brain and mulch. Still, Chinese poetry in particular has had a deep influence on the sources of my creativity. Like many others of my generation, I was astounded by Kenneth Rexroth's ravishing translations of the master poets of China. Hemingway was not a good poet, but if he had been, he might have written poems like these extraordinary Chinese verses: poems in which nothing is declared, but worlds are implied, poems that seem very distant and removed, yet which have the potential to riddle the reader with emotion, poems in which everything shines with an absolute clarity. I was fascinated by what this poetry did to me, and began to study and translate Chinese poets as a way of finding out how I might create these effects in my own poems.

Translation is like the medieval apprenticeship of a craftsman to a master. The master is writing in another language. You, the poet, are using your skill with that language to copy the master's work, to let the master's voice speak through your body, and through your words. In that process, you learn the master's craft. I can't think of a better creative writing workshop than to translate into English the poetry of somebody whose work you really love, because then you have to *write* the poems of the person you admire most, to come up with your own words for their words. However, in the process of translating the master, you are also

transforming the master's words, double-crossing the author. The translator always must be unfaithful to some aspect of the poem, in order to keep faith with other aspects of the original. This is the old translator's conundrum of spirit or flesh, meaning or words: when you translate a sonnet by Jorge Luis Borges, do you do so word by word, following his syntax? Or do you translate it poetic movement by poetic movement, image by image, emotion by emotion, meaning by meaning? I like to be close to the original, but as John Frederick Nims has said, the worst infidelity is to pass off a bad poem in English as a good poem in another language. You have to create new life, a poem that lives on its own. Perhaps in rearranging some of the elements of the poem in translation, you will create a better poem in English than a word-for-word translation would create. Thus, when translating, I try to get at what I call "the poem behind the poem," which is to say that I try to translate what a poem *does* in addition to what it *says*.

The process of translation is always also a process of betrayal. There is always loss, but for me, there is quite a lot of joy in this mutiny against the original, in this inevitable difference. I'm creating a poem in a different language for a new audience raised in a different cultural tradition. There is the potential to make the poem more powerful, but in the process, something is also lost. There is a Zen riddle, "If you meet the Buddha on the road, kill him." You cannot become the Buddha by following the Buddha, and you cannot become a poet by following a great poet. In the words of Chinese writer Huang Luzhi, "if you follow someone you will always be behind." Translator-poets sit down near the master, and through a long apprenticeship learn how to become master word-smiths themselves. They do this through betrayal. They do this through faith.

Meat Poetry

My very early favorite poets were a diverse bunch. I loved the classical Chinese poets—Li Po, Tu Fu, Wang Wei, and others. I loved the form of late continental surrealism that influenced the American Deep Image

poets (James Wright and Robert Bly), people like Trakl, Lorca, and Neruda. I loved Rilke and William Carlos Williams. From these early loves I learned important lessons about how to create a sense of deepening, of intensity in tone and image. It was only later, when studying first with Robert Pinsky and then with Robert Hass, that I began to see ways of breaking out of the short, jewel-like, beautiful but static pieces that I had been writing.

In this early work, I was attempting to write poetry that would bring a thrill to language, poems that would create an involuntary reaction in the reader. Sometimes they were sexual; sometimes they were designed to disgust or shock. More often, they strove to create through juxtaposition of images and synesthesia an experience equivalent to the "Zen flash" that I saw in the poetry of Wang Wei, Han Shan, and other great Chinese poets. I called these poems "meat" poems, because they were designed to trigger a reaction in the brain, like Pavlov's bell. I realize now that, like certain members of the advertising industry, I was attempting a form of "subliminal seduction" of the audience, based on an esthetic approximation of techniques of psychological suggestion. I wanted to create a *desire* for the poem by triggering bodily effects through language, to write poems directed at the instincts, not toward rational thought.

It may seem strange to attempt to create such physical effects through words, but words are, after all, bodily productions. When you read poetry out loud, you are playing a musical instrument: your "windpipe," with a tongue and lips to make music on the wind coming out of your mouth. It is a carnal and sensual thing that is happening, for poetry is streaming from the body. It's also a bodily experience for the person listening to the poem. We live in the world. We have names for most things in the world. Even when the things are physically absent to us, the names that we have associated with them can invoke their ghosts and cause them to walk through our mind and bodies. When you run your eyes along a line of words, the words try to create the ghost experience of life, and if you have that physical experience in your body, it is because

you are living the words as if you were living life. I love it when I can make an audience laugh or sigh, but when a poem of mine causes a listener to weep I feel humbled and even a little dismayed at the power of words.

Dark Laughter on the Other Side of Metaphor

I wrote my first poem at around age six. It was a limerick and had something to do with ants. I come from a family of writers, and we used to go to an old house in the Green Mountains of Vermont to live each summer, without television, for many years without a telephone. There, we were thrown upon our own resources. Without the blue world inside the television set to swallow us up, we had to go outdoors and make up our own worlds. We would go weekly to the public library and come home with dozens of books to devour. We would play games, but often the games were to paint fantasy figures with watercolor or to play the "poetry game," in which each person contributes several words to a word pool. Then everybody writes a poem incorporating these words.

The Chinese poets also had their version of the "poetry game." A group of poets would sit down next to a stream, and a servant would float a cup of wine to them on a lotus leaf. By the time the lotus leaf arrived, the poet whose turn it was had to extemporize a poem. If he failed to come up with one in time, he had to drink the wine. They were creative and playful, as in this passage by Song Zijing: "Whenever I see my old work I want to burn the poems I hate." In response, his teacher, the poet Mei Yaochen, congratulates him: "You have made progress." Most American poetry, by contrast, is terribly morose. All too often, it seems to fall into the elegiac mode—a poetry of loss, depression, death, abuse, pathos. I've written my share of these poems, but I find them to be ultimately limiting.

In my own writing, I learned how to be funny in equal measure from the Chinese poets and T. S. Eliot. In Eliot I found a great example of a

"serious poet" who is also a real crack-up. He uses Chinese juxtaposition to create hilarious couplets that work like the set-up and punchline of a joke. I often have to tell my students that it's okay to laugh when they read that "the evening is spread out against the sky/like a patient ether-ized upon a table." I learned from these models how a sudden shift in tone, a betrayal of expectation, or the substitution of a laughable com-parison for an apt metaphor can catch the reader off guard and surprise them into laughter. What an intense surprise that can be. After all, when you laugh, you hyperventilate as if in danger, your eyes tear as if you are weeping, you bare your teeth like an animal, and you emit a series of , short, sharp involuntary sounds. It is a very strange and visceral reaction, as powerful as the flush of sexuality or the sting of pathos. Humor is the dark side of metaphor, and it is too powerful a tool for American poets to be afraid of it.

The House Is Like a Poem

Recently, a young Romanian woman asked me, "Why do you write poetry? Why this particular form of expression?" For a moment I was stumped. It's a bit like asking someone "Why are you a heroin addict? Why do you breathe? Why do you like sex? Why do you sleep at night?" Each writer must have different answers to that question at different points in his or her life. These days, I think it is a way of living, a way of understanding the world. It has something to do with the fact that I've always been a big reader, one of those people who tries to figure out how to live in the world, and how to make sense of it through books. You've probably had this experience: you are reading the book, and suddenly your brain is on fire and you say, "Yeah, that's it!" and you have to throw the book across the room and run out and tell people about it? I have this experience all the time when I read Thoreau. It's almost impossible for me to get through *Walden,* because the moment I begin to take the book seriously I want to throw it across the room and run into the woods where everything is alive and electric. When I write I'm always trying to

get at that electricity. As the Chinese writer Song Zijing observes, "You can't build a house inside a house." I write poetry in part for the reason that people eventually move out of their parents' house—to enter into the world, and to leave behind something that, if I'm lucky, will cause someone else to throw my book across the room.

But then again, perhaps this is not a good answer to my Romanian friend's question. I think of the poem by Han Shan, "My mind is like the autumn moon/Shining clean and clear in the green pool./No, that's not a good comparison./Tell me, how shall I explain?" Perhaps the pleasures of writing are perhaps a bit more ordinary than these metaphors can get at. Let me take another stab at it. I worked construction for several summers as a grunt at my brother Robert's construction/architectural company. I learned quite a bit about tools and about how to put together a house, and it was great working with my brother. Rob does have one rather annoying habit when he works, however. Whenever he completes a task, no matter how small—hammering in a nail, snapping a chalk line, making a cut with the circular saw—he says under his breath "mmn-hmn" or "uh-huh." And then he does the next task, completes it, and says "mmn-hmn" or "uh-huh." I have a feeling that it is something similar that keeps me writing. There is a small charged thrill each time I build another little house of language. I have always been a project-oriented person, and I feel pleasure in my marrow, a sense that the world is just a little bit better ordered—that entropy has been staved off for another day—with each poem, book review, translation, short story, or critical essay that I write. Revised a poem, "mmn-hmn." Went over the proofs, "uh-huh." Finally wrote that letter, "mmn-hmn." It's not a profound theory of creativity, but it keeps me going.

Tony Barnstone is an associate professor at Whittier College, where he teaches creative writing. His first book of poetry, *Impure,* was a finalist for The Walt Whitman Prize of the Academy of American Poets, the National Poetry Series Prize, and the White Pine Prize. He is

the author of *Out of the Howling Storm: The New Chinese Poetry, Laughing Lost in the Mountains: Poems of Wang Wei, The Art of Writing: Teachings of the Chinese Masters*, and *Literatures of Asia, Africa, and Latin America*. His poetry, translations, essays on poetics, and fiction have appeared in dozens of American literary journals, from *The American Poetry Review* to *AGNI*.

29

Getting It

Susan McBride

I'VE ALWAYS HAD a passion for words, treasuring books above Barbie dolls, bikes or boys. By the time I was ten, I had written three novels, which I proudly showed off to anyone who'd pay attention. My babysitter, Marcie, thought I was a child prodigy, a budding E. B. White or Caroline Keene. Though the ink is faded, the paper brown and the spines taped together, I've still got them, safely packed in a box beneath my bed—along with the sweet nothings penned in red ink by my fifth grade beau. (Okay, so I did make time for boys now and again.)

It should have been obvious even then, but I didn't get it.

All I knew was that words came easy for me. Math and science were like a foreign tongue, but English class made my pulse race. I actually looked forward to book reports and essays, and, if you started me talking about similes and metaphors, I wouldn't stop.

Still, I didn't recognize the significance of my literary fascination, and so I went off to college to focus on a business major, following in my father's executive footsteps. But macroeconomics and calculus nearly did me in. I went home one weekend, depressed, and never returned. Why was I so unhappy? I still didn't get it.

That winter, we drove to my grandparents' house for Christmas on roads of ice with blinding snow; my mother hunched over the wheel

trying to see, windshield wipers going full speed, frozen tree branches snapping as we passed. It happened somewhere on the highway between Houston and St. Louis—an honest-to-God epiphany. It struck like lightning: I will write a book.

I dug out a pad of paper from my mother's purse and started writing then and there, envisioning an historical novel set around Vicksburg, Mississippi, during the Civil War. Within a matter of months, I completed a 600 page novel, typed on an old Selectric, no less. With utter naivety, I sent it off to several publishers, packaged in red tissue with a silk rose. Unbelievably, a contract arrived in the mail from a small press, but it was such a bad deal, I turned it down. Still, it made me realize I was on to something. It had taken me almost 20 years to figure it out, but I finally knew. I finally got it: I was a writer, and I was doing what I was meant to do. I would be published someday, and it didn't matter when.

I transferred colleges, heading to the School of Journalism at the University of Kansas and filling my electives with every creative writing course available. But even with my diploma in hand, it would be another eleven years before I would sell my first book. Eleven years of writing and nearly as many manuscripts produced, going through one agent after another like a much-married woman unable to hold a lover's interest past the honeymoon. And every time I read a story about an overnight sensation, I wondered why that wasn't me. I knew I was good enough: I had talent, and faith. So I hung in there, though it was often brutal. Like the day I ran into a long-time acquaintance at my grandmother's funeral.

"Still trying to get published?" he casually asked.

"Of course," I answered, surprised by the question.

He shook his head and said, "Don't you think it's time you gave up?"

Give up writing?

Was he crazy?

I've never forgotten his words to this day, for they are a reminder of the odds I was up against and the strength I would need if I really wanted to succeed. One year later, I signed a contract for *And Then She Was Gone*. I had done it.

If I'd been less stubborn, I would never have seen my novel on the bookshelves, would never have read the reviews, nor heard from people who'd been touched and moved to tears. If I had listened to the naysayers, I would have missed my chance, able only to wonder now and then, "what if?" Thank God, I'd listened to the voice inside me that kept saying, "Don't quit. Your time will come."

When you have a passion for words, nothing can stand in your way. All it takes to succeed is courage, hard work, and persistence.

Susan McBride received the Mayhaven Publishing's First Annual Award for Fiction for her novel, *And Then She Was Gone*. She was also a finalist in the St. Martin's Press Contest for the Best First Traditional Mystery Novel and won the National Writer's Association's Best Novel Contest. Susan collects antiques and stray cats and was once a stand-in for Fannie Flagg in a low-budget vampire movie.

30

Horsefeathers!

Roberta Jean Bryant

As a STUDENT back in my first writing class, I had no trust in myself, my creativity, or my early attempts at writing. I'd drive home from class revved up, stimulated by everything I'd heard. Ideas bloomed grand and glorious in my head. I couldn't wait to sit down and begin writing. I'd start to write, wrestling with my idea; I'd keep at it doggedly, become frustrated, and stop. Then I'd work at it some more, struggling to improve it. I'd read it over; it was terrible, horrible, stupid! What had happened to my exciting ideas?

They were dead! Somewhere between the excitement in my head and the words on paper the ideas had died an unnatural death; somehow I'd managed to kill them off. Reluctantly, I'd drag their lifeless bodies to class, and I'd cringe in the corner when they were read aloud. The sounds of rustling papers and faint snoring confirmed my negative self-assessment. Disappointed, disillusioned, discouraged, I remembered that I wasn't talented or creative. What did I have to write about anyway? I wasn't interesting, and neither was my life. What happened with me on paper was equally dull and boring. Everyone else in class did better than

I did. Dreaming of being a writer all those years had felt exciting and romantic. My reality felt awful.

I had started out thinking I had two things going for me, both due to avid reading habits: (1) a large and rich vocabulary—thanks to all the magnificent multisyllabled words I'd encountered, and (2) the many good writing techniques I'd gleaned from how-to-write books. Unfortunately, I'd been wrong on both counts. My greatest liabilities, and the first things I had to let go of, were my overpowered vocabulary and my know-it-all attitude about technique. Only after painfully letting go of what I thought I knew about how to write well, only after giving up the temptation to show off my storehouse of inappropriate twenty-dollar words, did my writing begin to improve and come alive.

The teacher never gave up on me; she encouraged me to continue. So, despite the agony of my weekly struggle with words on paper, despite the inadequacy of my early efforts, I persevered. I kept writing because the teacher was convinced that I could improve if I worked at it. I persevered primarily, however, because shyness restricted me verbally and, by the age of twenty-seven, I had a dire need to communicate. Writing, as difficult as it was for me in those days, was still easier than talking to people over the age of five.

Within two years I'd completed a few short humor articles and sold them to my local newspaper. Humor had been the only way I could deal with the truth of my life. I'd been appalled when the teacher said, "Write what you know." I didn't like what I knew; why would I want to write about it? Ultimately, I did write what I knew as humor—employing exaggeration and an ironic tone. Of course, I began many more pieces than I completed. Writing still was painful labor for me, but I was beginning to see the value of writing for self-discovery as well as for possible publication.

One thing that kept me going was the reward of reaching an audience. My first fan letter began, "Horsefeathers!" and was unsigned. I was delighted; I didn't care that the reader thought I was an idiot. I already knew my work needed lots of improvement. My delight sprang from the

fact that not only had it been published, but that someone had read it and *reacted*.

Roberta Jean Bryant is the author of *Anybody Can Write, Stop Improving Yourself and Start Living,* and *Loving Work.* For fun, she regularly leads tours of archeological sites in South America.

Chemistry, History,
and a Passion
to Write

Anna Lee Waldo

WHEN PEOPLE ASK ME what work I do, the first thing that comes
to my mind is to say that I am a college professor and research chemist. I
love teaching and working with students and building, analyzing or tak-
ing apart compounds in the laboratory. None of this seems like real work
to me, but writing is another matter, and although I have no formal train-
ing as a writer, I have, over the years written three best-selling novels:
Sacajawea (the Shoshoni woman who accompanied the Lewis and Clark
Expedition), *Prairie* (a story about the larger-than-life Westerner, Charles
Burton Irwin), and *Circle of Stones* (a tale about Brenda, the mistress of
Owain, Welsh Prince of Gwynedd).

Most of my students have trouble believing that I write historical nov-
els between the classes I teach. Instead, they stare at me without saying
anything, thinking that I am joking. Or else they whisper to friends that a
professor of chemistry could not possibly write an emotional, entertain-
ing book, certain that I will suddenly say that another writer with the
same name as mine was the actual author of those books.

My first book, *Sacajawea,* was born out of my early life in Montana. I grew up in Whitefish, close to Glacier National Park, among Blackfoot and Crow Indians, listening to the Indian grandmothers' winter tales and participating in the spring Running-With-The-Sun Ceremony. I would spend many hours with my Crow and Blackfoot friends collecting bird feathers, arrow heads, hunting, fishing, shooting gophers, eating pemmican and bear meat, and learning about medicinal plants. I had Ovaltine cans full of spear points I had found around Whitefish Lake.

I was so immersed in their culture that I believed that I was an Indian too, but when my third grade teacher told me I was wooden-shoe Dutch, I was devastated. My father softened the wound, explaining that it didn't make much difference because we were all red-blooded Americans. I told him that I wanted to be an Indian when I grew up.

I used to pretend that I was Sacajawea, making up stories about her and wondering what she was like before and after the Lewis and Clark Expedition. That wondering eventually grew into ten years of research, during which I read everything available about the Shoshoni Indians and Lewis and Clark. I even interviewed one of Clark's descendants. It was such a large, wonderful story that I became driven with a kind of compulsiveness to write what I had learned. I tied the research together with the Indian tales I had heard as a child, and, after half a dozen rewrites, it became a 1400-page saga about the life of my Shoshoni heroine.

I learned later that my compulsion was really the passion writers feel about their stories. A writer delves into someone else's life and becomes witness to something heroic, special or strange. Then she turns her passion into words. Even the old grandmothers taught me that passion was the most essential part when telling a story to others. The grandmother storytellers would howl like a wolf and laugh like a loon, raising their arms and eyes to the heavens and smacking their lips when the earth's shadow ate the moon during an eclipse.

Sacajawea's story has much to do with a way of life—of the attitudes and prejudices of the times, and the holding on to a dream. Lewis and Clark tried to fulfill President Jefferson's dream of a river passage through

the Rocky Mountains to the Pacific Ocean, but Sacajawea's dream was to be reunited with her family and later with her first-born. But I never considered writing a nonfiction book about Sacajawea because there are too many controversies with her life, too many questions and gaps.

By writing the book as a novel, I could continue my childhood game of pretending to be Sacajawea, and fill in the gaps imaginatively, making up conversations and adding idiosyncrasies to the characters. Still, as a first-time author, I wanted everything to be grammatically and historically correct. I thought about using footnotes, but my editor balked, reminding me that they stop the flow of the story for the reader. I compromised, keeping the footnotes at a minimum and creating a section of notes at the end of the book. My readers tell me they love them, for the notes bring an aura of authenticity to the book.

When I wasn't teaching or doing research I would write, especially when our five children were in school. One day after school our girls brought some friends home. "Be real quiet while Mom is writing," said the oldest child. Bless her heart, I thought, she does think of others. A moment later the middle child spoke. "If Mom sees us she'll read out loud." Oh, good, I thought. This is my chance to see if they like what I have written. And then the youngest chimed in: "And if she reads a sad part, you can see her cry real tears." Ah, children!

I sold the manuscript myself, without the aid of a literary agent. It is hard to find an agent if you have not been published in the literary world, even if you've been published in the scientific world.

Next, I found that authors have little control over publicity and the methods of sale of their books. They even changed my title, *From Savage to Saint,* in hindsight a benefit for now people would know who the book was about.

I was sent on two publicity tours to autograph books. The first tour took me to the major cities west of the Mississippi River. Avon Books, the publisher, had a book launching party, on the riverboat *Tom Sawyer,* which cruised the Mississippi River with media people from New York, St. Louis, St. Charles and Kansas City. My youngest son was shocked: he did not recognize me in a dress; I'm a blue jeans/tee-shirt sort of gal.

I traversed the continent, à la Lewis and Clark, giving interviews and talks and autographing stacks of books. When I arrived in Whitefish, Montana, my girlhood home, I believe everyone came to shake my hand and kiss me. I met grade school and high school teachers and hordes of friends. One friend called me by my girlhood name, given to me by my father because my cry sounded like a mountain lion. "Hey Cougar," Joe said, "remember the day in high school you and I and Zack skipped to go fishing?"

I remembered.

We fished in Cow Creek and Joe promised me his hand-tooled belt if I caught more trout than he and Zack together. He doped a royal coachman with bacon grease, swung his pole and reeled out the line so the coachman bobbed on top of the riffles like a real fly. Zack swung his line back over his shoulder. Then he snapped his rod forward and the hook caught in a bunch of leaves. He swore, left the fly hooked high in the tree and spent most of the morning untangling fish-line. I waded into the creek and had all the room in the world to cast my rod so my red-tail fly skimmed the surface of a deep pool under some willows. By noon I had a forked stick loaded with blue-back trout. I bubbled over with happiness because the boys were skunked; I had caught the only fish. Joe handed his brown belt, with tooled designs of flowers and deer, to me.

"I still have the belt," I said. "I wear it with jeans."

"Hey," Joe said, "it took me a month to work the flowers on that sucker."

"It's my favorite," I said. "I love it."

"I loved you," he said. "You were one of the boys; one of us. You were never scared, never screamed when you saw a snake. You were a real red-blooded kind of girl."

"Still am," I said, looking away from his big, dark eyes and broad smile. I did not want him to see my eyes spilling tears or hear him call me Rain-In-The-Face. "And so, where are you working?"

"Blackfoot Pencil Factory," he said. "Good job. They let us off early during huckleberry season. Wives make jam and sell it by the pint to tourists."

My publicity tour continued—Bismarck, Mandan, Williston, Havre, Great Falls, Kalispell, Missoula, Bozeman, Bonner's Ferry, Boise, Sandpoint, Coeur d'Alene, Moscow, Lewiston, Spokane, Tacoma, Longview, Astoria—as lines of Lewis and Clark fans gathered around city blocks. I put feathers in autographed books to signify Bird Woman, the Minnetaree translation of Sacajawea's name. I even filled a box with pinecones and sagebrush and sent it to the Publicity Department at Avon Books; New Yorkers, as you know, only read about such things.

In Pullman, Washington, a young man told me he had a painting of Sacajawea. "I would like to see that," I said.

"Wait ten minutes, I will go home and get it," he replied.

He came back carrying one end of a huge framed picture. His mother carried the other end. "Here she is," he said. "See, just like you said, her hair is braided and the part in the middle is painted with a vermilion stripe."

I looked at a picture of a young woman with black hair, whose leather tunic was pushed off one shoulder, her lips were painted as scarlet as the part in her hair. At the bottom of the picture was one large word: POCA-HONTAS. "Look," I said, "that is Pocahontas."

"I don't know what that means," murmured the young man.

"We'll just get more framing to go over that," his mother intruded. "Isn't it a beautiful painting of Sacajawea? Quite rare, I'd say. And worth a lot."

"I'm glad I saw it," I said.

A year later the French publisher, Pygmalion, invited me to Paris to visit bookstores and participate in a televised debate. I heard one of the French historians say that hundreds of American Indians are still being massacred every day. I sat up, ready to speak out and object, when suddenly the translator's voice coming from my earplug went dead. The moderator pointed to me and asked a question in French. Remembering my sixteen-year-old son's advice, "Keep talking, Mom; never leave dead space on the air," I burst into a rebuttal that Americans no longer massacred Indians. When no voice came from my earplug, I went on to say that when each of our five children was born, he or she was given a

Chinook Indian nickname. Not only did the names fit their personality, but they were prophetic as well:

Skookumchuck (Something Good) became a principal of a large public school, which needed help. Last year, her school was awarded the prestigious National Blue Ribbon.

Polliwog (Dancer or Wiggler) became a ballet dancer and is a staunch believer in exercise and alternative medicine.

Kloochman (Little Woman) became an art therapist, helping troubled children grow up.

Williwaw (Storm) is an independent thinker who often upsets the normal routine with innovative ideas. He is an electrical engineer working on our space program.

And Hee Hee Tum Tum (Happy Heart) grew up to be a computer engineer. Filled with creative ideas, his upbeat personality has garnered him hundreds of friends.

All of a sudden, the voice in my earplug was alive and saying, "Good job!"

Each book I've written has brought with it special challenges and unique rewards. When touring for *Prairie* (the story of a man who sought to clean up the politics in Wyoming but was killed before his dream was fulfilled), I traveled through snowstorms and sweltering heat, was given a branding iron with my initials, and was even conveyed by covered wagon, riding up hill, down hill, from one bookstore to the next. And as I traveled, I would eavesdrop for the way words sound together, the way people converse and the stories people tell. Then I would reshape and expand upon them, building them into a future story or scene. Writing and rewriting, again and again.

For me, writing is a joy when the words flow easily and when a sentence or paragraph says exactly what I want it to say. An author takes a chance when he writes, but I say be stubborn, take that chance, then stick with it and be logical. Ideas can wear thin, so I do not talk too much about what I am writing. I put everything on paper; on the computer. It can be rewritten and edited later. My novels have conflict, man against

nature, man against man. My protagonist must survive and like his author, he never gives up.

Anna Lee Waldo is the author of *Sacajawea, Prairie,* and *Circle of Stones.* She has also published several dozen papers in the fields of organic and biochemistry. None of these papers were best-sellers, but her historical novels were. With their five children grown, she and her husband now live where no one has to mow the lawn in summer or shovel snow in the winter.

32

Writing for Children

Zilpha Snyder

I came by my storytelling instincts honestly but their acquisition was all that was honest about them. It wasn't exactly that I was a liar. I don't think I told any more of the usual lies of childhood—those meant to get you out of trouble or get someone else into it—than most children. It was just that when I had something to tell I had an irresistible urge to make it worth telling, and without the rich and rather lengthy past that my parents had to draw on, I was forced to rely on the one commodity of which I had an adequate supply—imagination. Sometimes when I began an account of something I had heard or witnessed, my mother would sigh deeply and say, "Just tell it. Don't embroider it."

At the age of eight I became, in my own eyes at least, a writer. I sometimes say that I decided on a writing career as soon as it dawned on me that there were people whose life's work consisted of making up stories. Up until then my tendency to "make things up" was one of the things that came to mind when I repeated that phrase about "trespasses" in our nightly prayers. The idea that there were people who were paid, even praised, for such activities was intriguing. I began as most children do with poems and very short stories, and I was fortunate to have a

fourth-grade teacher who took an interest in what I was doing. She col-
lected my works, typed them, and bound them into a book. I loved it—
and her.

Books! Books were the window from which I looked out of a rather
meager and decidedly narrow room, onto a rich and wonderful universe.
I loved the look and feel of them, even the smell. I'm still a book sniffer.
That evocative mixture of paper and ink and glue and dust never fails to
bring back the twinge of excitement that came with the opening of a new
book. Libraries were treasure houses. I always entered them with a slight
thrill of disbelief that all their endless riches were mine for the borrow-
ing. And librarians: I approached them with reverent awe—guardians of
the temple, keepers of the golden treasure.

Lacking a refuge in books, would I have been forced to confront my
social inadequacies and set myself to learning the skills that would have
made me acceptable to my peers? Perhaps. But then I wonder if it would
really have been a fair trade. Would dances and parties and inexpert
kisses by pimply contemporaries have made me happier than did Mr.
Rochester, Heathcliff, the Knights of the Round Table, and the many
other heroes and heroic villains with whom I was intermittently in love?
Who's to say? In any event, I went on reading—and suffering—the daily
agony of the pre-teen outcast.

I went to college planning to be a writer. I wanted to live in New York
City, in an attic apartment, and write serious novels for serious people.
It's a good thing I didn't try it. New York City would have eaten me alive,
and that's without even trying to guess what the New York editors would
have done to me. The pages that have survived from the period suggest
that as a writer I still had the lively imagination of my childhood and
some feeling for the sound and sweep of a sentence. But style, theme,
subject matter, and even handwriting (I still didn't own a typewriter)
have a pronounced aura of puppy. Facing up to the fact that I didn't even
have the money for a ticket to New York City, I decided to teach, get mar-
ried, and have kids while the next ten years flew by.

In the early sixties the dust began to settle. I was still teaching but
there seemed to be a bit more time and I caught my breath and thought

about writing. Writing for children hadn't occurred to me when I was younger, but nine years of teaching in the upper elementary grades had given me a deep appreciation of the gifts and graces that are specific to individuals with ten or eleven years of experience as human beings. It is, I think, a magical time—when so much has been learned, but not enough to entirely extinguish the magical reach and freedom of early childhood. Remembering a dream I'd had when I was twelve years old— about some strange and wonderful horses—I sat down and began to write.

Now everyone has heard about the difficulties involved in selling a first book, the closets full of unpublished manuscripts, and walls papered with rejection slips, but I sold my first manuscript to the first publisher I sent it to. It's the truth, but not the whole truth: I received a long letter, two full pages, telling me what was wrong with my story. It was only at the very end that the editor stated that she would like to see it again, but only if I worked on it some more. I remember telling my husband that either she was slightly interested or I had just received the world's longest rejection slip. Finally, after the third complete rewriting, the book was accepted and I became a published writer.

Once, some years ago, during the question-and-answer period after a lecture, a man asked me why I wrote for children. "Do you do it for the pocket book, or just for the ego?" was the way he put it. He didn't give me any other choices, but there is another answer: I write for joy, the story-teller's joy in creating a tale and sharing it with an audience.

But why for children? Unlike many writers who say that they are not aware of a particular audience as they write, I know that I am very conscious of mine. Sometimes I can almost see them, and they look very much like the classes I taught and read to. When the story was going well, they were wide-eyed and open-mouthed, carried out of the constraining walls of reality into the spacious joys of the imagination.

I began to write for children through the fortunate accident of nine years in the classroom. But I've continued to do so because over the years I've come to realize that it's where I'm most happy. It is, I think, a matter of personal development (or lack of it, as the case may be).

There are several peculiarities that I share with children which, like having no front teeth, are perhaps more acceptable in the very young, but which, for better or worse, seem to be a part of my makeup. First of all, there is optimism. No one begrudges a child's natural optimism, but a writer's is another matter. It's not fashionable to write optimistically for adults, nor I must admit, even very sensible, given the world we live in today. But my own optimism seems to be organic, perhaps due to "a bad memory and a good digestion" (a quote that I can't attribute due to the aforementioned failing). Secondly, there is curiosity. Mine is as intense as a three-year-old's, but where a three-year-old's most obnoxious trait might be asking "why" several hundred times a day, I am given to eavesdropping on conversations, peering into backyards and lighted windows, and even reading other people's mail if I get a chance. And thirdly there is a certain lack of reverence for factual limitations and a tendency to launch out into the far reaches of possibility.

So I enjoy writing for an audience that shares my optimism, curiosity, and freewheeling imagination. I intend to go on writing for some time, and though I may occasionally try something for adults, I will always come back to children's books, where I am happiest and most at home.

Zilpha Snyder is the recipient of numerous awards, medals, and honors, including three Newbery Honor Book awards for *The Egypt Game, The Headless Cupid,* and *The Witches of Worm.* She has been writing books for children since 1964 and has since written and published thirty-seven books for children and young adults, four picture books, and a book of poetry. Her complete autobiography and list of awards can be found at http://www.microweb.com/lsnyder/.

33

To Fly
Without Wings

Jenny Davidow

CLIMBING UP TO the high scaffold of a trapeze, knees wobbly, I stand on the edge. I waver in the face of writing as honestly as I can, unsure there's a safety net below. Part of me wants to pull back, afraid I can't reach out far enough to grab the swing bar and take off. But I know I have to take this risk in order to be fully alive. It takes courage to kick out into empty space.

Recently, I learned that Anne Frank hid her diaries in her father's briefcase. When Anne's family was forced into hiding, the briefcase was hidden with them in the Secret Annex, which was up a stair, concealed behind a bookcase.

Anne was hiding her writing as well as herself. Her father's strong leather briefcase offered a sense of protection and privacy to her diary, the same way her father's presence gave her security in those uncertain times. No one would dare pry into Mr. Frank's locked bag, and Anne knew this. Now Anne's diary rested snugly inside this little oasis of privacy, along with the business papers Mr. Frank no longer needed.

I remember the intense excitement and recognition I felt at fourteen when I first read Anne's diary. Her words inspired me. She never doubted

the worthiness of telling her story and recording her thoughts, feelings and observations of others.

Looking at my teenage journals from thirty years ago, I realize that I learned three lessons from Anne Frank: I wrote to remember I was alive. I wrote to know I had a voice. I wrote to say I would survive.

But a fourth lesson eluded me: Anne wrote the truth. I hid the truth by not writing it down. Rather than hiding my notebooks in a briefcase or the linen closet, I hid them by writing only what would not reveal too much, would not incriminate me.

With wariness of my mother's prying, I attempted to say the dangerous truth and not say it at the same time. My desire to be free—but not too free—led me to develop my own code of partial truth, one that I did not know how to break. I wrote only half the story, sketching the outlines of my experience, but never filling in all the details, the shading of dark and light, the color. By cleaning up my thoughts for Mom and posterity, I lost touch with half of my humanity—the intimate, uncensored, juicy parts of myself.

I could have tried Anaïs Nin's solution to this dilemma: to keep two diaries, one a false front, and another which told the truth but presented it deceptively as fiction. This convoluted way of preserving the truth would have left me with a split identity, a false self to present to others and an authentic self which I felt I had to hide.

Writing summed up my life struggle—do I stay hidden or do I risk flying? Words can be walls of cool stone to hide behind. Or they can be rope bridges, swinging uncertainly above a deep canyon, connecting me to others.

For twenty-five years, my journal kept me going through the toughest times. It was a friend, as Anne described it, "more patient than man." Yet I became discontented. I did not feel more alive while writing in it, did not feel more aware from reading it, did not feel more connected to others by the very partial descriptions and stories within it. I wanted more— more of myself and more of the world. I wanted to touch the raw feeling that drove me away from myself and others. I wanted to take off my disguises and discover what was underneath, to meet myself and the truth without flinching.

I am not like Anne Frank, who was horribly deprived of freedom. But now I have learned her fourth lesson: I know that writing the truth keeps me free. Rather than being a retreat from living, an escape from the push and pull of life, writing my full story is as brave an assertion as swinging high above the earth on a trapeze.

Anne couldn't walk openly in the streets, but she found liberation in her diary. Her mind and heart were fresh and free and courageous. The pages of her diary, dumped out of the briefcase and scattered on the floor when she was taken away, turned out to be one of the most enduring personal histories of any era. The world came alive in her diary because her story was completely told. She described with equal honesty not just her own experience, but the bravery and fear of all the people in the Secret Annex.

It takes courage to write the truth. When I write without holding back, and share my writings with others, I feel more room inside, the uplifting sensation of deliverance. Writing helps me to be who I am. The tapestry is bigger and richer, I feel connected to other people, and that connection vibrates in my core and out into the world.

Jenny Davidow is the author of *Embracing Your Subconscious: Bringing All Parts of You Into Creative Partnership* and *The Dream Therapy Workbook*. She also holds a master's degree in psychology and a doctorate in clinical hypnotherapy. She currently teaches creative journaling, the topic of her next book. Jenny lives in the mountains above Santa Cruz, California, with her husband and three cats. Visit her Web site at http://members.cruzio.com/~twave.

34

A Storyteller's Soul

Collette Caron

I ONCE HEARD a story on writing that was attributed to Robertson
Davies, an icon of the Canadian literary scene. It went something like this:
there is a difference between storytellers and writers. A storyteller wanders
into the town square, puts down a blanket, sits on it, and begins to tell a
tale. Soon a crowd gathers, and half way through the recital, the teller of
tales passes the hat or the basket or the little tin cup. If the storyteller has
managed to enthrall the audience, the cup fills with offerings and tokens
of appreciation. A writer, on the other hand, applies for a literary grant.

I don't know if Mr. Davies really told that story, but it resonated within
me, because I have always felt more like a storyteller than a writer.
Although I have written more than twenty-four novels, with millions of
copies in every imaginable language and format, I'm embarrassed to
admit how little I know about the mechanics of writing. I simply use
words in a way that pleases me and reflects what I want to say. When my
kids bring me their homework and ask what the difference is between a
misplaced and a dangling modifier, I do my best not to admit that I do
not have a clue.

I have been a storyteller since my earliest memory. I have a particu-
larly fond recollection of being four or five years old, standing on a chair
beside my mother at the kitchen sink, and telling her a story—a retake

on a tale I had been told at Story Hour at the local library. I blush at my own ego, for even at that tender age, I felt that *my* way of telling it improved the story dramatically!

At that time, I didn't know what a tough and tragic childhood my Mom had experienced. I didn't know that she had been exhausted by betrayals and disappointments beyond what most people would endure. All I understood was that my Mom was sad, and that even when she was in the room with me, she was never quite there, with a distance in her eyes that I could not penetrate.

Until I told a story. And then my Mom asked questions and laughed. *Laughed.* And so, at a very young age, I got a powerful message about the capacity of the story—words and imagination united—to relieve pain, to heal, and to bring hope. A storyteller was born, standing on a chair at the kitchen sink, watching a light come on in her mother's eyes. Her emotional tin cup filled up.

But there were things I needed to get away from in my home, and my imagination gave me a place to go, where I could be in charge, and where everything went my way. I penned epic tales of mighty horses tamed by small girls, and completely rewrote the Western classic, *Shane*, only with a female protagonist. (I thought I improved that, too!) Writing fiction is a great career for people who love control.

I would have taken up a career telling stories but was told by an English teacher that I should be thinking of my future in terms of a real job. I finished high school and took a job as a switchboard operator, for all I wanted out of life was to have a car of my own and a horse. I soon had both, but was introduced to a part of myself that I had been blissfully unaware of.

My soul.

My soul hated being a switchboard operator. It spoke to me and told me that if I was going to spend eight hours a day, five days a week, for the next forty-five years doing work, it might as well be something I loved.

So, I quit my job (happily) and sold my horse (reluctantly) and went back to school. I also realized that drinking alcohol in copious amounts removed me from reality nearly as effectively as making up stories, but since I couldn't figure out a way to get paid for drinking, I chose a writing

career. I didn't have much faith, but my mother certainly did. My first fan was my Mom.

I took college journalism, but it almost killed my desire to write. It took something I loved and turned it into a job. And a boring one at that. If I had developed an allergy to answering phones, it couldn't hold a candle to how I came to feel about covering city hall meetings! Journalism did teach me a great deal, for it gave me a spareness of style I have never been able to shake.

I graduated college knowing I was never going to be a reporter. I was soon writing material for the Alberta Department of Education, and working a bit of freelance on the side.

Soul still wasn't thrilled. At all.

I tried to silence the grumblings of my soul by getting married, but that didn't work either. A few years later, in the middle of a painful divorce, I flipped on the TV and saw an interview with a woman, a romance novelist. Not only was she making more money than me, but she was happier than I was, too.

My soul said YES.

"Romance novels?" I asked. "You've got to be kidding!"

My soul was not kidding, and so I sat down to write my first novel, long hand, in a poorly lit government office surrounded by leaning files and dusty books. At first I only wrote on my lunch hours and on coffee breaks, but as the story progressed, I would forget sometimes to go back to the job I was being paid to do! Did I feel guilty for stealing time from the government? Not in the least. I felt passionate and alive, as if I was coming awake after years of being asleep.

Separated now, I would write sixteen hours a day on weekends, living on coffee and cigarettes. I was embarrassed to be so happy writing a romance novel! But the passion was contagious. The secretaries at work were volunteering to type just so they could read the next installment, but I also think they wanted to believe that dreams could come true and that ordinary lives could become extraordinary.

It never occurred to me that it might be hard to get my work published. My first three chapters came back from the romance giant, Harlequin, with an encouraging note. It wasn't quite what they wanted, but

they hoped to see something again. SOON. I took that as a sale, and the secretaries and I went into overdrive.

Harlequin did take my book—but it took two years because they made me rewrite it five times. During that time, I moved to British Columbia, where I wanted to live, and worked as a waitress in a place that was very similar to the Chewbaca bar in *Star Wars*. I slung beer until one or two in the morning, and then would go home to a little apartment with two pieces of furniture—a picnic table and my computer—where I would work on my book til dawn.

It's a good thing I finally sold that book because I was a terrible waitress. Soul simply does not allow me to excel at things that move my life in the wrong direction.

My first book was penned under the name Quinn Wilder, and my second, which went to Silhouette, used the pen name Cara Colter. I used these names because I wasn't sure if what I was doing was something I could be proud of. Despite these successes, I told myself that I would move onto things more important and meaningful than romantic fiction. There was lots of talk about the "great Canadian novel" and I thought I would probably write it one day.

While my professional life moved ahead comfortably, my personal life was a series of disasters. I enjoyed writing far more than I enjoyed the actual business of living, but the journey I was on was miserable. While my books were full of the light-hearted pursuit of love, my personal life was full of failed relationships, bouts of depression, and substance misuse. This is not soul's intent.

The birth of my daughter brought me to a moment of complete surrender. I looked at the mess I had made of my life, and knew I wanted something different—for myself, and for this tiny soul I had been entrusted with. I went to God, my life in a shambles, and I said, "Uh, do You think You could fix this?"

He could, He did, and I was put on a path that was finally guided by soul. Through meditation, gratitude, and prayer, I faced the realities of my painful past. I gave up tobacco and alcohol, for I had lost my desire to anesthesize my life.

My growth began to spill over into my books in subtle and lovely ways. My writing, once an escape mechanism from life, became something rich and full, an opportunity to be of service to God and my fellow man. My spirit, once wounded, began to soar, finding its way into my stories and life. Though I have completed the rough draft for a mystery novel, and I am dabbling with humorous poetry, I have no intention of "graduating" from writing romance novels. After all, they have allowed me to carry a most meaningful message to the world: that Love conquers all, that Love is the most powerful force in the Universe, and that miracles happen all the time. To embrace a lifestyle of spirit is to allow oneself to be surprised by the presence of God, *everywhere*.

My stories have become stories of ordinary people breaking free, finding themselves, embracing love, honoring their souls. Today, when I begin a book, I ask that my soul be open and that each word and page and chapter be allowed to sing with Spirit: joy, hope, strength, triumph, gratitude. I am always answered. My spirit comes out to play when I write, dancing in the air around me.

I don't write big, complicated, "literary" stories, but I have been given a gift—the ability to tell a story simply and straight from my heart. This gift, born in the pain of a less-than-perfect childhood, has become my greatest asset. And to me that is a miracle, pain making a metamorphosis, becoming Love.

Being a storyteller has brought me to a dream that is better than anything I had ever dreamed for myself. I look out of my office window over a white-covered field where five magnificent spotted horses are running, kicking up clouds of dazzling sunlit snow. Downstairs, I can hear the man I have spent a glorious decade with, and our three children playing Scrabble, arguing good-naturedly over how to spell a word. How could I not write about these wonderful garden-variety miracles that happen to ordinary people, like me, all the time?

I once got a letter from a reader in Russia who told me that my words, my story, had given her hope to live. In such moments, I know that the spirit of my mother, who died of breast cancer in 1995, comes to visit me. I can *feel* her pride, and I can *see* the light that is always on in her

now. I have come full circle, doing what I did as a child, when I stood beside her at the kitchen sink.

For fifteen years, I have been passing my little tin cup around village squares all over the world, using my words and imagination to relieve pain, to heal, and to bring hope.

My cup runneth over.

Collette Caron (pen names Cara Colter and Quinn Wilder) is the author of twenty-six books, including the recent three-book series, *Spring Weddings* (Cara Colter). Her 1999 release, *A Bride Worth Waiting For* (Cara Colter), is her personal favorite, a story about a young widow dealing with grief and arriving at a place where she can see the world, once again, as magical and exciting. She lives in a lush mountain valley in the wild Kootenay region of British Columbia, Canada, where she shares her life with her partner, three teenage boys, eight horses, and two cats. Collette is a motivational speaker and a devoted fundraiser for cancer research.

Part Three

Advice to Writers Young and Old

All good writing is built one good line at a time. You build a novel the same way you do a pyramid. One word, one stone at a time, underneath a full moon when the fingers bleed.

—KATE BRAVERMAN

Write with blood, and thou wilt find that blood is spirit.

—FREDERIC NIETZSCHE

As a writer I learned from Charlie Chaplin. Let's say the rhythm, the snap of comedy; the reserved comic presence—that beautiful distancing; the funny with sad; the surprise of surprise.

—BERNARD MALAMUD

I learn as much from painters about how to write as from writers. You ask how this is done? It would take a day of explaining. I should think what one learns from composers and from the study of harmony and counterpoint would be obvious.

—ERNEST HEMINGWAY

What is important? Living as active a life as possible, meeting all ranks of people, plenty of travel, trying your hand at various kinds of work, keeping your eyes, ears, and mind open, remembering what you observe, reading plenty of good books, and writing every day—simply writing.

—EDWARD ABBEY

Try again. Fail again. Fail better.

—SAMUEL BECKETT

"Why?" "What?" "When?" "Where?" "How?"

These are the questions most often asked by readers and students of the writing craft. What is the best advice an author can give? Are there rules to follow, rituals to perform, exercises to master? Must I write every day, whether I feel like it or not, or only when the inspiration strikes? And then there's the question of success: what do I have to do to get published, and how much money can I make? We hear the stories of million-dollar advances and we invest small sums in books: *How to Create the Perfect Novel, Secrets of the Publishing World, Writing for Profit and Fun.* But the real secret is that there is no right way to write—a truth that William Zinsser reveals in his essay when he compares two writers' styles. There are no ten commandments, no hard-and-set rules, nor promises of fortune or fame. Still, there is not a single author in this anthology (with the possible exception of Mark Twain) who would discourage a person from writing.

But writing is never an easy path to follow, as Janice MacDonald confesses in her piece. "Shouldn't I be refining cold fusion, or doing something U-S-E-F-U-L instead?" she pouts with each new novel she starts. Her comments touch home, for most of us will never earn a living from the stories and poems we create.

Throughout history, people did not yearn, as they do now, to make a career out of writing. The reasons for this are complex, filled with theories and facts. Prior to 1900, both reading and writing were primarily avocational acts, reserved for those who had the time, money, leisure, and educational background to invest in books. Libraries were few, bookstores were rare, and the publishing business itself was run by a small

entourage of entrepreneurs, many of whom cherished literary quality over financial success.[1]

Beginning in the 1950s, a transformation in power was slowly taking place. First, there was a substantial rise in reading, brought about by America's postwar emphasis on education. Magazine sales proliferated, and many were filled with outstanding short stories and poems. The media also promoted the public's interest in celebrity authors' lives. These forces may have encouraged a burgeoning interest in the craft, but books about writing were scarce (a rare exception was Brenda Ueland's *If You Want to Write,* a perennial classic published in 1938—an excerpt from which is included in this section). This, too, was about to change.

In the early 1960s, corporations began to merge the small, prestigious publishing houses into multinational conglomerates, and with this transition, the emphasis shifted from quality and literary craftsmanship to quantity and profitability. Publishers began to focus on authors and topics with the greatest popular appeal. Indeed, a mass-market readership was created, and with it—or in spite of it—a countercultural rebellion kicked in. Small presses sprang up and proliferated, publishing experimental poetry and radical prose. Within this underground market, new authors emerged who encouraged others to speak out and write. Throughout the country, universities developed expansive programs in literature and creative writing, embracing authors like Miller, Ginsberg, and Nin—writers who seemed to echo Brenda Ueland's advice: "Be careless! Be reckless! Be a lion or a pirate when you write!"

In 1978, Ueland's battle cry was picked up by a young writer named Natalie Goldberg. Her book, *Writing Down the Bones,* was filled with spiritual wisdom and wit, and it encouraged a new generation of writers and workshops and books. Several years later, a new memoir splashed upon the scene—Annie Dillard's *The Writing Life*—perhaps the most beautiful and bristling description of writing that has ever been published. Then came Anne Lamott, a self-described "cranky Christian," whose autobiographical *Bird by Bird* captured the world. These three books have come to represent the new American force in writing, encour-

aging millions of Americans, young and old, to surrender themselves to their muses. In this section, I have included representative excerpts from Goldberg and Lamott (Dillard's essay is in Part 1 of this book).

In constructing this section, I have included well-known advisors on the discipline of writing, beginning with an excerpt from Rainer Maria Rilke's *Letters to a Young Poet*. In this famous passage, written in 1903, he illuminates the spirit of creativity and the need to look deeply within for inspiration and strength. Rachel Naomi Remen, an oncologist by profession, complements Rilke's vision by emphasizing the healing power of poetry. But, if you're not moved by Rilke's and Remen's advice, you might try Mark Twain's cynical suggestion for curing poetic malaise: a gun! Another daring solution is offered by Joel Saltzman, who gave up the writing life to become a publisher himself.

I have also included an early piece of advice from Stephen King, who is much more than a master of horror, having written such classic tales as *Stand By Me* and *The Shawshank Redemption*. Don't do it for money, he insists. "Don't even do it for love, although it would be nice to think so. You do it because to not do it is suicide," he writes in his introduction to *Skeleton Crew,* a collection of stories. "The thing to do is to keep trying, I think. It's better to keep kissing and get your face slapped a few times than it is to give up altogether."

If you decide to submit your writing for publication, you'll find Eric Maisel's advice encouraging when handling the inevitable rejection slip: "Each time you are rejected and someone else is accepted, each time your literary agent fails to return your call but returns the call of a more favored writer, each time you pitch an idea which is booed but bought next year when your rival pitches it, each time your poem is smacked around or your manuscript drowned in red ink, remember: you must hold your own good opinion of yourself." But before you send that cherished manuscript to a prospective publisher, you might want to try a tactic used by Julius Goldstein, who seeks outs his dog for editorial advice, a technique that John Steinbeck also used. "When my red setter chewed up my manuscript *Of Mice and Men,* I said at the time that the dog must have been an excellent literary critic."

If I were to summarize the advice of these wise authors, it would be this: write because you want to write—not for the money, or the fame, or even for the glory of seeing your name in print. Write because you have something that has to be said, something that burns inside and needs to be shared with others. Write about your fears, your fantasies, your hopes and memories and dreams, about intimacies lost and found, the embarrassments and ecstasies and pains. Write dangerously and read everything you can—the classics, the poets, the experimental writers of today. Finally, write for the love of writing itself, for discovering the beauty of language and exposing the interior landscapes within.

Note

1. For a fascinating overview of the publishing world, as seen through the eyes of British and American publishers, read *Publishers on Publishing* (Bowker, Grosset & Dunlap, 1961, but unfortunately out of print), by Gerald Gross. Gross's more recent book, *Editors on Editing* (Grove Press, 1993), explores some of the dilemmas that corporate publishing has brought, and should be read by every writer (beginner or professional) who seeks to publish a book.

35

Letter to a Young Poet

Rainer Maria Rilke

Paris

17 February 1903

My dear sir,

Your letter reached me just a few days ago. I want to thank you for the deep and loving trust it revealed. I can do no more. I cannot comment on the style of your verses; critical intent is too far removed from my nature. There is nothing that manages to influence a work of art less than critical words. They always result in more or less unfortunate misunderstandings. Things are not as easily understood nor as expressible as people usually would like us to believe. Most happenings are beyond expression; they exist where a word has never intruded. Even more inexpressible are works of art; mysterious entities they are, whose lives, compared to our fleeting ones, endure.

Having said these things at the outset, I now dare tell you only this: that your verses do not as yet have an individual style. Yet they possess a quiet and hidden inclination to reveal something personal. I felt that very thing most notably in the last poem, "My Soul." There, something of your inner self wants to rise to expression. And in the beautiful poem,

"To Leopardi," something akin to greatness and bordering on uniqueness is sprouting out toward fulfillment. However, the poems cannot yet stand on their own merit, are not yet independent, not even the last one to Leopardi, not yet. In your kind letter accompanying them, you do not fail to admit to and to analyze some shortcomings, which I could sense while reading your verses, but could not directly put into words.

You ask whether your poems are good. You send them to publishers; you compare them with other poems; you are disturbed when certain publishers reject your attempts. Well now, since you have given me permission to advise you, I suggest that you give all that up. You are looking outward and, above all else, that you must not do now. No one can advise and help you, no one.

There is only one way: Go within. Search for the cause, find the impetus that bids you write. Put it to this test: Does it stretch out its roots in the deepest place of your heart? Can you avow that you would die if you were forbidden to write? Above all, in the most silent hour of your night, ask yourself this: *Must* I write? Dig deep into yourself for a true answer. And if it should ring its assent, if you can confidently meet this serious question with a simple, "I must," then build your life upon it. It has become your necessity. Your life, in even the most mundane and least significant hour, must become a sign, a testimony to this urge.

Then draw near to nature. Pretend you are the very first man and then write what you see and experience, what you love and lose. Do not write love poems, at least at first; they present the greatest challenge. It requires great, fully ripened power to produce something personal, something unique, when there are so many good and sometimes even brilliant renditions in great numbers. Beware of general themes. Cling to those that your everyday life offers you. Write about your sorrows, your wishes, your passing thoughts, your belief in anything beautiful. Describe all that with fervent, quiet, and humble sincerity. In order to express yourself, use things in your surroundings, the scenes of your dreams, and the subjects of your memory.

If your everyday life appears to be unworthy subject matter, do not complain to life. Complain to yourself. Lament that you are not poet

enough to call up its wealth. For the creative artist there is no poverty—nothing is insignificant or unimportant. Even if you were in a prison whose walls would shut out from your senses the sounds of the outer world, would you not then still have your childhood, this precious wealth, this treasure house of memories? Direct your attention to that. Attempt to resurrect these sunken sensations of a distant past. You will gain assuredness. Your aloneness will expand and will become your home, greeting you like the quiet dawn. Outer tumult will pass it by from afar.

If, as a result of this turning inward, of this sinking into your own world, *poetry* should emerge, you will not think to ask someone whether it is good poetry. And you will not try to interest publishers of magazines in these works. For you will hear in them your own voice; you will see in them a piece of your life, a natural possession of yours. A piece of art is good if it is born of necessity. This, its source, is its criterion; there is no other.

Therefore, my dear friend, I know of no other advice than this: Go within and scale the depths of your being from which your very life springs forth. At its source you will find the answer to the question, whether you *must* write. Accept it, however it sounds to you, without analyzing. Perhaps it will become apparent to you that you are indeed called to be a writer. Then accept that fate; bear its burden, and its grandeur, without asking for the reward, which might possibly come from without. For the creative artist must be a world of his own and must find everything within himself and in nature, to which he has betrothed himself.

It is possible that, even after your descent into your inner self and into your secret place of solitude, you might find that you must give up becoming a poet. As I have said, to feel that one could live without writing is enough indication that, in fact, one should not. Even then this process of turning inward, upon which I beg you to embark, will not have been in vain. Your life will no doubt from then on find its own paths. That they will be good ones and rich and expansive—that I wish for you more than I can say.

What else shall I tell you? It seems to me everything has been said, with just the right emphasis. I wanted only to advise you to progress quietly and seriously in your evolvement. You could greatly interfere with that process if you look outward and expect to obtain answers from the outside—answers which only your innermost feeling in your quietest hour can perhaps give you.

Rainer Maria Rilke (1875–1926) was the greatest lyric poet of modern Germany. His poetry was introspective and rich in visual imagery and symbolism. His books include *Stories of God, The Book of Hours, New Poems,* and *Duino Elegies,* which contain his highest praise of human existence.

36

A Sure-Fire Cure for Writer's Block

Mark Twain

I ALWAYS HAD taken an interest in young people who wanted to become poets. I remember I was particularly interested in one budding poet when I was a reporter. His name was Butter. One day he came to me and said, disconsolately, that he was going to commit suicide—he was tired of life, not being able to express his thoughts in poetic form. Butter asked me what I thought of the idea. I said that it was a good idea.

"You can do me a friendly turn. You go off in a private place and do it there, and I'll get it all. You do it, and I'll do as much for you some time."

At first he determined to drown himself. Drowning is so nice and clean, and writes up so well in a newspaper. But things ne'er do go smoothly in weddings, suicides, or courtships. Only there at the edge of the water, where Butter was to end himself, lay a life-preserver—a big round canvas one, which would float after the scrap-iron was soaked out of it. Butter wouldn't kill himself with the life-preserver in sight, and so I had an idea. I took it to a pawnshop, and soaked it for a revolver. The pawnbroker didn't think much of the exchange, but when I explained the situation he acquiesced.

We went up on top of a high building, and this is what happened to the poet: He put the revolver to his forehead and blew a tunnel straight through his head. The tunnel was about the size of your finger. You could look right through it. The job was complete; there was nothing in it. Well, after that, that man never could write prose, but he could write poetry. He could write it after he had blown his brains out.

There is lots of that talent all over the country, but the trouble is they don't develop it.

Mark Twain gave this speech at the Manhattan Dickens Fellowship on February 7, 1906, in commemoration of the ninety-fourth anniversary of the birth of Charles Dickens. When you compare this essay with "Littery Men," another tale about poets that appears in this anthology, you may indeed wonder what Twain's true sentiments were toward poets great and small.

37

Poetic Medicine

Rachel Naomi Remen

As a girl, I hated poetry. So, much more the irony that I have spent hours, even whole days, writing and reading poetry with people with cancer, with their doctors and their nurses, and with their family members. But this poetry is different from the poetry of my youth. Much of the old poetry was pretentious and erudite, full of references to mythology or the ancient Greeks, poetry whose words I could not easily understand. The poetry of my youth made me feel diminished.

But this poetry, this poetry makes me proud to be a human being.

Poetry is simply speaking truth. Each of us has a truth as unique as our own fingerprints. Without knowing that truth, without speaking it aloud, we cannot know who we are and that we are already whole. In the most profound way, speaking our truth allows us to know that our life matters, that our viewpoint has never existed before. That our suffering, our joy, our fears and our hopes are important and meaningful. One of the best kept secrets in this technically oriented culture is that simply speaking truth heals.

Often the first poem is the hardest, the one caught by a lifetime of being smaller than you are, trapped by your ideas of what art is, what an artist is, immobilized by the judgments of teachers whose names you

may never again remember. How did we come to forget that anything true is beautiful? How young were we then?

Writing poetry is contagious. Once past the first, we may discover that we have written poetry for years without knowing. Because no one was listening, not even we ourselves. Those of us on the Commonweal Cancer Help Retreat staff began by listening to the poems of people with cancer, then joining them in the writing sessions, and finally writing for ourselves just because we too are alive.

Our poetry allows us to remember that our integrity is not in our body, that despite our physical limitations, our suffering and our fears, there is something in us that is not touched, something shining. Our poetry is its voice. To hear that voice is to know the power to heal. To believe.

The first poem I ever wrote took me by surprise. Between one breath and the next, there was the truth of my own decades of chronic illness.

O body—
for 41 years
1,573 experts
with 14,355
combined years of training

to
cure
your
wounds.

Deep inside,

I
am
whole.

A lot of healing lies in the recovery of a personal sense of meaning, that capacity which enables us to endure difficulties, to find and draw

on unsuspected strength. In times of crisis, meaning *is* strength. But the deepest meaning is carried in the unconscious mind, whose language is the language of dreams, of symbols and archetypes. Poetry speaks this language, and helps us hear meaning in illness, in the events of our lives often for the first time. Finding such meaning feels like revelation. Like grace.

Writing poetry together heals loneliness. What is true for someone on the deepest level is often true for us all. Reading a poem aloud and listening to the poems of others can heal the alienation which is so much a part of our world. These days, much in life is masked. Poetry wears no mask. In taking off the masks we have worn to be safe, to protect ourselves, to win approval, we become less vulnerable. Less alone. Our pain becomes just pain. It is no longer suffering.

We may have lost faith in our ability to write poems, just as we have lost faith in our ability to heal. Recovering the poet strengthens the healer and sets free the unique song that is at the heart of every life.

Rachel Naomi Remen, M.D., is a pediatrician, psychotherapist, and medical director of Commonweal Cancer Help Program. Author of *The Human Patient, Kitchen Table Wisdom,* and *My Grandfather's Blessings,* she has pioneered new techniques in imagery and is a leader working with cancer and chronic illness.

38

It's Not the Money

Stephen King

A FRIEND OF MINE asked me a year or two ago why I still bother [to write short stories]. My novels, he pointed out, were making very good money, while the short stories were actually losers.

"How do you figure that?" I asked.

He tapped the then-current issue of *Playboy*, which had occasioned this discussion. I had a story in it ("Word Processor of the Gods," © 1983 by Stephen King), and had pointed it out to him with what I thought was justifiable pride.

"Well, I'll show you," he said, "if you don't mind telling me how much you got for the piece."

"I don't mind," I said. "I got two thousand dollars. Not exactly chicken-dirt, Wyatt."

(His name isn't really Wyatt, but I don't want to embarrass him, if you can dig that.)

"No, you didn't get two thousand," Wyatt said.

"I didn't? Have you been looking at my bankbook?"

"Nope. But I know you got eighteen hundred dollars for it, because your agent gets ten percent."

"Damn right," I said. "He deserves it. He got me in *Playboy*. I've always

wanted to have a story in *Playboy*. So it was eighteen hundred bucks instead of two thousand, big deal."

"No, you got $1,710."

"What?"

"Well, didn't you tell me your business manager gets five percent of the net?"

"Well, okay—eighteen hundred less ninety bucks. I still think $1,710 is not bad for—"

"Except it wasn't," this sadist pushed on. "It was *really* a measly $855."

"What?"

"You want to tell me you're not in a fifty-percent tax bracket, Steve-O?"

I was silent. He knew I was.

"And," he said gently, "it was *really* just about $769.50, wasn't it?"

I nodded reluctantly. Maine has an income tax which requires residents in my bracket to pay ten percent of their federal taxes to the state. Ten percent of $855 is $85.50.

"How long did it take you to write this story?" Wyatt persisted.

"About a week," I said ungraciously. It was really more like two, with a couple of rewrites added in, but I wasn't going to tell *Wyatt* that.

"So you made $769.50 that week," he said. "You know how much a plumber makes per week in New York, Steve-O?"

"No," I said. I hate people who call me Steve-O. "And neither do you."

"Sure I do," he said. "About $769.50, after taxes. And so, as far as I can see, what you got there is a dead loss." He laughed like hell and then asked if I had any more beer in the fridge. I said no.

I'm going to send goodbuddy Wyatt a copy of this book with a little note. The note will say: *I am not going to tell you how much I was paid for this book, but I'll tell you this, Wyatt: my total take on "Word Processor of the Gods"*—net—*is now just over twenty-three hundred dollars, not even counting the $769.50 you hee-hawed so over at my house at the lake.* I will sign the note *Steve-O* and add a PS: *There really was more beer in the fridge, and I drank it myself after you were gone that day.*

That ought to fix him.

Except it's not the money. I'll admit I was bowled over to be paid $2,000 for "Word Processor of the Gods," but I was equally as bowled over to be paid $40 for "The Reaper's Image" when it was published in *Startling Mystery Stories* or to be sent twelve contributor's copies when "Here There Be Tygers" was published in *Ubris*, the University of Maine college literary magazine (I am of a kindly nature and have always assumed that *Ubris* was a cockney way of spelling *Hubris*).

I mean, you're glad of the money; let us not descend into total fantasy here (or at least not yet). When I began to publish short fiction in men's magazines such as *Cavalier, Dude,* and *Adam* with some regularity, I was twenty-five and my wife was twenty-three. We had one child and another was on the way. I was working fifty or sixty hours a week in a laundry and making $1.75 an hour. *Budget* is not exactly the word for whatever it was we were on; it was more like a modified version of the Bataan Death March. The checks for those stories (on publication, never on acceptance) always seemed to come just in time to buy antibiotics for the baby's ear infection or to keep the telephone in the apartment for another record-breaking month. Money is, let us face it, very handy and very heady. As Lily Cavenaugh says in *The Talisman* (and it was Peter Straub's line, not mine), "You can never be too thin or too rich." And if you don't believe it, you were never really fat or really poor.

All the same, you don't do it for money, or you're a monkey. You don't think of the bottom line, or you're a monkey. You don't think of it in terms of hourly wage, yearly wage, even lifetime wage, or you're a monkey. In the end you don't even do it for love, although it would be nice to think so. You do it because to not do it is suicide. And while that is tough, there are compensations I could never tell Wyatt about, because he is not that kind of guy.

Take "Word Processor of the Gods" as a for-instance. Not the best story I ever wrote; not one that's ever going to win any prizes. But it's not too bad, either. Sort of fun. I had just gotten my own word processor a month before (it's a big Wang, and keep your smart comments to yourself,

what do you say?) and I was still exploring what it could and couldn't do. In particular I was fascinated with the INSERT and DELETE buttons, which make cross-outs and carets almost obsolete.

I caught myself a nasty little bug one day. What the hell, happens to the best of us. Everything inside me that wasn't nailed down came out from one end or the other, most of it at roughly the speed of sound. By nightfall I felt very bad indeed—chills, fever, joints full of spun glass. Most of the muscles in my stomach were sprung, and my back ached.

I spent that night in the guest bedroom (which is only four running steps from the bathroom) and slept from nine until about two in the morning. I woke up knowing that was it for the night. I only stayed in bed because I was too sick to get up. So there I lay, and I got thinking about my word processor, and INSERT and DELETE. And I thought, "Wouldn't it be funny if this guy wrote a sentence, and then, when he pushed DELETE, the subject of the sentence was deleted from the world?" That's the way just about all of my stories start; "Wouldn't it be funny if—?" And while many of them are scary, I never *told* one to people (as opposed to writing it down) that didn't cause at least some laughter, no matter what I saw as the final *intent* of that story.

Anyway, I started imaging on DELETE to begin with, not exactly making up a story so much as seeing pictures in my head. I was watching this guy (who is always to me just the I-Guy until the story actually starts coming out in words, when you have to give him a name) delete pictures hanging on the wall, and chairs in the living room, and New York City, and the concept of war. Then I thought of having him *insert* things and having those things just pop into the world.

Then I thought, "So give him a wife that's bad to the bone—he can delete her, maybe—and someone else who's good to maybe insert." And then I fell asleep, and the next morning I was pretty much okay again. The bug went away but the story didn't. I wrote it, and you'll see it didn't turn out exactly as the foregoing might suggest, but then—they never do.

I don't need to draw you a picture, do I? You don't do it for money; you do it because it saves you from feeling bad. A man or woman able to turn

his or her back on something like that is just a monkey, that's all. The story paid me by letting me get back to sleep when I felt as if I couldn't. I paid the story back by getting it concrete, which it wanted to be. The rest is just side effects.

Stephen King has sold over one hundred million copies of his fifty-plus books in print. He was teaching high-school English when his first manuscript, *Carrie* (fished out of the trash can by his wife), was purchased for a $2,500 advance. He recently landed an $8,000,000 advance for *Bag of Bones*. Married, with three grown children and a dog, he once confessed that he kept a fly-eating scorpion named Boris next to his typewriter. Oh, the idiosyncrasies of writers!

39

The Great Writer

Julia Cameron

LAST NIGHT I HAD a Great Writer over to dinner. He was one of a dozen people, all invited for roast chicken, corn-bread stuffing, salad, biscuits, and homemade pies—strawberry, peach, and cherry. It was a perfect summer evening and a perfect dinner. The conversation went around like the biscuits, everybody taking their turn and everybody sharing . . . until the Great Writer started talking about writing.

"There are too many people writing now," he grumped. "There are too many people who want to call themselves writers. I lived without heat to be a writer. I suffered . . ."

I nodded politely, determined not to get into it. I knew this soliloquy of the Great Writer. I knew the garret and the whole starving-artist story line—complete with the omitted wife so it all sounded like he did it with no support, no cheering section, and no fun at all. I wasn't going to be baited. My dinner guests, all of whom knew I saw writing very differently, kept flashing me glances. Was I going to let him get away with this elitist stuff? (Yes, the stuffing was delicious and he was just a stuffed shirt.)

"What does suffering have to do with art? What does no heat have to do with anything?" my daughter, Domenica, finally piped up. The Great Writer ignored her.

"I've suffered," the writer continued. "I fought to be a writer. That's how it was done in my day, only the strong survived."

A pall fell over the table. A great many of the diners loved to write, but none was so illustrious as the curmudgeon holding forth.

The Great Writer continued. "I don't mind if people write to express themselves, but they shouldn't call themselves writers or really call it writing. They're not real writers. And you, Julia, with that book of yours [*The Artist's Way*], I don't care if four million people buy it. All it's good for is propping up tables. Everybody shouldn't write. All that slush keeps the good writers from being published. Writing isn't for amateurs."

Now he had me.

"I'm offended," I said. "I'm offended for me and for everybody else you're talking about. I believe people have the right to write. I don't believe that writers are like salmon and the truly gifted and strong are the ones who make it. I think—I know from my teaching—that some of the most beautiful voices we have have been silenced. They had a cruel teacher or parent, some creative accident or mishap. If I can help restore those voices—that's what I am after. Some of my students are in their mid-fifties and have always wanted to write, and when they do they write like angels. We all have the right to write."

The Great Writer glowered. "So what do you want me to do? Leave?"

"Stop being such a _____ in my face at my dinner table," I said. "Have some pie."

"No, thank you."

And the Great Writer huffed off to the living room to sulk while the rest of us finished eating. When coffee was served, a young woman painter drifted in to sit by his side. He began holding forth again.

"I tell my students Joyce was a great writer. Joyce I would give an A. All of you in here, the best you can get from me is an A minus unless you can show me you've got something more than Joyce." The Great Writer pontificated.

Trying to concentrate on my slice of strawberry pie, I found my stomach twisting in knots. This Great Writer ran a creative writing program.

He should have spelled it "pogrom." I winced at the damage his compet-
itive machismo could do to a sensitive young writer.

As the evening wound down, the Great Writer came up to say
good-bye.

"You'll really hate what I am writing now," I told him. "I am arguing
that the term 'writer' should be abolished. I am arguing that everybody
should write. That we should have a million amateur writers making
novels just for the hell of it. Hell, we all begin as amateurs. Have you
forgotten that?"

The Great Writer clearly had. He began to backpedal. "We're all
worms," he said. "I'd use anybody's book but my own for toilet paper."

With that he left.

After he had gone, the rest of the dinner party sat around and played
detox.

"I've heard that line of his forever," Nave said. "It's just elitist postur-
ing. What's worse, it's one step away from censorship. Only 'Great Writ-
ers' should be allowed to write? Who decides who they are? Doesn't it
come down, then, to approving of what they decide to write? I think it
does. And that is censorship. What's he so threatened about? He's got a
little club and he wants to keep everybody out."

I want to let everybody in. I want us all to write. I want us to remem-
ber that we used to write. Before phones, we wrote each other letters.
We're doing it again with e-mail, and I think it's a balancing of the wheel.
We have been going too fast and we know that. Taking the time to write
something down grounds us. Taking the time to write how we feel helps
us to know how we feel. Taking the time to write to each other, we find
ourselves doing more right by each other. Yes, I want a revolution.

I want us to take back the power into our own hands. I want us to
remember we have choices and voices. I want us to right our world, and
writing is the tool I feel helps us to do it. We are a restless lot here in the
West. We do not take easily to meditation. Writing is an active form of
meditation that lets us examine our lives and see where and how we can
alter them to make them more sound.

Yes, writing is an art, but "art" is part of the verb "to be"—as in "Thou art truly human." To be truly human, we all have the right to make art. We all have the right to write.

Julia Cameron, the author of seventeen books, including *The Artist's Way, The Vein of Gold, The Right to Write,* and *God Is No Laughing Matter,* is an active artist who teaches internationally. A novelist, playwright, musician, and poet, she has extensive credits in film, television, and theater.

40

The "Right" Way
to Write

William Zinsser

A SCHOOL IN Connecticut once held "a day devoted to the arts," and I was asked if I would come and talk about writing as a vocation. When I arrived I found that a second speaker had been invited— Dr. Brock (as I'll call him), a surgeon who had recently begun to write and had sold some stories to magazines. He was going to talk about writing as an avocation. That made us a panel, and we sat down to face a crowd of students and teachers and parents, all eager to learn the secrets of our glamorous work.

Dr. Brock was dressed in a bright red jacket, looking vaguely bohemian, as authors are supposed to look, and the first question went to him. What was it like to be a writer?

He said it was tremendous fun. Coming home from an arduous day at the hospital, he would go straight to his yellow pad and write his tensions away. The words just flowed. It was easy. I then said that writing wasn't easy and wasn't fun. It was hard and lonely, and the words seldom just flowed.

Next Dr. Brock was asked if it was important to rewrite. Absolutely not, he said. "Let it all hang out," he told us, and whatever form the

sentences take will reflect the writer at his most natural. I then said that rewriting is the essence of writing. I pointed out that professional writers rewrite their sentences over and over and then rewrite what they have rewritten.

"What do you do on days when it isn't going well?" Dr. Brock was asked. He said he just stopped writing and put the work aside for a day when it would go better. I then said that the professional writer must establish a daily schedule and stick to it. I said that writing is a craft, not an art, and that the man who runs away from his craft because he lacks inspiration is fooling himself. He is also going broke.

"What if you're feeling depressed or unhappy?" a student asked. "Won't that affect your writing?"

Probably it will, Dr. Brock replied. Go fishing. Take a walk. Probably it won't, I said. If your job is to write every day, you learn to do it like any other job.

A student asked if we found it useful to circulate in the literary world. Dr. Brock said he was greatly enjoying his new life as a man of letters, and he told several stories of being taken to lunch by his publisher and his agent at Manhattan restaurants where writers and editors gather. I said that professional writers are solitary drudges who seldom see other writers.

"Do you put symbolism in your writing?" a student asked me.

"Not if I can help it," I replied. I have an unbroken record of missing the deeper meaning in any story, play or movie, and as for dance and mime, I have never had any idea of what is being conveyed.

"I *love* symbols!" Dr. Brock exclaimed, and he described with gusto the joys of weaving them through his work.

So the morning went, and it was a revelation to all of us. At the end Dr. Brock told me he was enormously interested in my answers—it had never occurred to him that writing could be hard. I told him I was just as interested in *his* answers—it had never occurred to me that writing could be easy. Maybe I should take up surgery on the side.

As for the students, anyone might think we left them bewildered. But in fact we gave them a broader glimpse of the writing process than if only

one of us had talked. For there isn't any "right" way to do such personal work. There are all kinds of writers and all kinds of methods, and any method that helps you to say what you want to say is the right method for you. Some people write by day, others by night. Some people need silence, others turn on the radio. Some write by hand, some by word processor, some by talking into a tape recorder. Some people write their first draft in one long burst and then revise; others can't write the second paragraph until they have fiddled endlessly with the first.

But all of them are vulnerable and all of them are tense. They are driven by a compulsion to put some part of themselves on paper, and yet they don't just write what comes naturally. They sit down to commit an act of literature, and the self who emerges on paper is far stiffer than the person who sat down to write. The problem is to find the real man or woman behind the tension.

William Zinsser became Master of Branford College in 1973. He has been a columnist for the *New York Herald Tribune* and *Life* and has contributed regularly to *The New Yorker.* Among the books he has written are *On Writing Well, The Lunacy Boom,* and *The Haircurl Papers and Other Searches for the Lost Individual.* He has edited other books on writing.

41

The Courage to Write

Harriet Lerner

DURING MOST OF my growing-up years in Brooklyn I kept one of those lock-and-key diaries. This helped me to see writing as an ordinary daily activity, to not be afraid of seeing my words on paper, and to understand the act of writing as comforting. And my diaries were my place to tell the truth, although I didn't always do that.

Was there a glimpse of future talent in those diaries?

Absolutely none. No evidence of literary talent, insight, imagination, or even courage. Today, when I'm invited to talk to students in the public schools, I bring a diary along and pass it around. If I'm going into a sixth-grade class, I bring my sixth-grade diary.

The students are enthralled. They thumb through the pages and say to one another, "Wow, if she can write a book, I can do it too!" They realize that writers don't have fairy dust sprinkled on them. We're just plain folks.

Isn't that very brave—passing your diaries around?

When you reach fifty, your life is no longer embarrassing, because you realize that everyone's life is embarrassing.

So many women want to write and don't dare or think they can't. Do you really believe that anyone can write?

I don't think there is a writing gene, or a publishing gene, although some people have a larger share of natural talent and luck. But I believe that writing, like conversation, is a basic form of human communication rather than the property of a gifted few.

We should not allow someone to discourage us from writing any more than we should allow someone to discourage us from talking. If another person tells you that you can't write—well, disbelieve them.

Writing is so difficult that I sometimes wonder what motivates writers to write?

Many, many things move us to write. We can write as a spiritual practice, like climbing a sacred mountain, as Deena Metzger puts it. Or writing can be the tactic of a "secret bully," as novelist Joan Didion reminds us—"a way to say listen to me, see it my way, change your mind." Many of us write with modest goals, like to change the world.

I know that you've been critical of so many experts jumping on the advice-giving bandwagon. So how did you get into writing self-help books?

With enormous reservations, actually. I think women can't be cautious enough in facing the advice-giving industry, which is a multibillion-dollar business sensitively attuned to our insecurities, our purses, and our endless and impossible pursuit of perfection.

But the truth is, I've come to love and value writing self-help books. And I've managed to avoid recipes for success, quick-fix solutions, and blueprints for relational bliss.

So you didn't start out seeing yourself as a "popular writer"?

Definitely not. First I published in scholarly journals and scientific publications. It was a sudden and unexpected turn in my career when I wrote *The Dance of Anger* in "just plain English" and for "just plain folks."

It was an incredibly difficult transition, but I was dedicated to the task. Anyone who thinks that it's simpler to write simply has never done it, or has never done it well. Of course, I had many worries at the time.

Like?

Like I was worried that my colleagues would write me off. And I wondered whether a book could really change people's lives.

And what did you conclude?

Some self-help books do change people's lives. I know, because many, many people have told me so and I believe them. I've been incredibly moved by the response to my work.

And surprised?

Yes, very much so. As a psychotherapist I know that substantive change often occurs slowly, sometimes at glacial speed. So it has amazed me to see how people can take an idea from a book and just run with it.

When you were working on The Dance of Anger, *did you know that other books would follow?*

No way. *The Dance of Anger* was a five-year project with endless revisions—and this was in the days before I had a computer. I could wallpaper the largest room in my house with rejection slips from my first book. When it finally was published, I was convinced no one would read it besides my mother and my seven best friends. And I said, "I will never do this again. Never. It's too hard."

But you kept writing more books?

Yes I did. But I learned that the line between being a *New York Times* bestselling author and being a writer who never gets published at all—well, it's a thin line indeed.

And do you have any thoughts about what makes the difference between success and failure?

Perseverance, talent, and yes, luck.

Why do you write for women, when you're an expert in families and relationships?

There is a long and short answer to that question. The short answer is that I write for women because I want to, it's where my heart is. Men read my books as well, usually because their therapists tell them to. And of course, they find themselves in them. On most days I believe humans are more alike than different.

I know that you identify yourself as a feminist. How has the feminist movement influenced your writing?

How hasn't it? My debt to feminism is simply incalculable. Feminism allowed me to see past a "reality" that I had once taken as a given. It helped me to pay attention to countless voices, my own included, that I had been taught "don't count." Feminism allows me to maintain hope.

What do you most want to accomplish in your books?

I want to help people navigate their relationships in clear and solid ways. Learning a bunch of "techniques" won't cut it. I want my readers to understand how relationships operate and why they go badly. And this includes seeing the part that we ourselves play in the problems that bring us pain. And I want readers to see the broader picture of injustice and inequality that affects us all. There is never a resting place in the struggle for a fair world. I once heard Maya Angelou say that courage was the most important of all virtues. Because without courage, we can't practice any of the virtues—patience, honesty, forgiveness—with consistency. I agree with her.

Do you see yourself as a courageous woman?

Not in terms of facing physical challenges, like say, climbing a mountain or rushing into a burning building to attempt a rescue. I'm not heroic. But I'm brave in terms of speaking out and saying what I think, even if my heart is pounding and I'm terrified. Without this kind of courage, I might as well not write.

Harriet Lerner, Ph.D, is a clinical psychologist and psychotherapist at the Menninger Clinic in Topeka, Kansas, and a faculty member of the Karl Menninger School of Psychiatry. She has authored seven books, including *The New York Times* best-seller *The Dance of Anger* and, most recently, *The Mother Dance: How Children Change Your Life.* For more than a decade her monthly advice column appeared in *New Woman* magazine. She also writes children's books with her sister, Susan Goldhor. You can visit her Web site at www.harrietlerner.com.

42

When? Why? What? Where? Answers to Questions Inevitably Asked

Janice MacDonald

PEOPLE ASK ME if I always wanted to be a writer and I usually answer yes, because I know that's what all the Language Arts teachers hosting the school visit want to hear me say. The truth is, I don't recall ever particularly *wanting* to be one, and even now I'm not sure I want to be a writer. However, I have always been a writer and I'm not sure it's something you can escape. Even when I was small and dithered between becoming an elevator operator or a concert pianist, writing was what I did that set me apart from the rest of the crowd. You probably were, or grew up with someone very much like me. We were the ones who always came up with the next line in games of *Let's Pretend*, allowing all of us to get off the weeping willow island and past the flying crocodiles, and back to the safety and sanctuary of under the steps. Back then you thought we were just bossy, but heck, someone had to keep the story going. If it weren't for people like us, we would all still be under that tree.

I have to confess that I spend a great portion of my life thinking I shouldn't be wasting my time writing. I should be working in the inner city, I should be refining cold fusion, I should be doing something U-S-E-F-U-L. How can I presume that anything I write might be of value? Who appointed me scribe or visionary or cultural historian? Shouldn't I, and indeed all writers, be out rolling bandages or digging wells in Africa?

Then a book makes me cry or laugh out loud. Or I am so taken with the phrasing of a certain passage that I just have to wake my husband up to share it with him. Or a little kid comes up to me at a library reading and gives me a hug because he feels like he knows me from my books. Or a woman tells me that an article I've written has expressed exactly how she felt as a single parent. That's when I know that writing can change the world. I can put down the applications to UNESCO and go back to daydreaming after all.

Once I'm past the hurdle of whether or not I should be writing, I get to the *what* question. Should I be working on the next kids' book, even without a commitment from the publisher? Should I be trolling for steady editorial work? Should I stop writing on spec? Should I stop jumping between genres and settle down to either be a mystery writer, a kids' writer, a nonfiction writer, or what?

Of course, I am not a big planner, nor a careful career constructor. I may know how to construct a plot, but trust me, my finances are a mess. I just write what I feel like writing, in between writing what I get hired to write. "What I feel like writing" is not necessarily feel-good writing. Some of the topics stem from issues that come burbling up to the surface and need to be therapeutically dealt with. Some others are gifts that happen, dropping into my mind or my life like manna, that edible insect product. And some of the stories that get written happen because they just won't go away until I do something about them.

Several stories came out of my divorce. In fact, I attended a *Parenting After Separation* workshop that was mandatory for parents suing for divorce in our province. There was a section on dealing with anger, and we were asked to share various means with which we filtered our anger

with our former spouses. "Revving my engine in her driveway," "forgetting to pack the kids' snowpants for their weekends with him," and "phoning her up after the kids are asleep to yell at her" were all listed under the heading of "bad" ways to deal with the frustrations we all were feeling. My mumbled admission of "I've killed him off in three short stories" went up on the "good" side of the blackboard, and was lauded as therapeutic. Go figure. Whatever the case, I've managed to sell two of the three stories.

Of course I take inspiration from my own life. It's not that I think I am so very interesting, it's just that I think *life* is fascinating. The things that happen to me are probably very much like the things that happen to you. The reason for mine appearing on paper, though, is that writing them down helped me to make sense of them. I toss them on the page, like spaghetti against the wall to test its readiness. As it all slides about, I quickly jump metaphors and try to find some sense in the entrails. I have managed to work elements like my family relationships, my hideous adolescence, my educational experience, my divorce, the bout of single parenthood, the breast lump scare, the courtship with my present husband, and teaching college students into various fictions and literary attempts. These things transform as they hit the paper, much like shrimp chips hitting hot oil. They stop being situations and become scenes. They are now artifacts, not heartaches; anecdotes instead of actual events. Once I can get over the immediacy of the experience, and begin to prod and poke, it often ceases to perturb and begins to intrigue.

I hasten to add that nobody sees my writing at this stage of the game. As I tell my students in college communications classes, just because your essay is within the realm of "nonfiction" and thus, by extension, has to be "truthful," doesn't mean that every minute section of your life has to be recorded within the construct. Being the writer means *you* are the one who gets to decide which moments are most important. This is the only perk to being a writer: you get to choose your own narrative moments. I don't mean to say that I am advocating lying about events in your life. I never lie about the strange and funny things which happen to me. I do admit, however, to embroidering, winnowing, and teasing things into a

presentable package. We all do. We are always the heroes of our own stories, regardless of what David Copperfield or J. Alfred Prufrock might think.

So there are my true answers to the questions writers inevitably get asked. *Did you always want to be a writer?* I think choices like that are made for you. *Why do you write?* I write because I can't help but write. *Where do you get your ideas?* I write what appears and what seems to need to be written; and I write to make sense of my world for myself and those who wish to come along for the ride. Of course, I don't tell these answers to everyone, because everyone isn't looking for the truth. Usually I just say: *Yes; So I can be included in nifty anthologies,* and *I eavesdrop on public transit.*

Janice MacDonald was born in Banff, Canada, and grew up in Edmonton, where she still lives. She studied English literature at the University of Alberta and, when not freelancing, writing, or giving writing workshops, teaches communications, writing, and English literature at Grant MacEwan College. Best known as a mystery writer, she is the author of *Sticks and Stones, True North: Canadian Essays for Composition, The Ghouls' Night Out, The Next Margaret, Canoeing Alberta,* and *The Northwest Fort.* She has two wonderful daughters and one glorious husband. She also has a very nice mother.

43

Be Careless, Be Reckless, Be a Lion or a Pirate When You Write

Brenda Ueland

I WANT TO tell some things I have learned about writing from my class.

Though everybody is talented and original, often it does not break through for a long time. People are too scared, too self-conscious, too proud, too shy. They have been taught too many things about construction, plot, unity, mass and coherence.

My little brother wrote a composition when he was twelve and almost every third sentence was: "But alas, to no avail!" That is the sort of thing that everybody does for many years. That is because they have been taught that writing is something special and not just talking on paper.

Another trouble with writers in the first twenty years is an anxiety to be effective, to impress people. They write pretentiously. It is so hard not to do this. That was my trouble.

For many years it puzzled me why so many things I wrote were pretentious, lying, high-sounding, and in consequence utterly dull and uninteresting. It was a regular horror to read them again. Of course they did not sell either, not one of them.

The explanation of this I learned from my class. Again and again after a few weeks of a kind of rollicking encouragement, they would all—even those whose work seemed hopelessly dull, trite, angular and commonplace—they would break through this, as from a cocoon, and write suddenly in a living, true, touching, remarkable way. It would happen suddenly, overnight. They would break through from composition-writing, theme-writing, to some freedom and honesty and to writing with what I call "microscopic truthfulness."

What made them do this? I think I know. I think I helped them to do it. And I did not do it by criticism, i.e., by pointing out all the mediocrities in their efforts (and so making them contract and try nervously to avoid all sorts of faults). I helped them by trying to make them feel freer and bolder. Let her go! Be careless, reckless! Be a lion, be a pirate! Write any old way.

Francesca helped me to understand this. When giving violin lessons she never tells a child that he is playing a bad note. Why do that? He knows it himself. All are trying to get nearer and nearer to the true pitch, to perfection, anyway. Why fix their attention on the avoidance of mistakes? It just tightens them up, contracts them, and makes them dislike lessons. Moreover, when they are thinking so vividly about the bad notes that they are warned to avoid, they play them again and again, just as a man learning to ride a bicycle goes into the tree he is afraid of. To play a note *truly,* as the simplest person knows, your mind must be on the true note, your Imagination hearing it as you *want* to play it.

I found that many gifted people are so afraid of writing a poor story that they cannot summon the nerve to write a single sentence for months. The thing to say to such people is: "See how *bad* a story you can write. See how dull you can be. Go ahead. That would be fun and interesting. I will give you ten dollars if you can write something thoroughly dull from beginning to end!" And of course no one can.

Brenda Ueland's classic book, *If You Want to Write,* was first published in 1938. Carl Sandburg considered it "the best book ever written about how to write." She was part of the Greenwich Village bohemian crowd and was knighted by the king of Norway. She died in 1985 at the age of 93.

44

Man Eats Car

Natalie Goldberg

THERE WAS AN ARTICLE in the newspaper several years ago—I did not read it, it was told to me—about a yogi in India who ate a car. Not all at once, but slowly over a year's time. Now, I like a story like that. How much weight did he gain? How old was he? Did he have a full set of teeth? Even the carburetor, the steering wheel, the radio? What make was the car? Did he drink the oil?

I told this story to a group of third-graders in Owatonna, Minnesota. They were sitting on the blue carpet in front of me. The students looked confused and asked the most obvious question, "Why did he eat a car?," and then they commented, "Ugh!" But there was one bristling, brown-eyed student, who will be my friend forever, who just looked at me and burst into tremendous laughter, and I began laughing too. It was fantastic! A man had eaten a car! Right from the beginning there is no logic in it. It is absurd.

In a sense, this is how we should write. Not asking "Why?," not delicately picking among candies (or spark plugs), but voraciously, letting our minds eat up everything and spewing it out on paper with great energy. We shouldn't think, "This is a good subject for writing." "This we shouldn't talk about." Writing is everything, unconditional. There is no separation between writing, life, and the mind. If you think big enough

to let people eat cars, you will be able to see that ants are elephants and men are women. You will be able to see the transparency of all forms so that all separations disappear. . . .

Your mind is leaping, your writing will leap, but it won't be artificial. It will reflect the nature of first thoughts, the way we see the world when we are free from prejudice and can see the underlying principles. We are all connected. Metaphor knows this and therefore is religious. There is no separation between ants and elephants. All boundaries disappear, as though we were looking through rain or squinting our eyes at city lights.

Natalie Goldberg is the author of *Writing Down the Bones* and five other books, including a novel, *Banana Rose*. Her latest book, *Living Color: A Writer Paints Her World,* is about painting as a second art form. She lives, writes, and exhibits her art in Taos, New Mexico.

$$45$$

Shitty
First Drafts

Anne Lamott

FOR ME AND most of the other writers I know, writing is not rapturous. In fact, the only way I can get anything written at all is to write really, really shitty first drafts. . . .

I used to write food reviews for *California* magazine before it folded. (My writing food reviews had nothing to do with the magazine folding, although every single review did cause a couple of canceled subscriptions. Some readers took umbrage at my comparing mounds of vegetable puree with various ex-presidents' brains.) These reviews always took two days to write. First I'd go to a restaurant several times with a few opinionated, articulate friends in tow. I'd sit there writing down everything anyone said that was at all interesting or funny. Then on the following Monday I'd sit down at my desk with my notes, and try to write the review. Even after I'd been doing this for years, panic would set in. I'd try to write a lead, but instead I'd write a couple of dreadful sentences, xx them out, try again, xx everything out, and then feel despair and worry settle on my chest like an x-ray apron. It's over, I'd think, calmly. I'm not going to be able to get the magic to work this time. I'm ruined. I'm through. I'm toast. Maybe, I'd think, I can get my old job back as a

clerk-typist. But probably not. I'd get up and study my teeth in the mirror for a while. Then I'd stop, remember to breathe, make a few phone calls, hit the kitchen and chow down. Eventually I'd go back and sit down at my desk, and sigh for the next ten minutes. Finally I would pick up my one-inch picture frame, stare into it as if for the answer, and every time the answer would come: all I had to do was to write a really shitty first draft of, say, the opening paragraph. And no one was going to see it.

So I'd start writing without reining myself in. It was almost just typing, just making my fingers move. And the writing would be *terrible*. I'd write a lead paragraph that was a whole page, even though the entire review could only be three pages long, and then I'd start writing up descriptions of the food, one dish at a time, bird by bird, and the critics would be sitting on my shoulders, commenting like cartoon characters. They'd be pretending to snore, or rolling their eyes at my overwrought descriptions, no matter how hard I tried to tone those descriptions down, no matter how conscious I was of what a friend said to me gently in my early days of restaurant reviewing. "Annie," she said, "it is just a piece of *chick*en. It is just a bit of *cake*."

But because by then I had been writing for so long, I would eventually let myself trust the process—sort of, more or less. I'd write a first draft that was maybe twice as long as it should be, with a self-indulgent and boring beginning, stupefying descriptions of the meal, lots of quotes from my black-humored friends that made them sound more like the Manson girls than food lovers, and no ending to speak of. The whole thing would be so long and incoherent and hideous that for the rest of the day I'd obsess about getting creamed by a car before I could write a decent second draft. I'd worry that people would read what I'd written and believe that the accident had really been a suicide, that I had panicked because my talent was waning and my mind was shot.

The next day, though, I'd sit down, go through it all with a colored pen, take out everything I possibly could, find a new lead somewhere on the second page, figure out a kicky place to end it, and then write a second draft. It always turned out fine, sometimes even funny and weird and helpful. I'd go over it one more time and mail it in.

Then, a month later, when it was time for another review, the whole process would start again, complete with the fears that people would find my first draft before I could rewrite it.

Almost all good writing begins with terrible first efforts. You need to start somewhere. Start by getting something—anything—down on paper. A friend of mine says that the first draft is the down draft—you just get it down. The second draft is the up draft—you fix it up. You try to say what you have to say more accurately. And the third draft is the dental draft, where you check every tooth, to see if it's loose or cramped or decayed, or even, God help us, healthy.

What I've learned to do when I sit down to work on a shitty first draft is to quiet the voices in my head. First there's the vinegar-lipped Reader Lady, who says primly, "Well, *that's* not very interesting, is it?" And there's the emaciated German male who writes these Orwellian memos detailing your thought crimes. And there are your parents, agonizing over your lack of loyalty and discretion; and there's William Burroughs, dozing off or shooting up because he finds you as bold and articulate as a houseplant; and so on. And there are also the dogs: let's not forget the dogs, the dogs in their pen who will surely hurtle and snarl their way out if you ever *stop* writing, because writing is, for some of us, the latch that keeps the door of the pen closed, keeps those crazy ravenous dogs contained.

Quieting these voices is at least half the battle I fight daily. But this is better than it used to be. It used to be 87 percent. Left to its own devices, my mind spends much of its time having conversations with people who aren't there. I walk along defending myself to people, or exchanging repartee with them, or rationalizing my behavior, or seducing them with gossip, or pretending I'm on their TV talk show or whatever. I speed or run an aging yellow light or don't come to a full stop, and one nanosecond later am explaining to imaginary cops exactly why I had to do what I did, or insisting that I did not in fact do it.

I happened to mention this to a hypnotist I saw many years ago, and he looked at me very nicely. At first I thought he was feeling around on the floor for the silent alarm button, but then he gave me the following exercise, which I still use to this day.

Close your eyes and get quiet for a minute, until the chatter starts up. Then isolate one of the voices and imagine the person speaking as a mouse. Pick it up by the tail and drop it into a mason jar. Then isolate another voice, pick it up by the tail, drop it in the jar. And so on. Drop in any high-maintenance parental units, drop in any contractors, lawyers, colleagues, children, anyone who is whining in your head. Then put the lid on, and watch all these mouse people clawing at the glass, jabbering away, trying to make you feel like shit because you won't do what they want—won't give them more money, won't be more successful, won't see them more often. Then imagine that there is a volume-control button on the bottle. Turn it all the way up for a minute, and listen to the stream of angry, neglected, guilt-mongering voices. Then turn it all the way down and watch the frantic mice lunge at the glass, trying to get to you. Leave it down, and get back to your shitty first draft.

A writer friend of mine suggests opening the jar and shooting them all in the head. But I think he's a little angry, and I'm sure nothing like this would ever occur to you.

Anne Lamott is the author of five novels, including *Hard Laughter, Rosie,* and *Crooked Little Heart.* She wrote *Bird by Bird: Some Instructions on Writing and Life,* and *Traveling Mercies,* a collection of autobiographical essays on faith. She has been honored with a Guggenheim Fellowship and has taught at the University of California, Davis. Lamott's biweekly *Salon Magazine* online diary *Word by Word* was voted The Best of the Web by *Time* magazine.

46

A Writer's Best Friend

Julius Goldstein

AFTER FORTY AND MORE years of the precise and confining work of a dentist I resolved to free myself; to go from filling teeth to fulfilling myself. I decided after much soul searching to become a writer.

I started writing in a tentative way, confronting all the problems of a beginning writer. My writing rambled, I preached too much, I explained too much, and I told too much. I attended writer's workshops where I exposed my vulnerable ego to the eyes and ears of mentors and tormentors.

My writing improved slowly, but my self-editing was weak. I plodded along, just not able to break through the quagmire of mediocrity.

While reading my latest work aloud, my dog Fred (under my desk) started scratching my shoes. I pushed him away and started to read aloud again. Again at the same sentence, Fred started scratching my shoes. I realized that I had a grammatical error at just the spot on the paper where Fred had started scratching. Just a coincidence, of course. How could a dumb mutt have any literary talent?

I continued to read aloud. A low growling arose from under my desk. I looked down at my script, and I perceived that my chief character was

not credible. I made the correction. Excitement mounted in me. Did Fred have an instinctive flair for literary criticism? I dismissed the thought as being unworthy of consideration.

I began typing early in the morning. My words just klunked along. My dog started yelping without letup. I read at the point where his yelping began, and no question—the klunkiness began there. I rewrote it. Fred still yelped, but more softly. Another revision, and Fred gurgled with delight. My words soared and sang. There was no longer any doubt; my dog was a skilled editor.

At my writer's workshop session my instructor commented on the vast improvement in my writing. She was proud of the influence the class had on my writing; I knew better. I felt guilty about not giving Fred some credit.

After a particularly grueling, growling writing session I became annoyed with Fred's constant barking at my story. I could no longer tolerate his criticism, so I locked him out of the room.

The following day when I returned to the final draft, there were chew marks all over it, with certain parts gnawed into illegibility. On rereading it I realized how much more smoothly the words flowed than the day before. Fred had taken it upon himself to cut all the fat out of my story. I had been chewed out by editors before, but never like this!

I now realized what a gifted editor I possessed, and I officially acknowledged his talent and dedication by dropping the first two letters from his name. I now addressed him as Ed. I purchased a remnant of an authentic oriental rug for Ed's office under my desk and handprinted an official sign, "The Editor Is In." In gratitude he licked my shoes.

I no longer received publishers' rejections. My problem was finding time for the assignments that poured in.

About a month later I noticed that Ed was listless. When I read aloud his ears did not perk up. The vitality in his bark was gone. Was Ed suffering from "Editor's Burnout"? I could not forgive myself. In my desire for recognition, I had driven him to this state. I consulted with all the leading veterinarians, to no avail.

Ed passed away recently, a martyr to the cause of good editing. An autopsy verified the cause of death: documentitis. He had died from ingesting too many imperfect sentences.

In a shady corner of my backyard on a polished piece of black granite stands the following inscription:

To dearest Ed, who's gone away
You made me the writer I am today.

Julius Goldstein graduated from New York University Dental School and spent three years in the army artillery in World War II. When he retired from dentistry, he returned to his first love, writing, and published a number of articles in various magazines. He still pays homage to Ed for the literary help he had given.

The Fortune Cookie
That Saved My Life

Joel Saltzman

AFTER COLLEGE, living in New York City, it seemed like everyone I met was a writer. They were working on novels, writing plays and destined for greatness. Or so I convinced myself. These were *real* writers; I was a fake it and it was only a matter of time before they found me out. So I tricked them—dropped out from writing and spent the next five years not writing a word.

It was agony, Joel Saltzman's personal Dark Ages. I spent my time drinking, going to therapy and wondering if one day I'd finally have the courage to throw my typewriter out the window—and myself right after it.

Then one night, still in the throes of writer's block, I got a fortune cookie that saved my life. My fortune read:

> TO AVOID BEING DISAPPOINTED,
>
> MINIMIZE EXPECTATIONS.

Not being a true believer in the Fortune Cookie School of Wisdom, I was about to toss my fortune aside and never think of it again.

But there was something about those words that almost made sense to me.

What if I did lower my expectations—*really* lowered them? What if I said to myself: "I don't care if it makes any sense or not. Whatever's in my head, I'm going to write it down."

Suddenly, it hit me: *That's how I started writing in the first place.* I was eleven years old, banging away at an old Royal typewriter, not a worry in the world.

That night, I started writing again, the same way I'd started out as a kid—just for the hell of it. I was fooling around again, having fun on the page, finger painting with words and ideas. I didn't care how crazy, or wild, or silly it was. It got me going again and that's all that mattered.

I signed up for a playwriting class, writing hard, angry speeches—my "angry young man" phase. Only each time I read my work aloud, the class wound up laughing. It went on like this, humiliatingly, week after week, until it finally dawned on me. *Maybe I'm a comedy writer.*

I hung up my leather jacket and went to work in this new direction. Thinking I'd be perfect for *Saturday Night Live,* I wrote a bunch of sketch material, got an agent at William Morris and got nowhere fast.

Okay, how about sitcoms?

I wrote some sitcoms, sent them to my agent, and discovered I was living 3,000 miles away from the action.

Okay, how about Hollywood?

I found another agent, got some assignments and started to make a living as a writer. Okay, a "Hollywood writer." Which, many will tell you, is not "real" writing at all. I'm still not sure what "real" writing is, but Hollywood writing—and Hollywood *begging*—soon lost its luster.

Okay, how about books?

I took a year off and wrote *If You Can Talk, You Can Write.* And what I discovered—rediscovered, actually—is how much I enjoyed being in control at the keyboard, without some producer calling in changes by phone. Or my agent taking me to lunch to tell me how my latest screenplay was "wonderful" but "not commercial."

I wrote more books, *sold* more books and launched a new career as a speaker, someone who could *write* a speech, then deliver it with passion—especially when it came to the business of writing.

But all was not well in book writing town.

I'd do radio interviews to promote my book, and my publisher would shrug. I'd call them to pitch a "great new marketing idea," and my publisher would shrug. Finally, I got the message: Unless you were someone BIG (say Danielle Steel or Stephen King), writers were to be read, not heard from.

Okay, how about my own publishing company?

And that's how *Shake It!* Books came to be—figuring I could sell half as many books, make twice as much money, and have lots of fun in the process. Best of all, *I* was in charge. I just wish I had the time to write.

<p style="text-align:center">* * *</p>

Years ago, I was going over my taxes with Harry, my accountant, when he boorishly inquired: "That's all you made this year? What the hell are you doing with your life?"

"I'm trying to be a writer."

"That's what you were trying to do last year."

"And the year before and the year before that."

"You're not embarrassed by this? When are you going to give it up, already? Get a real job?"

Enough was enough. I leaned over the desk and looked him square in the eye. "You listen to me: I'm going to hit it big one day and you're going to be the first person to go around bragging, 'I knew him before he made it big; *I* used to do his taxes!'"

Harry squirmed in his chair. "You're right."

"I know I'm right."

PS: Harry no longer does my taxes, though I did send him an autographed copy of my first best-seller.

Wanna be a writer?

Be persistent, be flexible, avoid the company of naysayers, and—if you want the true American experience—start your own damn company.

Joel Saltzman is the author of *If You Can Talk, You Can Write*. As J. S. Salt, he created *Always Kiss Me Good Night: Instructions on Raising the Perfect Parent by 147 Kids Who Know.* As the publisher of *Shake It!* Books, his latest offerings include *How to Be the Almost Perfect Husband: By Wives Who Know* and *How to Be the Almost Perfect Wife by Husbands Who Know.* He lives in Thousand Oaks, California, with his wife, son, and two large dogs. You can visit his Web site at: www. shakeitbooks.com.

Coming In Second

Eric Maisel

SOME YEARS AGO I received word that I'd come in second in a pres-
tigious national novel-writing competition. Coming in second in a
national novel-writing competition is like coming in second in major
league sports. You are a loser. Of course, you don't have to feel like a loser.

You can say to yourself, "I came so far" or "I came *this* close." You can
say, "What do *they* know?" You can say, "Did I really enter *that*?" But still,
when all is said and done, in this America of ours, second place makes
you a loser.

Actually, I was busy with other things and didn't much notice the
rejection. After the first hundred rejections that come in a writer's life,
each subsequent one is easier to ignore; except, of course, those that
really matter or that somehow get under the skin. This wasn't one of
those—for one thing, the rejection letter was gentle and flattering—and
I didn't give it much thought. I prepared to put the manuscript away
until I could think of a new place to send it.

But as I went to put the manuscript away, I noticed that the readers'
comments had been accidentally included. Here was a moment of truth.
Did I dare read them? Did I want some "objective feedback"? Did I want
some hurt feelings? I went ahead and read them. One said, in an intelli-
gent and carefully crafted paragraph, that the novel I'd submitted was

among the best things the reader had ever read. The other said, in an equally intelligent and carefully crafted paragraph, that the novel was among the worst things the reader had ever read.

Isn't this a lesson that we have to learn again and again: that every opinion is an assertion of personality? That every belief is a fragment of autobiography? There was a book I once read that contained nothing but reviews of E. M. Forster's *A Passage to India*. To say that there was a range of opinion hardly captures the absolutely mind-boggling diversity of opinion expressed in those reviews. Brilliant and boring, humane and inhuman, slow and gripping, crystalline and impenetrable: there was nothing under the sun that wasn't said about that novel! Each reviewer had an agenda, not necessarily with Forster, but just with life.

I noticed the other day in the library, while reading some book reviews in a data bank, that each one came with a letter grade: A, B, C, D, or F. I looked up a well-known novelist's most recent novel and saw exactly what I expected to see: five reviews, five different grades. I looked up a review of one of my own books, *Staying Sane in the Arts,* and of course, someone had given it a "B."

Another second place!

In this culture of winning and losing, the criticism we receive is more painful because we ourselves are rankers. Theodore Roethke once ran into the house of a fellow poet and exclaimed, "I believe that right now I am the number one poet in America, you are number two, and 'x' is number three!" We may fervently wish to eradicate this criticizing and ranking from our own makeup, but it is very hard to do in a culture that traffics in bottom lines and top dogs.

So each time you come in second and not first, each time you are rejected and someone else is accepted, each time your literary agent fails to return your call but returns the call of a more favored writer, each time you pitch an idea which is booed but bought next year when your rival pitches it, each time your poem is smacked around or your manuscript drowned in red ink, remember: you must hold your own good opinion of yourself. The blows you receive may double you over in pain; even so, come back from the brink. Regain your good opinion of yourself. Second

place, fifth place, a hundredth place, a millionth. Love yourself anyway and keep rebounding and resubmitting manuscripts.

Eric Maisel is a psychotherapist, creativity consultant, and writing teacher. He has authored twenty-three works of fiction and nonfiction, including *The Creativity Book, Living the Writer's Life, Deep Writing, A Life in the Arts, Fearless Creating,* and *Affirmations for Artists.* Dr. Maisel lives with his wife and their youngest daughter in Concord, California.

49

If You Could Write One Great Poem, What Would You Want It to Be About?

Robert Pinsky

*(Asked of four student poets at the Illinois
Schools for the Deaf and Visually Impaired)*

Fire: Because it is quick, and can destroy.
Music: place where anger has its place.
Romantic Love—the cold or stupid ask why.
Sign: that it is a language, full of grace,

That it is visible, invisible, dark and clear,
That it is loud and noiseless and is contained
Inside a body and explodes in air
Out of a body to conquer from the mind.

Robert Pinsky was recently reelected to a third term as United States Poet Laureate and continues work on the Favorite Poem Project, which will create an audio and video archive featuring Americans from all walks of life reading and talking about their favorite poems. His books include *Jersey Rain, The Inferno of Dante,* and *The Figured Wheel: New and Collected Poems, 1966–1996,* which was nominated for the Pulitzer Prize and received the 1997 Lenore Marshall Poetry Prize. He teaches in the graduate writing program at Boston University and is the poetry editor of *Slate Magazine.*

Part Four

Bending the Muse
and Breaking the Rules

I invent, distort, deform, lie, inflate, exaggerate,
confound and confuse as the mood seizes me. I obey
only my own instincts and intuitions. I know nothing
in advance.

— HENRY MILLER

I insert a specially designed crank in my left ear
and turn, slowly at first, then with increasing vigor,
making my tongue dart in and out and my eyeballs
roll around in my head like the images in a slot
machine till I start ejaculating ink on the page.

— RON SUKENICK

Follow your inner moonlight. Don't hide the madness.

— ALAN GINSBERG

Get yourself in that intense state of being next to madness. Keep yourself in, not necessarily a frenzied state, but in a state of great intensity. The kind of state you would be in before going to bed with your partner. That heightened state when you're in a carnal embrace: time stops and nothing else matters. You should always write with an erection. Even if you're a woman.

—TOM ROBBINS

Experiment? God forbid! Look at the result of experiment in the case of a writer like Joyce. He started off writing very well, then . . . he ends up a lunatic.

—EVELYN WAUGH

"When *I* use a word," Humpty Dumpty said in rather a scornful tone, "it means just what I choose it to mean—neither more nor less. They've a temper, some of them—particularly verbs, they're the proudest—adjectives you can do anything with, but not verbs."

—LEWIS CARROLL

Words strain,
Crack and sometimes break, under the burden,
under the tension, slip, slide, perish,
decay with imprecision, will not stay in place,
will not stay still.

THERE IS NO better description—and demonstration—of a writer's propensity to push the boundaries of form than this poetic passage by T. S. Eliot. Words are meant to be played with and tweaked, many writers will argue, in order to bring forth new meaning and texture. "If it is predictable, not experimental," said Robert Penn Warren, "then it will be worthless," for every sentence must be an innovation, if a writer's talent is to grow.

Joyce, Stein, Cummings, Pinsky, Ginsberg, Nin, and Roth—all have daringly flirted with their muse, but the person who was infamous for breaking the rules was Henry Miller. Although he is now considered one of greatest writers of the twentieth century, his work was banned in America for nearly three decades. Reflecting upon his style of prose, he wrote to a friend:

Words are never just words, even when they seem just words. . . .
Some write syllabically, some cabalistically, some esoterically, some
epigrammatically, some just ooze out like fat cabbages or weeds. I
write without thought or let. I take down the dictation, as it were.
If there are flaws and contradictions they iron themselves out even-
tually. If I am wrong today I am right tomorrow. Writing is not a

game played according to rules. Writing is a compulsive, and delec-
table thing. Writing is its own reward. *The men of 2500 A.D. will
enjoy reading this little passage, I am sure.*[1]

Although critics have labeled him sexist and crude, his work remains
essential reading today, for he transformed the publishing world and
opened the door for other experimental forms. His technique of blending
autobiographical material with stream-of-consciousness prose not only
exposes the raw psychological underpinnings of the author's life, but it
also stirs up powerful emotions in the reader. Take, for example, the fol-
lowing passage from *Sexus,* which Miller published in 1949: "I too love
everything that flows: rivers, sewers, lava, semen, blood, bile, words, sen-
tences. . . . I love the words of hysterics and the sentences that flow on
like dysentery and mirror all the sick images of the soul." Critical reac-
tion was swift; even his ardent champion and promoter, Laurence Dur-
rell, telegraphed the publisher with this castigating remark: SEXUS
DISGRACEFULLY BAD WILL COMPLETELY RUIN REPUTA-
TION UNLESS WITHDRAWN.[2] Each time a writer breaks new
ground, he or she risks censure.

This section is devoted to writers past and present who have bent the
rules by experimenting with literary forms, and their essays address the
obstacles they encountered in their pursuit. Additionally, most of these
authors incorporate their innovative talents as they ponder the writing
life (six of these essays were expressly written to address the themes of
this anthology). First there is Miller's frenzied description of his muse,
followed by Susan Suntree's manifesto, whose feminist approach to writ-
ing echoes Miller's familiar tone. Clive Matson's piece also reflects
Miller's stream-of-consciousness approach, but he uses it to illuminate
his own brand of deconstructive linguistics to free himself from the rep-
etitious voices within.

I have also included an essay by Anaïs Nin, famous not only for her
personal diaries but also for being one of the first women of the twentieth
century to write sexually explicit prose. Knowing that much of her mate-

rial would be suppressed by her publishers (she was, after all, closely associated with Henry Miller during his formative writing years), she opted to print several of her own books using an old-fashioned printing press. "Instead of being embittered," she writes, "the press gave me independence and confidence." For those who seek publishing independence today, computer technology provides yet an easier access for all.

Provocative composition is but one form of experimental writing, for there is also the sensuality of language itself, powerfully conveyed in Octavio Paz's "Proem." Professor and poet Pierre Joris follows a different course by pointing out that language has no line, "not even a well-designed symmetrically-correct curve, but rather something 'en pointillé,' a needlework crisscrossing like tracks in the snow, uneven, hobbling, appearing/disappearing." Joris, it seems, suffers from an unusual disease of the pen—he misplaces various letters as he writes. Experimental writing often brings forth unsuspected problems coupled with creative visions and cures.

The Internet provides another avenue for experimentation that is beginning to transform the literary world, for there, in cyberspace, words and sentences are not linearly bound to a page. Content can be merged with sound and graphics, which projects the experience of both writing and reading into a virtual three-dimensional space (often referred to as hypertext). With a click of a mouse, a story or a poem can unfold in a variety of ways, bringing the reader into a fascinating interplay with authors and their work.[3] Although it is difficult to capture such writing in a book, I have included a representative example by Arizona poet Ward M. Kalman. Constructed like a crossword puzzle, the reader is free to decipher his "essay" in any number of ways. Kalman suggests that if you use a little imagination, you can decipher his 400-word commentary on how writers must struggle with the subtleties of syntax and meaning when they structure each sentence or phrase. Similar examples of "words-as-art" can be found in major museum exhibits throughout the world.[4]

Two writers who are actively involved in the promotion of hypertext literature are Charles Deemer, one of a handful of playwrights in the world

who currently produces hyperdramas for the stage (his essay explores the frustrations and surprises that occur when a director tries to orchestrate multiple theatrical stages through which audience members randomly move), and e-zine publisher Mark Amerika, who will warn you that his essay is not really an essay at all, but an essay that only *pretends* to be an essay—an example of what he calls "a hyperrhetorical display of animated typography." To put it another way, Mark Amerika breaks rules that aren't necessarily rules.

Two other literary works help to illuminate the unique processes of creativity that can permeate a writer's life. Judith Simundson, a story-teller who specializes in Norwegian folklore and history, weaves a poem that is part dream, part myth, and part memoir as she describes her writing experience, a world in which reality and fiction can blur. A similar process occurs with Holcomb Reed, who surrenders himself to the L'langualuxe, a mythical muse who guides him through phantasmagorical realms where language twists upon itself. Reed's creative wordplay has a long tradition in literature—from Lewis Carroll, to e.e. cummings, to Tolkien's wondrous worlds.

Finally, there is Steven Connor's autobiographical piece—is it postmodern, deconstructionist, or creative cynicism at work? I suspect we'll never know, for Connor, who is a professor of modern literature, must write whether he wants to or not. It's the rule of academia, he explains, for if you do not publish, you will lose your teaching post. "I promise never to be a writer," he declares as he writes about his refusal to write. Essays such as Connor's encourage us to question what we see and disrupt the status quo. Otherwise we shall never find that splinter of individuality that is essential to the writing life.

Salman Rushdie once said that authors must push the limits of what they know: "Books become good when they go to this edge and risk falling over it—when they endanger the artist by reason of what he has, or has not, artistically dared."

"Write *dangerously*," the authors in this section proclaim, "if you want to transform the world."

Notes

1. T. Moore, editor, *Henry Miller on Writing* (New Directions, 1964).

2. M. Dearborn, *The Happiest Man Alive* (Simon and Schuster, 1991).

3. For an excellent experience of this type of writing, try out The Company Therapist site at www.thetherapist.com, where you would find yourself peeking into the confidential files of a fictional psychiatrist and listening to his clients' confessions. You can even become a "patient" yourself, contributing your own literary case history for other cybervoyeurs to read.

4. You can view Eduardo Kac's famous three-dimensional poems at www.ekac.org. Other sites can be found by typing one of the following keywords into your Internet search finder: "hyperfiction," "hypertext non-fiction," "hypertext poetry," or "holopoetry." This will lead you to dozens of links, including scholarly discussions and critiques.

50

That Voice!

Henry Miller

THAT VOICE! It was while writing the *Tropic of Capricorn* (in the Villa Seurat) that the real shenanigans took place. My life being rather hectic then—I was living on six levels at once—there would come dry spells lasting for weeks sometimes. They didn't bother me, these lulls, because I had a firm grip on the book and an inner certainty that nothing could scotch it. One day, for no accountable reason, unless it was an overdose of riotous living, the dictation commenced. Overjoyed, and also more wary this time (especially about making notes), I would go straight to the black desk which a friend had made for me, and, plugging in all the wires, together with amplifier and callbox, I would yell: *"Je t'écoute . . . vas-y!"* (I'm listening . . . go to it!) And how it would come! I didn't have to think up so much as a comma or a semicolon; it was all given, straight from the celestial recording room. Weary, I would beg for a break, an intermission, time enough, let's say, to go to the toilet or take a breath of fresh air on the balcony. Nothing doing! I had to take it in one fell swoop or risk the penalty: excommunication. The most that was permitted me was the time it took to swallow an aspirin. The john could wait, "it" seemed to think. So could lunch, dinner or whatever it was I thought necessary or important.

I could almost *see* the Voice, so close, so impelling, so authoritative it was, and withal bearing such ecumenical import. At times it sounded like a lark, at other times like a nightingale, and sometimes—really eerie, this!—like that bird of Thoreau's fancy which sings with the same luscious tones night and day.

When I began the Interlude called "The Land of Fuck"—meaning "Cockaigne"—I couldn't believe my ears. *"What's that?"* I cried, never dreaming of what I was being led into. "Don't ask me to put *that* down, please. You're only creating more trouble for me." But my pleas were ignored. Sentence by sentence I wrote it down, having not the slightest idea what was to come next. Reading copy the following day—it came in installments—I would shake my head and mutter like a lost one. Either it was sheer drivel and hogwash or it was sublime. In any case, I was the one who had to sign his name to it. How could I possibly imagine then that some few years later a judicial triumvirate, eager to prove me a sinner, would accuse me of having written such passages "for gain." Here I was begging the Muse *not* to get me into trouble with the powers that be, *not* to make me write out all those "filthy" words, all those scandalous, scabrous lines, pointing out in that deaf and dumb language which I employed when dealing with the Voice that soon, like Marco Polo, Cervantes, Bunyan *et alii,* I would have to write my books in jail or at the foot of the gallows . . . and these holy cows deep in clover, failing to recognize dross from gold, render a verdict of guilty, guilty of dreaming it up "to make money"!

It takes courage to put one's signature to a piece of pure ore which is handed you on a platter straight from the mint. . . .

Henry Miller (1891–1980) described himself as a confused, negligent, reckless, lusty, obscene, boisterous, thoughtful, scrupulous, lying, and diabolical man. He was acclaimed by the world as one of this century's literary giants, yet his books were banned in America for twenty-seven years. This memoir is excerpted from *Big Sur and the Oranges of Hieronymus Bosch.*

5 /

The Story of
My Printing Press

Anaïs Nin

IN THE 1940s, two of my books, *Winter of Artifice* and *Under a Glass Bell,* were rejected by American publishers. *Winter of Artifice* had been published in France, in English, and had been praised by Rebecca West, Henry Miller, Lawrence Durrell, Kay Boyle, and Stuart Gilbert. Both books were considered uncommercial. I want writers to know where they stand in relation to such verdicts from commercial publishers, and to offer a solution which is still effective today. I am thinking of writers who are the equivalent of researchers in science, whose appeal does not elicit immediate gain.

I did not accept the verdict and decided to print my own books. For seventy-five dollars I bought a second-hand press. It was foot-powered like the old sewing machines, and one had to press the treadle very hard to develop sufficient power to turn the wheel.

Frances Steloff, who owned the Gotham Book Mart in New York, loaned me one hundred dollars for the enterprise, and Thurema Sokol loaned me another hundred. I bought type for a hundred dollars, used orange crates for shelves, and bought paper remnants, which is like buying remnants of materials to make a dress. Some of this paper was quite beauti-

ful, left over from deluxe editions. A friend, Gonzalo More, helped me. He had a gift for designing books. I learned to set type, and he ran the machine. We learned printing from library books, which gave rise to comical accidents. For example, the book said, "oil the rollers," so we oiled the entire rollers including the rubber part, and wondered why we could not print for a week.

James Cooney, of *Phoenix* magazine, gave us helpful technical advice. Our lack of knowledge of printed English also led to such errors as my own (now-famous) word separation in *Winter of Artifice:* "lo-ve." But more important than anything else, setting each letter by hand taught me economy of style. After living with a page for a whole day, I could detect the superfluous words. At the end of each line I thought, is this word, is this phrase, absolutely necessary?

It was hard work, patient work, to typeset prose, to lock the tray, to carry the heavy lead tray to the machine, to run the machine itself, which had to be inked by hand, to set the copper plates (for the illustrations) on inch-thick wood supports in order to print them. Printing copper plates meant inking each plate separately, cleaning it after one printing, and starting the process over again. It took me months to typeset *Under a Glass Bell* and *Winter of Artifice.* Then there were the printed pages to be placed between blotters and later cut, gathered into signatures, and put together for the binder. Then the type had to be redistributed in the boxes.

We had problems finding a bookbinder willing to take on such small editions and to accept the unconventional shape of the books.

Frances Steloff agreed to distribute them and gave me an autograph party at the Gotham Book Mart. The completed books were beautiful and have now become collector's items. . . .

But the physical work was so overwhelming that it interfered with my writing. This is the only reason I accepted the offer of a commercial publisher and surrendered the press. Otherwise I would have liked to continue with my own press, controlling both the content and design of the books.

I regretted giving up the press, for with the commercial publishers my troubles began. Then, as today, they wanted quick and large returns. This gamble for quick returns has nothing whatever to do with the deeper

needs of the public, nor can a publisher's selection of a book be considered as representative of the people's choice. The impetus starts with the belief of the publisher, who backs his choice with advertising disguised as literary judgment. Thus books are imposed on the public like any other commercial product. In my case the illogical attitude of publishers was clear. They took me on as a prestige writer, but a prestige writer does not rate publicity, and therefore sales were modest. Five thousand copies of commercially published *Ladders to Fire* was not enough.

The universal quality in good writing, which publishers claim to recognize, is impossible to define. My books, which were not supposed to have this universal quality, were nevertheless bought and read by all kinds of people.

Today, instead of feeling embittered by the opposition of publishers, I am happy they opposed me, for the press gave me independence and confidence. I felt in direct contact with my public, and it was enough to sustain me through the following years.

Anaïs Nin (1903–1977) is best known for her diaries—considered one of the outstanding literary works of the twentieth century—in which she recorded her psychological, sexual, and artistic development. She wrote numerous essays and several novels, including *A Spy in the House of Love.* An outspoken advocate encouraging sensuality for both women and men, she was also known for her intimate relationship with Henry Miller.

52

Write!

Susan Suntree

Write to empty your waste basket, to follow ants back
to their queen, to barge past bouncers at the Temple
Bar. Write to forget the past twenty years and then
write forward for twenty years. Write careful lines
posed elegantly like nudes displayed on Renaissance
draperies for tasteful examination by millions of serious
art students and their professors. Write to unzip or zip
up. What difference does it make? Oh, for Christ's
sake (and believe me, Buddha will do just as well),
don't write. What two bit, hollow romance is this hard
gripping of the long, firm pen until it's so hot the
plastic softens, or this tip-tapping of fingers over a
keyboard like fingers lightly grazing warm, bristly
shoulders or smooth shoulders. Don't do this. Hold the
fork, not the word fork. Dig your fingers into dirt, not
metaphorical earth. Abandon writing like the living
expel the dead, like the dead renounce their ghosts.

If you can't leave the pen alone, write your way to the
edge of a diving board. Sit there, bent over, dangling

your feet just above the water while you examine the
reflection of your face. If you can't calm the torrent
between mind's eye, mind's ear, mind's mouth, mind's
skin, mind's shudder, mind's hearty laugh, and your
fingers, and your fingers won't put down the pen, and
the pen won't abandon the empty page, then write for
the resurrection of your oldest and softest pair of jeans.
Write to drive the sweat out of sweatshops and to
swing open the tidegates wherever seawater longs for
the interior creeks. Write to retool your childhood and
remodel that look on your mother's face. Write to
wrestle the belt from your father's hand. And write a
cage around the man who nearly killed you in his
jealous or drunken rage. Write his heart right out of
his body and reshape its quaking, red wound into the
steady, useful organ his mother meant to shape for
him in the Delphic cave where she urged him out
of shadows into form.

Don't take my word for it. Write tree rings back into
this paper and see what happens. If nothing happens,
you can go home and talk about your experience with
your friends when you have beers at P.J.'s before
catching a film. If nothing happens, you can drink a
cup of hot milk with honey, take a bath, and sleep for
eight hours. If a tree rises off the page, climb it right
to the top. Scratched and panting, settle among the
rough-barked branches, steady yourself, and look out
at the view. Take careful note of the horizon, the rise
and fall of the land, the waterways cutting canyons on
their way to the sea. Notice the patterns of light and
shade, the throng of colors, the angle of the wind,
birds, insects, and your own pounding heart and
heightened breath. Notice when the impulse to

descend surges through to your hands and feet.
Notice if you are dizzy while carefully hanging from
one branch while discovering your footing on another.
Feel the thick breadth of the tree trunk and smell the
tree's sweet sap. When you swing from the lowest
branch to the ground, feel your feet connect to the
earth, like a lamp plugged into a socket, and your
body fatten with a mineral surge.

What's writing got to do with it?

Susan Suntree is a poet, playwright, and educator whose work
investigates relationships among art, science, and the environment. She
has presented her poetry and performances nationally and internation-
ally, and her writing has appeared in numerous journals. Author of *Eye
of the Womb,* coauthor of *Tulips* and *Rita Moreno,* and editor of *Wisdom
of the East,* she has received dozens of awards, honors, and grants for
her work. She teaches at the University of Judaism and at East Los
Angeles College.

Membrane Porous

Clive Matson

What do I feel? A bubbling on the surface, excitement
for the topic of this essay, inking the soul. Delight to
hang at the edge again, some fear of dropping off
into unknowns. Winds there, blowing up out of
the ground. Straw, rusty metal. Bits of weeds
flying.

No need to take that path, I can stay with the obvious.
Your question, my answer. Quite a bit of pride in my
sight, the ability to see what is. Honesty in putting the
words down. Joyful anticipation of my prowess, in
staying with what's happening in the split second. My
biceps, rounding at an angle, light flowing around the
skin like a rippling stream. Blown into tiny ripples and
tides across my back. Wind squeezing through the
cracks. Frost and debris across the room.

Where is this stuff coming from? Some membrane,
some protective membrane is missing. I can answer
the question, even if I'm tossed around in the light,

pushed at angles. I feel good. I have something to say.
There is warmth in the center of my chest, the sense of
immersion coming, in the topic. Where the curve of
my chest is like a hill, where the hill meets the river,
sweet paisley sigh. A wind coming across my chest.
Blowing hard.

Wait a minute. I do not have to do this. Put that
membrane back, firmly. Get grounded, touch the back
of my neck, the hair just washed, comb marks and gel
holding it in place. I look all right. The cranium arcing
high over the tiny experience. The vast experience, a
universe of faces tumbling. My father, asleep. Mother
bustling around. Their orbits outline a vast hole. Wind
whipping pieces of tar paper around the ceiling. Hazy
light. A cracked window.

Stop! Too much like boundaryless rambling. Steady
yourself, stick with the issues of our times, poverty,
race, the earth. Countering voice: you can't aid
anything without knowing what you feel. What
odd messages tumble out of my pen. Every one of
us pegged already, what we like, what food, what
house, what car, what sex, what exercise, what drug.
The layers underneath the membrane chopped
minutely into data-base fields. Lost virginity.
Tightrope. It's all odd, floorboards creaking far
below. Wind whipping straw and shredded disks.
Coins flutter through air.

Wait. Is this the trauma of the self invaded? A pocket
of rage riding over the swelling current? Commonality
scorned. Walking around on two legs, wanting love,
wanting excitement, wanting contentment. The proud

warmth rising again, toes to belly to head. Secure.
Why dive off the edge? Why threaten well-being?
Why tip-toe? Do I see a primordial power running
through us? A current in the darkness below. Trucks.
Floating debris.

This detritus comes from a writing exercise. The Crazy
Child exercise. Simple. Get the Editor and Writer in
our minds to back off, write instead from impulse.
From the feeling in the body. Strain and sweat and
grunt and pry up a window, pull through shreds of
untamed energy. Unconscious creativity dancing and
growling in the distance. Little ripples, wavelets, and
bits of leaves scoot across the land. One pauses on the
sill and we'll snatch at it, squeeze it into the room and
onto the paper. The issue: how to pull more of that
wild, energetic stuff into the room.

There are others, the scene so different for them.
When the Writer and Editor take a hike, they roll up
the membrane and take it with them. Say "Crazy
Child" and it's gone. Walls fall down. No windows. No
down, no up. No way to sort. Just write. Wind howling
as ink runs across a wavy crack in the sky.

Who needs the exercise? My students do, but I
thought I didn't. And while beginning writers wrestled
with winds or stillness or ink dribbling across
eyeglasses I did a revision. Tinkered with a story. A
play. One day I did the democratic thing and joined a
workshop. Found I was one of those: say the word and
no walls. Wind. Straw. Shards. Coins. An aching. A
nameless nothing. Words coming out of the ink,
random-seeming and energetic.

A pre-verbal place, someone said, one-and-a-half years
old. You must go back. Relive the no-sense-of-self, no
boundaries, the world and the "I" the same. Wind
coming. I wrote that chaos for three years, five years,
ten. I would read it and cringe. Three lines and the
impulse to vomit so strong I'd put the page away. Acid
up the channels. Tomato juice, raw sagebrush, rolling
in dust. The wind.

One day I found I could fiddle a few minutes
and organize a non-understandable poem. Wind.
Coins. Noise. Floorboards cracking. No one around.
Hot water stream. Smoke. Later, from decade-old
images, I could sometimes make a poem that would
communicate. We have only our uncertainties to write,
said a mentor.

So many holes the last centuries punched into the
membrane. World War I. Darwin. God exiled from
constant awareness. Atom bombs. Feminism knocking
out male struts. The unknown languages behind these
words. Freud's id pulling eye and thought like finger
puppets. Neurolinguistics. Hormones teasing our arms
and legs like engine pistons. From skeletons to cells to
protein mechanisms running currents beyond control.
And now at every breath poison and radiation. The
membrane a fiction or flimsy or tattered. Can't
stomach anything that doesn't admit the underside.

Love the open spaces between bones. Emptiness.
Uncertainty. Put ink on a plate and watch it change
shape from pressure of air currents. Shift in the
direction of who we are, from the wind that blows
through us. A notebook in my pocket? At bedside?

To be woken up to in the middle of the night by
chimeras. A blank page not so fragile it can't accept
chaos. Mystery. Hold and absorb the colors. Take in
what is there without judgment. Seeing what is. Inking
the soul.

Clive Matson is the author of *Let the Crazy Child Write*. His seven
volumes of poetry include *Squish Boots, Equal in Desire,* and *Hourglass.*
He was a protégé of the Beat Generation and a member of the Berkeley
Poets Cooperative. In 1989 he won a fellowship to Columbia Univer-
sity. He lives with his wife, poet Gail Ford, and their son in Oakland,
California. Visit him at www.matson-ford.com.

54

This Could Be the First Day of the Rest of My Life

Mark Amerika

THE DAY THAT I was to be slaughtered was a very busy day. First I had to go meet my agent who wasn't really my agent anymore but, rather, my gallery director. Well, not exactly my gallery director either. You see, we had decided that it would be better for me to completely forget about my publishing life and to take a leave of absence from my multi-media installation life and to just do the same thing my Modernist predecessors had done, that is, "create an art that imitated life that had actually imitated art, in admittedly unexpected ways." Or so that's how I had described it in the dissociative prose-rant I distributed via my Internet column which wasn't really an Internet column anymore but a kind of performance art spectacle since it now incorporated what my personal critic called a "hyperrhetorical display of animated typography" which, if you stop to think about it, is exactly what all my work has been about. Although who's to say what a work is "about," I mean, the important question to ask nowadays is "what is the artist trying to do?" Everybody knows that.

When I tried to explain this to my painter friend who kept telling me that "every 'system' is a seduction with all of the consequences of a seduction," I improvisationally stole some of his ideas which weren't really his ideas at all but something Robert Motherwell said in his Big Dada Book all those years ago, that is, I suggested that every God-like feature invented by Microsoft and built into their latest version of Word was an opportunity for artists to become independently wealthy and that what we needed was to create an expressive set of virtual forms that could relate to the various tribes of consumerism that, in toto, composed the mass market, and that playing to the interiorized logic of this mass market's desire to experience the consummate orgasm would be a phe-nomenon of public morality not seen since the days of Joe Dimaggio.

Actually, my painter friend isn't a painter at all, rather, he's a poet, or not a poet since he really hates poetry and says he would rather be a garbage man or a web-designer than a starving poet with nothing new to say, but a kind of network programmer who uses verbal constructions to conjure up a spirit of superiority that certain people in his rolidex are willing to pay big cash dollars for. Well, not really cash dollars. Digicash. A kind of simulation-crude that, when applied to the anal vortex, enables the butthole surfer to imagine what it's like to take part in a large-scale swindle. This, and the occasional foreign translation, not to mention par-ticipation in digital arts festivals and traveling exhibitions, has proven to be the key to his survival.

But this is all beside the point because I was stuck inside my apart-ment in Battery Park City and it was Sunday and all of the rich interna-tional financiers who usually troll through the neighborhood due to their occupation of the various World Trade and Financial Centers were nowhere to be found and as I looked down from the advantageous per-spective of my bedroom on the 36th floor I saw schools of yellow cabs transport whosoever wished to be brought into the heart of capitalism's immortal lock on the human race whose winning gift-horse, a filly called Information-Currency, was rounding the millennial bend with its intel-lectual cousin, *The New York Times*, who, it ends up, was now going to slaughter me in the most normal of ways.

You see, my girlfriend, who's not really my girlfriend but my common-law wife, had already received three emails from various friends of ours in the literary network that my new book was going to be reviewed in the *Times Book Review* and that it would be devastating and that it would effectively kill my career. None of them wanted to tell me directly because they knew that she'd have a way of preparing me for it that I myself could never come up with. And I must say, I found this honest distantiation of our friends to be perfectly legitimate.

Nonetheless, as I told my girlfriend/wife before she could even begin rolfing my ego, I had willed the end of my career myself, having started the process three years ago by refusing to publish anything in print again. I was adamant. "The literary print world is totally useless," I remember telling my editor, who was really not an editor but a marketing-representative for a tobacco company that happened to be in the book business, "and," I continued, "I'm quite content seeing it die its much-ballyhooed death." But then my agent, if you could call this person who represented me an agent, sold the rights to what was at that time my collected Net columns and everyone thought that this acquisition was a total waste of time and money, which it was, yet the market can be funny sometimes, and now they were going to be my friend, yes, my good-cop bad-cop publicity buddy, in that they weren't going to ignore me anymore, which is really worse than death itself, no, they weren't going to turn their heads away from me anymore, they were just going to slaughter me and my anti-literary digerati arrogance in the most public way possible and, my girlfriend/wife kept reminding me, that's what friends are for.

My publishing friends had reason to slaughter me. First of all, I had already slaughtered them. My imported butcher knives cut through all of their pretensions and displayed their cronyistic innards in ways that I didn't even realize I had in me. The whole pathological deformation that passed itself off as The Publishing Industry was laid bare inside my operating system so that the sloppy mishmash of bleeding organs and twisted tubes leaking silvery rivulets of fatty acids and venereal diseases ate through my computer screen in an attempt to become me, but, alas, my utility programs were powerful enough to not only disinfect my desktop

of the gargantuan grotesquerie it had rapidly morphed into, but even managed to clear my work-space of the corpse-like stench that filled my hairy nostrils. It was as if an undifferentiated Digital God of Endless Being had approximated my need to tear off the grubby hands that were feeding me—and by bypassing their deadwood paper-mill distribution system of eco-death and black desire, I could go out of my way to bury those cold, manicured *manos* in their own blood and bones and the contaminated dirt that filled their pockets.

As my friend the film theorist recently told me, although he's really not a film theorist but, rather, an underground comix artist whose periodical forays into avant-garde ventriloquy stubbornly resist psychological and linguistic categorization, "our bodies still retain the marks of the old bacterial freedoms, even when our institutions work busily to suppress them."

Knowing this doesn't make things any better. Rather, knowing that you'll be butchered in ten minutes gives you a funny kind of feeling (the altruism of a girlfriend/wife's love)—until then, you never in your life know what it's like to play the leading role in a social play whose theme is animal sacrifice. It's like you have to totally grow up and learn to live beyond that sacrifice and even use the painful knowledge you associate with that sacrifice to build up the kind of inner-strength and self-confidence one needs if they plan on using their own aesthetic positioning and network-armory to slaughter others with. This is what "being social" in a competitive environment is all about. And this isn't even really being social anymore although it feels better than, say, taking smart-drugs while watching smart-bombs do dumb things on TV. It's much more REAL. Visceral. A kind of self-inflicted public execution where one is caught ripping out their organs and putting them on display as a kind of creative exhibitionism (my girlfriend/wife doesn't really like this). I'm not sure I'm making much sense here but that's not the point.

Let me start over. The day that I was to be slaughtered was a very busy day. True, it was a Sunday, and in New York, nothing really happens on Sunday, but it was a very busy Sunday for me because I had 15 deadlines to reach as a result of taking on too many freelance writing gigs which was

a result of me being broke or so I perceived myself as being broke. All of my friends say that I'm not doing that bad but that's because all of my friends are artists or musicians or writers who live in New York and the first thing you learn when you move to New York is that if you're serious about being an artist or writer or musician you kind of have to tell white lies to all of your friends about how great things are going so that they'll think you're really up to something important and will want to spend more time with you which, if everything works out okay, will lead to more gigs which, when put through the multiplier effect, exponentially increases the amount of work you get, work you then can't say no to because you never ever want to be poor and have to ask someone who once offered you work and who you refused, that you'd now like to have work again. So that two weeks ago I had no gigs but then I got one gig, then three more gigs, then seven more and now I have 24 gigs. 24 gigs and 15 deadlines. And meanwhile I'm going to be slaughtered and all of my friends tell me I'm doing great and my girlfriend/wife keeps telling me that it's important that they supply me with these necessary white lies, lies that insist that, first of all, the reviewer is stupid, that he doesn't know what he's talking about and that he has it out for me, and that *The Times* is the worst piece of crap ever published and that it keeps getting worse, just look at what they review.

"Yeah," I'll say, "they're reviewing me."

"No," they'll come back at me, "they're not reviewing you—they're slaughtering you."

Mark Amerika is the author of two literary novels, *The Kafka Chronicles* and *Sexual Blood*, and the founding director of the Alt-X Online Publishing Network (www.altx.com). He is the editor for *Black Ice Fiction*, a Web-based magazine featuring experimental hypertext writers. Mark's *Grammatron* (www.grammatron.com) was chosen for the Whitney Biennial 2000, and his Web project, PHON:E:ME (http://phoneme. walkerart.org), an mp3 concept album with an accompanying "hyper: liner:notes," was commissioned by the Walker Art Center. It was nominated for an International Digital Arts and Science Webby Award.

55

How Do I Number the Pages?

Charles Deemer

"Hyperdrama" is a recent form of theater generated by scripts written in hypertext. These plays generate into simultaneous story-lines that are developed with scenes running simultaneously throughout a performance space. An audience member, who cannot be in more than one place at one time, makes a series of choices that determines the flow of action—the "play," if you will—being revealed to her. Different audience members experience different "plays." In order to see all of the action, an audience member must return to the performance many times.

To get a better grasp of what hyperdrama is like, imagine your last big family Thanksgiving dinner. You are in a house. Half an hour before the turkey is served, groups have formed throughout the house: in the kitchen, last minute preparations are made; in the den, a group watches football on TV; elsewhere through the house, groups form, all chatting at once.

Now imagine that each person in the house is an actor and what they say is dialogue written by a playwright. That's hyperdrama! And the audience? Drop them into the house as invisible ghosts, able to wander at will.

Hyperdrama is not for everyone. Many people are upset by the profound changes in dramatic storytelling that hyperdrama presents. For example: In traditional theater, the audience sits in the dark and is "shown" a story; in hyperdrama, the audience is mobile and puts together a particular "version" of the story on the run, determined by the flow of action one chooses to follow.

In traditional theater, there are main characters and minor characters; in hyperdrama, all actors are in the performance space at all times, making such distinctions meaningless.

In traditional theater, the audience practices voyeurism from a distance, as if peeking through a window; in hyperdrama, the audience practices voyeurism within the action itself, often watching the action by standing next to the performers, sometimes even spoken to by an actor. In traditional theater, the story is wrapped up at the end; in hyperdrama, each "viewing" of "the play" serves as additional input into the grander vision of the play that results when one finally has seen all of the action, which usually takes many viewings.

In traditional theater, everyone sees the same play; in hyperdrama, each audience member creates the play (defined as the flow of action one follows, which is determined by individual choices along the way). This kind of dynamic "create-your-own-play" on the run is not for everyone. However, it is a model for how the real world works and as such is more "real" than traditional theater.

At my recent hyperdrama, *The Bride of Edgefield*, a former student of mine told me afterwards that the play gave him a headache. "It was too real," he complained, "with too much happening at the same time." This is not an unusual complaint. This "reality of performance" can result in some dramatic intersections between the performance space and the "real world."

For example, one of my hyperdramas, performed in a large mansion, ends with undercover narcotics agents firing at drug dealers as they dart into the woods surrounding the mansion. This play has been performed at the Pittock Mansion in Portland, Oregon, which is available to the public.

One night, a family was picnicking on the grounds when the ending above happened. Not knowing a play was going on, the husband called the police. Also, as part of the play's ending, an ambulance races up the winding road to the mansion, siren blaring. A dead body is in the mansion. On this night, our ambulance was followed by three uninvited police cars! Police officers, with guns drawn, raided the mansion to give my play's ending more a sense of reality than I had scripted. Fortunately, the director headed them off before the officers disrupted the play, and the audience later complimented me for adding such a huge dose of convincing atmosphere.

Hyperdramas are not easy to produce—finding a "live" and appropriate space for the story is essential—but one, *Tony and Tina's Wedding*, has toured widely, even though this script uses much more improvisation than my own. This practical difficulty works against a wide exposure for this exciting new theater form, which is too bad.

Hyperdrama scripts, with all their choices, are best written and read in hypertext, which makes the Internet a natural home for them. You can try out my one-act hyperdrama, called *The Last Song of Violeta Parra,* which can be found at http://www.teleport.com/~cdeemer/chile/chile-m.html.

I still vividly remember the paralysis that met me when I began my first hyperdrama. I had a contract and a deadline, and an advance—but no notion what I was getting into. I also had a story concept that my producer had approved. All I had to do was to write the script.

For two weeks I sat staring at the computer screen (an old Kaypro 2x with a CP/M operating system and a green screen; I felt like a radar man in World War II), unable to answer a simple beginning question: HOW DO I NUMBER THE PAGES? In other words, if there is no linear story—if many scenes are going to happen at the same time but in different areas of the mansion—HOW DO I NUMBER THE PAGES?

I never did answer the question. Instead, I wrote scripts for each room, putting a "time code" down the margins, a guesstimate when each action was supposed to occur. I found myself writing with a stop watch, reading aloud and timing all the scenes. Alas, I neglected to include the time it would take for actors to walk from one scene to another—and even when

that was added during rehearsal, we neglected to predict that sometimes audience members would be in their way, slowing them down!

Needless to say, every hyperdrama includes considerable improvisation. Yet certain timing is essential in any story. What to do? My first director, Ghita Hager, whose background was opera, had a brilliant solution. Since the setting of the mansion story, *Chateau De Mort,* was a party hosted by a wealthy couple in a mansion, why not have live classical music performed throughout the play, just like the live entertainment that the upper crust might hire? Operatic singers were chosen who could really belt out an aria and be heard throughout the large mansion. This would serve as a cue for the actors, who would then know that a critical moment was coming up. Many actors cannot deal with this unusual demand of on-script, off-script, thinking-on-one's feet performance skills, and during every hyperdrama rehearsal I've been associated with, a few actors have dropped out in frustrated defeat.

As far as I know, few writers are working with hyperdrama. 400-page scripts for a short two-hour performance are not something that appeal to many, yet there is something wonderfully addictive about the dimension and chaotic energy of live hyperdrama. I'm hooked on the form, and I know a few people who are hooked as audience members as well. So, if you get a chance to see a hyperdrama, don't miss out on the fun. It is an experience that you will never forget.

Charles Deemer is the webmaster of the Screenwriters & Playwrights Home Page (www.screenwright.com). He is the author of *Seven Come Eleven: Stories and Plays, 1969–1999* and *Screenwright: The Craft of Screenwriting.* He teaches screenwriting at Portland State University, plays a twelve-string guitar and harmonica, and performs a tribute to Woody Guthrie. He also makes his own pasta.

56

Proem

Octavio Paz

At times poetry is the vertigo of bodies and the vertigo of speech and the vertigo of death;

the walk with eyes closed along the edge of the cliff, and the verbena in submarine gardens;

the laughter that sets fire to rules and the holy commandments;

the descent of parachuting words onto the sands of the page;

the despair that boards a paper boat and crosses,

for forty nights and forty days, the night-sorrow sea and the day-sorrow desert;

the idolatry of the self and the desecration of the self and the dissipation of the self;

the beheading of epithets, the burial of mirrors;

the recollection of pronouns freshly cut in the garden of Epicurus, and the garden of Netzahualcoyotl;

the flute solo on the terrace of memory and the dance of flames in the cave of thought;

the migrations of millions of verbs, wings and claws, seeds and hands;

the nouns, bony and full of roots, planted on the waves of language;

the love unseen and the love unheard and the love unsaid: the love in love.

Syllables seeds.

Octavio Paz is a Mexican poet and critic, born in 1914. His numerous books include *The Violent Season* and *Configurations, The Labyrinth of Solitude, The Bow and the Lyre, Children of the Mire: Modern Poetry from Romanticism to the Avant-Garde,* and *The Monkey Grammarian.* He received the T. S. Eliot Award, the Neustadt International Prize, the Britannica Award, and the 1990 Nobel Prize for literature.

[w] [o] [r] [d] [p] [l] [a] [y]

(a 400 word essay, more or less)

Ward M. Kalman

w	O	r	D	s	W	o	R	d	S
O	r	D	s	W	o	R	d	S	w
r	D	s	W	o	R	d	S	w	O
D	s	W	o	R	d	S	w	O	r
s	W	o	R	d	S	w	O	r	D
W	o	R	d	S	w	O	r	D	s
o	R	d	S	w	O	r	D	s	W
R	d	S	w	O	r	D	s	W	o
d	S	w	O	r	D	s	W	o	R
S	w	O	r	D	s	W	o	R	d

Are we rowing through words and sod, or playing
with swords of the mind?

58

L'langualuxe

Holcomb Reed

Inspiration

I was born in upper Maine, a stone's throw from the Canadian border. There the winters were long, nights came early, and the warmest place outside a fire was inside the cocoon of heavy blankets—especially at story time.

I have vague memories of my mother pulling up a small wooden chair, lamplight yellowsoft, crepuscular with dust, illuminating only her animated features. It was our little theater *waaaaaaay* off Broadway. Nightly I found myself transported in that darkness . . . Honey-hungry Pooh stuck in a tree! Salutations from Charlotte, the master web spinner! Mary Poppins, Captain Nemo, a Jabberwock that snicker snacked!

Maine: memories of stories read every time I went to bed. Wild dreams following.

꒰꒱

Inside me lives l'langualuxe. I feel her stir from an early age . . . When she does, I write. I remember once when she stirred twice.

Reinspiration

The children's poem *MidKnight Snack* took me ten years to write—in part, because I forgot about it for eight years. One night, as I prepared for bed, a light-limned, ghostalope flicked across my consciousness—the barest outline shape of . . . beauty. There was a vague sense of recognition: *I know you, stranger . . . but from where?* Silence. And suddenly, into the light of my fully conscious mind pranced a gazelle so rare in her beauty that she stole my breath away.

She stood fawnlike, shaking, flecked tan by white on reed-thin legs that stretched down to tiny black hoofs. She cocked her head, stared at me, soft brow lifting to a question mark. Her mouth made a perfect "O" as if surprised and asking, *Is this the one?* Before me stood, to my utter amazement, l'langualuxe—muse to Milton, Hopkins, Williams and Milne. Her doe-eyes blinked, flash-lashing, flash-lashing . . . She shook her thin, fragile head as if to shake off her own doubts and whispered,

> *Intent upon snitchin' a snack from the kitchen . . .*

and instantly was gone.

My god . . . Clouds of memory began to part—vague recollections of a difficult poem that I worked on years before . . . I saw myself sitting on a slat-backed, wooden chair, dressed in skivvies, drinking coffee from a dirty mug at my then girlfriend's dining room table in a small, fifth-floor walkup apartment in Greenwich Village. Now, for a second time, this particular gazelle had crossed my path: a reinspiration.

The hunter in me sniffed the air . . .

When stalking begins, lines flee across the paper veldt like ibex. When approached, words hiss and claw at me like cornered lynx. Phrases fight with all their strength not be mounted on the wall of my literary hunting lodge. In the end, one of us stands—bloodied and victorious. The truth is, I lose most of my battles with words.

Whenever I start a new poem I never know what I am going to write. Something strikes me—usually a particular combination of words. Sensuous sound tickles my ear. I feel a tingle. Breath cuts short. I become hyper-alert and *respectful.* There is something inside me working. It is smarter than I.

It took two more years to finish *MidKnight Snack.* Half way through six pages of Panda Bears and refrigerators I finally understood the poem's point and could finish it.

Desperinsperation

Philosophically, I am a throwback Kantian: through intuition man constitutes the only world he can possibly know with symbols. Therefore, our essential identity is Symbol Creator. Our essence is artistic inescapably.

<center>⌇</center>

After two years battling l'langualuxe of *MidKnight Snack,* no wordmeat tasted fresh to me. Every line smelled of *snitchin's and kitchens . . .* Night after day after noon I wrote the same, the same, the same shit—for months. Desperation set in. Screamed I, *Loose the mind! Let it go . . . improvise!*

Frustrated, I typed the following line not thinking,

<center>I love the chin of the girl next door.</center>

God knows why, (except that, for a short while, I confess, my blonde neighbor had become an obsession of sorts, undressing, as she would, shameless before her shadeless bedroom window.) I cannot retrace exactly the steps that followed, but by iteration, three-quarters down the page emerged a line of nonsense.

<center>*dewerst nonforflongest flingerflyer*</center>

The line stood behind the cursor blinking, staring up at me fawnlike, flecked tan by white on reed-thin legs that stretched down to tiny black hoofs and smiling. I stared at the characters before me, white type on royal blue, giving not a clue. What did it mean? I closed my eyes. And soft she whispered once more to me, *Not what, but who . . . ?* and was gone.

The hunter in me sniffed the air . . .

Dewerst Nonforflongest Flingerflyer!

Six weeks later Dewerst had become . . .

The Flingerflyer

On summer days we, the kids of Opal County, Georgia, would tromp with slingshot flingers and balsawood flyer-planes to *The Thremsheft Threshold*—a line of four dead, fingery-limbed trees—three sumgum and a giant fiddle leaf fig. Question was, how far could you flooshfly through *The Threshold* before one of them thrust knock you out? Bubba Flongest became Captain of the Flingerflyers when he flew through two. Nobody ever touched the third tree, much less the giant fiddle leaf. We'd talk about it; dream about the kid that'd beat that old fig.

Late one afternoon a boy named Dewey, nicknamed *Duck*, showed up at *The Threshold* with a black painted, handmade—not store bought like ours—flingerflyer. Bubba shouted out, *What is that ugly thing Duck, a baby gator?* We laughed and yelled, *Dewey Duck, you gonna fly a baby gator through the Thremsheft Threshold?*

Dewey licked his finger and held it in the air. He studied the trees, did something to the wing, slipped the hook over the slingshot flinger-strap and pulled way back. The thick brown band of rubber stretched white, ribbed—taut like tendon. One eye closed, one eye bottle-bottomed, he tilted the balsawood flinger-plane and . . .

THWAAAAAAAACK!

It shot through the first sumgum like a thirty-aught-six, broke a twig coming out of the second sumgum, veered into the third and whacked into a huge branch. The flinger-jet keeled over and collapsed onto an old sump—six feet past that third tree.

We Opal kids stood there shocked. Amazed. How many summers? How many flooshflings?

We walked to Dewey's plane, crumpled on the sump.

What's its name? I asked.

Stealthfrum . . . he said.

We all nodded, *That's a good name.* I could see him clenching his jaw . . . *Gonna try again?*

Do or die, he said.

I never met someone who had to do whatever he did so intensely. I mean, he just had to do what ever he did in the worst way! So right there and then I gave him a new, secret name. Dewey was no longer *Duck* to me. He was Dewerst Nonforflongest Flingerflyer . . . That night, Dewerst made Opal County history.

Dewerst Nonforflongest Flingerflyer,
Captain of the floosh-flung flight;
Zoomer through three Thremsheft thresholds,
Thrust his stealthfrum—crasht—from sight.

Deep within a pocket-pudhole,
Slunken from his frooosh fraught fright;
Dorshed this Dewerst was and frumbling,
Frizzling frets throughout the night.

How could Stealthfrum, crushed from froosh-fling:
Floosh-fling! Swing! Smasht! Gnasht! Nosht! Nixt!
Having crasht-crumpt on the sump pump,
Be from nasty gnasht-nosht fixed?

Finger mingling glue-glost stuckelfrets,
Morguestall papalwackers, sling-tang tucks;
Dewerst tackelwackered papered knicker-knackers,
To his Stealthfrum's interterrelled shucks.

"There!" cried Dewerst, and grabt the Stealthfrum,
Slung, the Stealthfrum frooshed with might!
Zuuuumed the Stealthfrum to the sumgum,
To the first Thremsheft of night.

Couuraaack! The flashmasht blast of Thremsheft!
Unfurlt, the cricklt-cruncht zormed zoomstopper!
But late, the Stealthfrum shot to freedom—
Two more Thremshefts and then the Eyepopper . . .

Morguestall papalwackers strained at tackle-
wackered joints, as Stealthfrum smashed,
Into the second terrifying Thremsheft—
Burst through the Thremsheft, zoomstopper bashed!

One last Thremsheft to flingerflying-froosh through,
One last Thremsheft, and then the great unknown;
Slashed the tiny papalwackered Stealthfrum,
Into the Thremsheft's underbellyzone . . .

Sonics blasted Nastnooks! Interrelled shucks shook!
Thrimble crested Zourkentacks were startled, shocked and dazed!
Inward tiny Stealthfrum, fragile little Stealthfrum,
Zormed and flooshed alacrelooshed, Dewerst was amazed.

Only mattered Eyepopper, never passaged stealth-stopper,
Shaky little Stealthfrum rose and started to engage;
Never had a flooshflung dared the nasty wing-lopper,
Fearsome was the tail-chopper, should he disengage?

Sundercrushing Eyepopper spied the tiny Stealthfrum,
Wizzlewafting, limpalofting, hardly worth its time;
Belly laughed the Eyepopper, final wall of stealth-stopper,
At the frizzly tacklewackered Stealthfrum in its climb.

Sudden was a gurst of sicklefrizzle Northwooorst,
Blasting low along the line of Thremshefts left behind;
Sliding under Stealthfrum, wounded little Stealthfrum,
It lifted high the tiny craft that Dewerst had designed.

Long and ancient enemies, Northwooorsht and Eyepopper,
Sickelfrizzle Northwooorsht a wink to Dewerst gave;
Together they would flingerfly to meet their common destiny,
They set their face against the night, their aspect was most grave.

Rolling down and sideways slashing, tiny little Stealthfrum,
Slipped between the outer walls of Popper's fierce defense;
Ripple-warring tanglesnatchers grappled for the tacklewackers,
Dewerst grit his teeth and cried, "This match I here commence!"

Lightning flashed and crackleshafted,
Rippling holes and raggleslashes
Through the dark night canopy
That menaced just above;

Dewerst wiped a bead of sweat,
And aimed his tiny flingerjet,
Over, under bolts and jolts—
His throttle gave a shove.

Dewerst Nonforflongest Flingerflyer,
Captain of the floosh-flung flight,
Zouuurmed the crest of Northwooorsht's frizzle,
Eyepop thrashed with endless might;

Savage battle, twisted, gnarling,
Frightful flashes, windbashed screams;
Young Forflongest blasted through . . .
And finally reached his dream of dreams.

A Dewerst is someone who learns
To master heart and will;
But knows that at triumphant ends,
There's much to master still.

꩜

Textadermy

L'langualuxe: a gazelle flecked tan by white, spotted, *flashing* out of sight. I have hunted her through thorn and brush for words that ink my soul. Like Dewerst and Eyepopper, she and I have done savage battle. The time has come for me to move on—there's much to master still.

Holcomb Reed has been producing and editing television for CBS News, ABC News, and the National Geographic Society for the past twenty years. He lives in Brooklyn, New York, with his wife, and is the author of a children's picture-and-poem book called *Wird Bird*.

59

Dreaming a Story

Judith Simundson

AUTHOR'S NOTE: *Hulders are folklore troll types so human looking that you cannot know for sure unless you see the tail hanging down. But if they tuck it into their belts in back under the skirt, or drape it down a long, loose pant leg, who is to know? As they age, however, they go for comfort and cut a hole in the back of the pants and just let it hang out. Hulders are believed to try to lure humans into their world to enrich the blood line. They will entice humans when they are most vulnerable during certain life changes: birth (especially prior to baptism), confirmation and marriage. Or simply when a human is alone and may feel lonely. They look just like us but offer a parallel underworld of life, a shadow counterpart to our own.*—J.S.

A legend from Norway—

A tale of a fisherman
fishing for fish
but suddenly he
is dragged through the sea.
Holding fast to the line
he plows down deep,
just glimpsing the fish
as it slips out of sight
and into a hole.
His frozen hand
on the end of that line
cannot let go
and "pop" through the hole
where the hulder fish dived,
at deep sea bottom
he enters a world
of sand and sky.
Dry sand at his feet
and over his head
the slate green sea
held aloft by a gauze
of shifting light.

His line went slack
as he followed it to
an azure lake.
Through shafts of mist
he thought he saw
the great fish flip
then out from the lake
stepped a hulder maid
her tail lifted up

(but hidden behind her)
to dry in the air.

He fished for fish,
she manned for man

I, too, am a hulder
not fishing for fish
nor manning for man
but seining for stories
each night in my bed
where watery dreams
draw me to tales
of humans and hulders—
they with their tails
can slip into fish,
slide out a wo-man.

Yawning, I fluff
the pillow of feathers,
slip down in the bed.

Bed
where billowy comforter
floats over me.

I slide my cold toes
to the hot water bottle
stretch out in luxury.
Puzzling a story
I drift down to sleep

The Hulder Woman
drew closer and said,
"Come join me for dinner

in my seashell house
where curtains of sea weed
stretch gossamer light."

"Yes," the Man said
as he reached for her hand.
He saw that her eyes
were focused and clear
unblinking . . . almost
like a . . . fish?
"That's absurd!" thought the Man.

And down I go
to the sea's second bottom.
Night fishing and catching
just bits of a story,
til one day, I weave
that poem pulling you
down
and
down
to the
bottom
of
the
page.

Judith Simundson is a Norwegian storyteller, singer, writer, and sculptor specializing in Norwegian folklore. Her compact disc recording, *Norwegian Tales of Enchantment,* was selected "Editor's Choice" by *Booklist* and awarded "Notable Children's Recording 1999" by the American Library Association. In 1987, she received a stipend from the Norwegian Government Emigration Fund to study folk music, dance, and stories at Ole Bull Akademiet in Voss.

60

The Case of
the Missing "M"

Pierre Joris

SOMEWHERE ALONG THE LINE an M went on the lam (but already language asks for correction: it was no line, at least no straight line, not even a well-designed symmetrically-correct curve, but rather something "en pointillé," a needlework crisscrossing like tracks in the snow, uneven, hobbling, appearing/disappearing, a scar left on water & air & earth, a now-you-see-it, now-you-don't nomadic "ligne de fuite" but maybe we'll have time to come back to this question later). Let's start here, with that missing letter. This seems to happen all the time as I write. Letters go missing. Or just one, to begin with. A letter goes missing. For example, & among others, an "M"—the letter that opens the word "missing," leaving something like (h)issing, where the "h" in between the parenthesis rhymes with the Arabic hamsa, the unsounded letter, though here it is more like a speech impediment, im-pedes-ment, in there there are *pedes,* feet, limbs, & immediately we got trouble, trouble in paradise, trouble walking, getting our, well, my feet caught, though this is not the infamous swollen foot, that oedipal thing, or then maybe again it is, under another guise, one I would call richer, in that it involves becoming/remaining an eternal toddler. But I don't really want to begin

with the family scene, those ugly "scènes de famille." I'm not in any-
body's pharmacy right now, thus also in no need for a scape-goat, this is
another shop, the body-shop of language maybe, where the letters get
put together & as happens with watches or other machinery, you take
one apart because you think it's not working the way it should & put it
back together & it works but you're astounded that a little screw or
weirdly shaped piece is left over, you don't know where it fits but imme-
diately it seems more essential to you than the rest of the coherent
machine. Here's how this happened in this poem from 1986:

0.45 a.m.
after the storm
 the flat
lineaments of
word
 I
 meant
world a letter
on the lam
 a greek
lamb-
 da / fort
missing the
eleventh leg
—not a wooden
—not a toy
of this journey
though it is
the meat we eat
in this house
after the storm
the skies
washed
 dangling

limbs
lamdas
 fort
where we
fiction our
selves to be
at one

But the letter I was thinking of was that first letter of the word miss-
ing, which is also the first letter of the word mother. This is what hap-
pened to the language: it went from mother tongue to other tongue. At
times when I stand up, on my own two legs, limbs, like right now in front
of you, I have the hubris to claim that it was I who lopped it off, though
when I sit down & face my job, writing, it becomes clear that this letter
fell off on its own accord somehow & that it is in the gap between
mother-tongue/other-tongue that I am written. This gap, this emptiness
is liable to take my breath away. It is the closest I've come to understand-
ing what someone like Edmond Jabès means when he talks of the void,
of emptiness, the desert, that interface between language and the world.

Pierre Joris teaches poetry & theory at State University New York
in Albany. He has authored, coauthored, and edited numerous books
and anthologies of poetry, including *Poasis: Selected Poems 1986–1999,*
h.j.r, the manifessay *Towards a Nomadic Poetics,* and, with Jerome
Rothenberg, *Poems for the Millennium: A University of California Book
of Modern & Postmodern Poetry* (two volumes). His translations include
books by Paul Celan, Maurice Blanchot, Edmond Jabès, Habib Ten-
gour, Tchicaya U'Tamsi, Kurt Schwitters, and many others. He is cur-
rently translating, with Jerome Rothenberg, the writings of Pablo
Picasso. This memoir was excerpted from a larger piece that was first
performed in 1990 and printed in *Sulfur* (#34, spring 1994).

Not a Case
of Writing

Steven Connor

I PROMISE NEVER to be a writer. This is an odd thing for me to say, because I am, of course, a career writer already, of a minor kind. I have to do it at regular intervals because of my job. As a Professor in the University of London I have a contract that says I have to do it. I am locked professionally into an absurd situation, where, as a Professor of English, I am required to write about writing.

What I mean, I suppose, is that I intend to avoid becoming a Writer, the kind of writer who writes 'writer' on their passport, who does readings and public book signings, has photos taken of them trying to look as pretty as they were before they became a writer, takes part in fatuous TV discussions about 'the art of writing', or the condition of 'the writer' and so on. Obviously, all these things would be nice in and of themselves, but would inevitably stymie the chance of doing writing in the way I want to be able to. Being a professional writer would be like being a porn star, compelled to be combed and pointy at 9:00 sharp every morning, ready to perform private pleasures in public.

I write selfishly, and for entirely selfish reasons. I write in the same semi-addicted daze as the computer gamer or internet surfer. Me me me.

But the medium through which I move as I exude it, is not the pool of Narcissus: it is the pull and press of other lives, other ways of getting a life. When I do certain kinds of writing, I am able to slip the noose of me, to taste with other mouths something other than the sour mash of which I have always tasted to me.

I surprise myself with an interest in how writers write about writing. The writers who interest me the most are those who discover that writing about writing compels the discovery of a new kind of writing again, a writing that doesn't neatly fold over or fit into the fingerholes of the writing it's supposed to be about: Virginia Woolf, puzzling about what on earth to call her novels, Henry James in his baroque agonies of self-scrutiny, James Joyce and his fluent inventions for ways of describing stylistic newness.

The discovery of all of this came about for me in the middle of the way. One morning, I just started writing a sentence that I knew would, by the time it was over, have already become the first of a new kind of writing for me, one that would allow a different kind of thing to come to be done. It was like a prostration, a shifting about of weights inside me. It wasn't the discovery of a new kind of sentence, or manner, or method, so much as an intuition about how I might be able to pay attention to a whole range of ordinary things in which I was interested. From now on, I would have to take time off to find out how to write about things like sweets, wires and bags, about the tender madness of mundane actions like counting, folding and falling over. I was going to have to write amid things, rather than getting on top of them, especially the strangeness of intimate feelings and conditions, like embarrassment and envy and itch and shame. This was to be my underworld, a world of things retrieved from the back of the sofa.

I know, at sweet last, that I will have to avoid writing a novel. To write a novel is to come into a huge, suffocating inheritance, a vast all-seasons wardrobe of costumes and plots and styles and themes and tricks of the trade, a bulging hoard of accomplishment. To write a novel would be to become plated with all that dignity, when my aim is to open up chances to become poor beyond my wildest dreams.

I seek what occupation I can amid the implicit, the orphaned, the omitted, the obvious and the overblown, the approximate, the abortive and the also-ran, the negligible, the nonsuch, the infant, the sorry, the worse for wear, the incipient and the ruined. I am resigned to becoming an addict of the endotic. I am going to forgive everything. Anything in the whole rag and bone shop will do from now on, though nothing demands that anything of the sort should be done. The point is not to redeem or transfigure any of this, only to think up ways for it to scrape a living from me, to consent to its gratuity, and for free, for I have been paid already, with an embarrassment of pittance. It has taken me the worse part of a lifetime to get to so queer a pass, from which I can scarcely imagine wishing again to stir. Far from unfriended, I shall nevertheless be taking to truancy. School is indeed out completely. For a kind of ordinary glory has made a stay in my life, by which I cannot for the moment imagine that I am to be let be. I have been put to all this as to a task or, gentle saying, to death, and intend staying put. Writing doesn't come into it, it's not a case of writing.

Steven Connor is a professor of Modern Literature and Theory at Birkbeck College, University of London. He is the author of critical books on Charles Dickens, Samuel Beckett, James Joyce, and the post-war novel, as well as *Postmodernist Culture* and *Theory and Cultural Value*. He is also a broadcaster who has written and presented radio series for the BBC on noise and magical objects in everyday life (bags, wires, screens, and sweets). His most recent book is *Dumbstruck: A Cultural History of Ventriloquism*, and he is at work on a book about the historical understanding and imagination of the skin. Much of his work is available online at www.bbk.ac.uk/eh/skc/.

Last Words: Faulkner and Steinbeck on Writing

FOR MOST OF US who have ventured into the writer's life, our musings are but humble exposés—we do not pretend to address the deeper issues of life, of humanity's tragedies and strengths, nor do we start out with a vision to transform the world. But once in a great while, a story or an essay or a speech transcends the idiosyncracies of everyday life, cutting through the night to illuminate the soul.

In the twentieth century, two writers achieved such greatness by focusing on humanity's needs. I want to leave you with their words, in the hope that they may foster within you the courage to write and speak out against the injustices that permeate this world.

William Faulkner, from His 1950 Nobel Prize Acceptance Speech

The young man or woman writing today has forgotten the problems of the human heart in conflict with itself. . . . He must learn them

again. He must teach himself that the basest of all things is to be afraid: and, teaching himself that, forget it forever, leaving no room in his workshop for anything but the old verities and truths of the heart, the universal truths lacking which any story is ephemeral and doomed—love and honor and pity and pride and compassion and sacrifice. Until he does so, he labors under a curse. He writes not of love but of lust, of defeats in which nobody loses anything of value, of victories without hope and, worst of all, without pity or compassion. His griefs grieve on no universal bones, leaving no scars. He writes not of the heart but of the glands . . . [Humanity] has a soul, a spirit capable of compassion and sacrifice and endurance. The poet's, the writer's, duty is to write about these things.

John Steinbeck, from His 1962 Nobel Prize Acceptance Speech

Faulkner, more than most men, was aware of human strength as well as of human weakness. He knew that the understanding and the resolution of fear are a large part of the writer's reason for being. This is not new. The ancient commission of the writer has not changed. He is charged with exposing our many grievous faults and failures, with dredging up to the light our dark and dangerous dreams for the purpose of improvement. Furthermore, the writer is delegated to declare and to celebrate man's proven capacity for greatness of heart and spirit—for gallantry in defeat, for courage, compassion and love. In the endless war against weakness and despair, these are the bright rally flags of hope and of emulation. I hold that a writer who does not passionately believe in the perfectability of man has no dedication nor any membership in literature.

Permissions

‿‿‿‿‿‿‿‿‿‿

I love being a writer. What I can't stand is the
paperwork.

—PETER DE VRIES

Franz Kafka in His Small Room on the Street of the Alchemists, 1916–1917:
Copyright © 2000 by Willis Barnstone. Used with permission of author.

Clawing at Stones: Copyright © 2000 by Sindiwe Magona. Used with per-
mission of author.

Writing for Revenge: Excerpted from "Breathing Space," which originally
appeared in *The Writing Life,* Random House. Copyright © 1995 by Bob Sha-
cochis. Reprinted by permission of Brandt & Brandt Literary Agents, Inc.

Ruining the Page : Copyright © 1989 by Annie Dillard. Reprinted by permis-
sion of HarperCollins, Inc.

Watcher at the Gate: Copyright © 1995 by Gail Godwin. Used with permis-
sion of author.

Mistress: Copyright © 2000 by Cathy A. Colman. Used with permission of
author.

And a Cold Voice Says, "What Have You Done?": From *The Journals of Sylvia
Plath,* by Ted Hughes (ed.). Copyright © 1982 by Ted Hughes as Executor of the
Estate of Sylvia Plath. Used with permission of Doubleday, a division of Random
House, Inc.

Sylvia's Honey: Copyright © 1997 by Catherine Bowman. Used with permis-
sion of author.

About the Editor

MARK ROBERT WALDMAN is a writer, editor, and therapist. His counseling practice is in Woodland Hills, California, where he specializes in relationship issues and creativity, working with individuals, couples, artists, and writers. He is the author of *Love Games,* a book that promotes communication and conflict-resolution skills, and *The Art of Staying Together,* an anthology of writings on the essence of intimacy and love. He is coeditor of *Dreamscaping: New and Creative Ways to Work with Your Dreams* and editor of *Will God Survive the 21st Century: Dangerous Visions, Radical Hope,* to be released by Tarcher/Putnam in 2002.

He was the founding editor of *Transpersonal Review,* an academic literature review journal covering the fields of psychology, religion, and mind/body medicine, and his essays, poetry, and fiction have been published in numerous anthologies and journals throughout the world. Mark frequently lectures on topics relating to psychology, writing, and the publishing industry and is an editorial consultant for publishers and authors. You may contact him through his office or email:

21241 Ventura Boulevard, Suite 269
Woodland Hills, California 91364
818-888-6690
markwaldman@cyberhotline.com